# THE A GAME

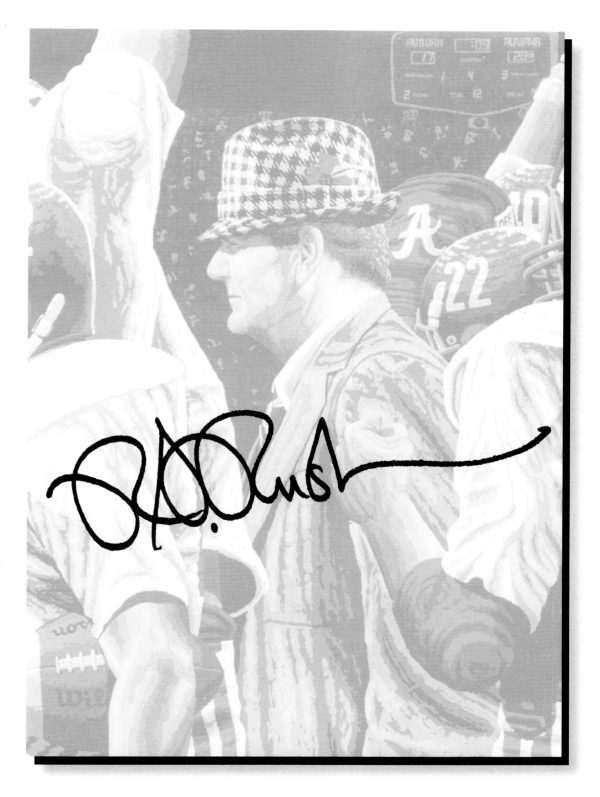

**Great Moments In The History Of Alabama Football**

## Original Art: Rick Rush

Text: Caleb Pirtle III  Book Design: Jutta Medina

ISBN: 978 - 0 - 9842083 - 0 - 2

*"The A Game: Great Moments in Alabama Football History"* is produced by London Square Media in association with The University of Alabama National Alumni Association, Tuscaloosa, Alabama.

The University of Alabama National Alumni Association

Director of Alumni Affairs:        Pat Whetstone
Director of Alumni Funds:        David Wilson

London Square Media

Publisher:        Herb Sorkin
Editorial Director:        Caleb Pirtle III
Art Director:        Jutta Medina
Director of Art Photography        Brad Smith
Editors:        Karen Lingo
        Linda Pirtle
Vice President, Sales:        Bill Stutts

Printed in the United States of America

First Edition

# Contents

# Nick Saban: To Be A Champion

It will be our goal to give Alabama the kind of football program, the kind of football team that you can be proud of, that will complement the tradition that this institution has been so proud of through the years ... I want everybody to know that we need a lot of positive energy for everybody to make a difference in how we go about what we try to do to have the best football team in the Southeastern Conference, the best football program in the Southeastern Conference. I think everybody should take the attitude that we are working to be a champion, that we want to be a champion in everything that we do.

Our mission statement here is to create an atmosphere and environment for everyone to be able to succeed, first of all as a person. We want players to be more successful in life because they were involved in our program, by the principles and values that we're able to develop with them so that they can be successful relative to the character and attitude they have as a football player at this institution.

I know there are tremendously high expectations here. I can tell you that I have even higher expectations for what we want to accomplish. I want to win every game we play. I've never gone out to play a game, we've never gone out to play a game, where we didn't want to win, and it wasn't important to win, and we didn't focus on winning, put all of our energy into winning.

The goals we have don't say anything about results. The first one is to be a team. Together, everybody can accomplish more. It takes trust, respect for each other in what everyone's role is, what they need to do. The first thing that's important is for us to work together, use all the resources we have to make this everything it is capable of being.

The last one is to be a champion.

What kind of football team do we want to have at Alabama? We want to be a big, physical, aggressive football team that is relentless in the competitive spirit we have to go out and play with week in and week out. What I would like for every football team to do that we play is to sit there and say, "I hate playing against these guys. I hate playing them. Their effort, their toughness, relentless resiliency to go hard on every play and compete for sixty minutes in a game – I can't handle that." That's the kind of football team we want.

*Nick Saban*

Press Conference, January 4, 2007

THE UNIVERSITY OF
# ALABAMA
CRIMSON TIDE

Alabama has long been a university of winners, in athletic venues as well as in the classroom. To our campus each year come the best and the brightest, the leaders and the builders of tomorrow.

The Alabama Athletic Department is proud to support the Alabama National Alumni Association in its untiring efforts to develop scholarships that will further enhance educational opportunities for those students who want to be a part of the Crimson Tide experience.

"The A Game" describes great moments in the history of Alabama football, and Saturday afternoons and nights spent at Bryant-Denny Stadium or at Legion Field in Birmingham do help form many of the most remembered traditions and memories associated with the University of Alabama.

When students arrive on campus, we want to be the conduit through which they can build their own great moments and experiences that will last a lifetime. The Alabama National Alumni Association is constantly paving the way with scholarships. We salute the association and its leadership in making this book a source of new revenue that will help open new doors for the students of tomorrow.

Baseball
Basketball
Cross Country
Football
Golf
Gymnastics
Rowing
Soccer
Softball
Swimming & Diving
Tennis
Track & Field
Volleyball

Kindest regards,

Mal Moore
Director of Athletics

323 Paul W. Bryant Dr.
Athletic Facility
Box 870323
Tuscaloosa, Alabama 35487-0323
(205) 348-3600
FAX (205) 348-2196

# Acknowledgements

Kenneth Gaddy, Director of the Paul W. Bryant Museum, Tuscaloosa, Alabama. The exhibits, displays, and archives of the museum hold the historical memories and showcase the great moments in Alabama football history.

Coach Clem Gryska for providing insight into Paul Bryant, the man and the coach. Gryska played for Alabama and served as an assistant coach with the Bear.

The authors of many outstanding books on Alabama Football:

Barra. Allen, "The Last Coach," W. W. Norton & Company, New York, 2005

Dunnavant, Keith, "The Missing Ring," Thomas Dunne Books, New York, 2006

Gaddy, Kenneth, editor, "Twelve And Counting," The University of Alabama Press, Tuscaloosa, 2009

Gold, Eli, "Bear's Boys," Thomas Nelson, Nashville, 2007

Hicks, Tommy, "Game of My Life," Sports Publishing LLC, Champaign, Illinois, 2006

Krauss, Barry, and Moore, Joe M., "Ain't Nothin' But A Winner," The University of Alabama Press, Tuscaloosa, 2006

Keith, Don, "The Bear," based on a screenplay by Al Browning, Jr., Cumberland House, Nashville, 2006

Marshall, Benny and Friends, "All Time Greatest Alabama Sports Stories," The University of Alabama Press, Tuscaloosa, 2003

Murphy, Thomas, "Game Day: Alabama Football," Triumph Books, Chicago, 2006

Scott, Richard, "Legends of Alabama Football," Sports Publishing LLC, Champaign, Illinois, 2004

Sharpe, Wilton, "Crimson Tide Madness," Cumberland House, Nashville, 2007

Townsend, Steve, "A Time of Champions," Sports Publishing LLC, Champaign, Illinois, 2003

Wade, Don, "Always Alabama," Simon & Schuster, New York, 2006

Yaeger, Don, with Sam Cunningham and John Papadakis, "Turning of the Tide," Center Street, New York, 2006

The newspapers that provide Alabama sports history as it happens, including:

The Anniston Star,
The Atlanta Journal,
The Birmingham News,
The Dallas Journal,
The Houston Post,
The Huntsville Times,
Knight-Ridder,

The Los Angeles Daily News,
The Knoxville News Sentinel,
The Los Angeles Examiner,
The Los Angeles Times,
The Miami Herald,
The Miami News,
The Mobile Press-Register

The Nashville Banner,
The New Orleans Item,
The New Orleans Times Picayune,
The New York Times,
The San Francisco Chronicle.

The great sports writers who covered Alabama football, including:

Clyde Bolton,
Morgan Blake,
Royal Brougham,
Jimmy Bryan,
Jimmy Burns,
Billy Campbell,
Ed Danforth,

Fred Digby,
Paul Duncan,
Gentry Estes,
Paul Finebaum,
Peter Finney,
Oscar Fraley,
Paul Gattis,

Jack Geyer,
Wayne Hester,
Mickey Herskowitz,
Cecil Hunt,
Jimmy Hyams,
Blinky Horn,
Dick Hyland,

Bob Kyle,
Charles Land,
Billy Lyon,
Ralph McGill,
Harold Martin,
Jim Minter,
Billy Mitchell,

Jim Murray,
Zipp Newman,
Ian Rapaport,
Grantland Rice,
Fred Russell,
Farmer Seale,
Tom Siler,

Will Steves,
Maxwell Stiles,
Walter Taylor,
Alf Van Hoose,
Michael Ventre,
Red Webster,
Adam Wren.

For convenient and luxury accommodations on the University of Alabama Campus:

Hotel Capstone, 320 W. Bryant Drive

Tuscaloosa, AL 35401

(205) 752-3200

# Prologue

In Alabama, a year has to do with one single season.

It deals with football.

The season is measured in games.

Games are marked by wins and losses.

Wins or losses are the results of moments.

Single moments.

Big.

And small.

The seasons fade in memory, as do the games and even the wins. The losses are erased from the mind and forgotten.

Only the moments remain.

The mad dash to the end zone with time running out.

Fourth down in the mud.

Or rain.

The field goal when all that separates disappointment and delirium is a scant three points. The yardage always changes.

The goal line stand.

The interception.

The game-saving tackle.

The punt block.

Or maybe it was a field goal.

The fumble recovery.

Defying the odds.

And beating them.

The hiring of a coach.

The right coach.

Crucial decisions made before a game, or during a game.

The right play call.

The right player to run it.

The boy from the end of the bench – untried, untested, unknown – who rises in a single, frozen instant and reaches for glory and finds it.

Since football was first kicked off at the University of Alabama in 1892, the Crimson Tide has experienced so many great moments, unforgettable moments, often life-changing moments.

Here are a handful of them.

They only scratch the surface, perhaps, but for all time, in lore and legend, they remain as the bedrock of Alabama football.

"Preliminary Drawing" for original painting of Coach Paul "Bear" Bryant.

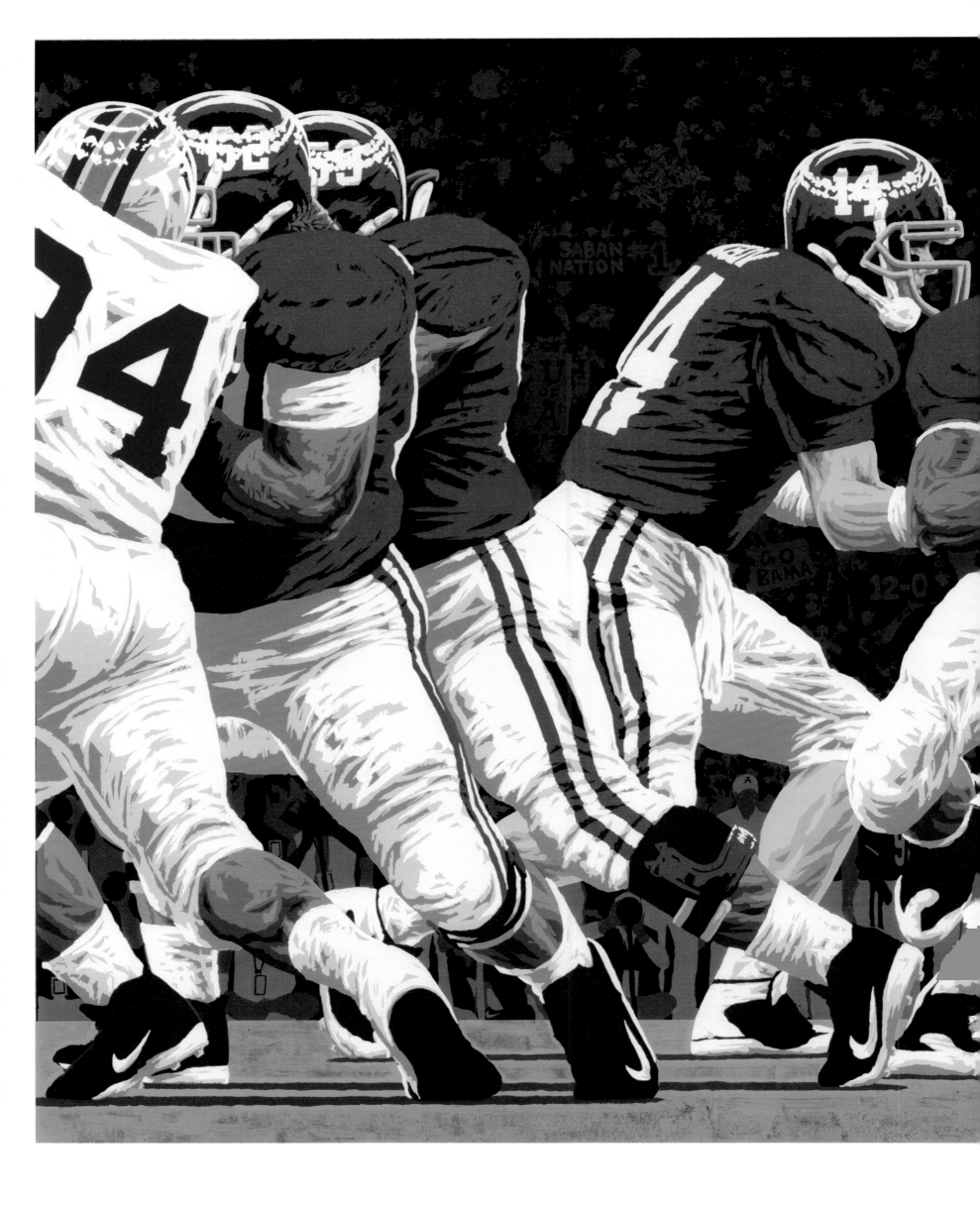

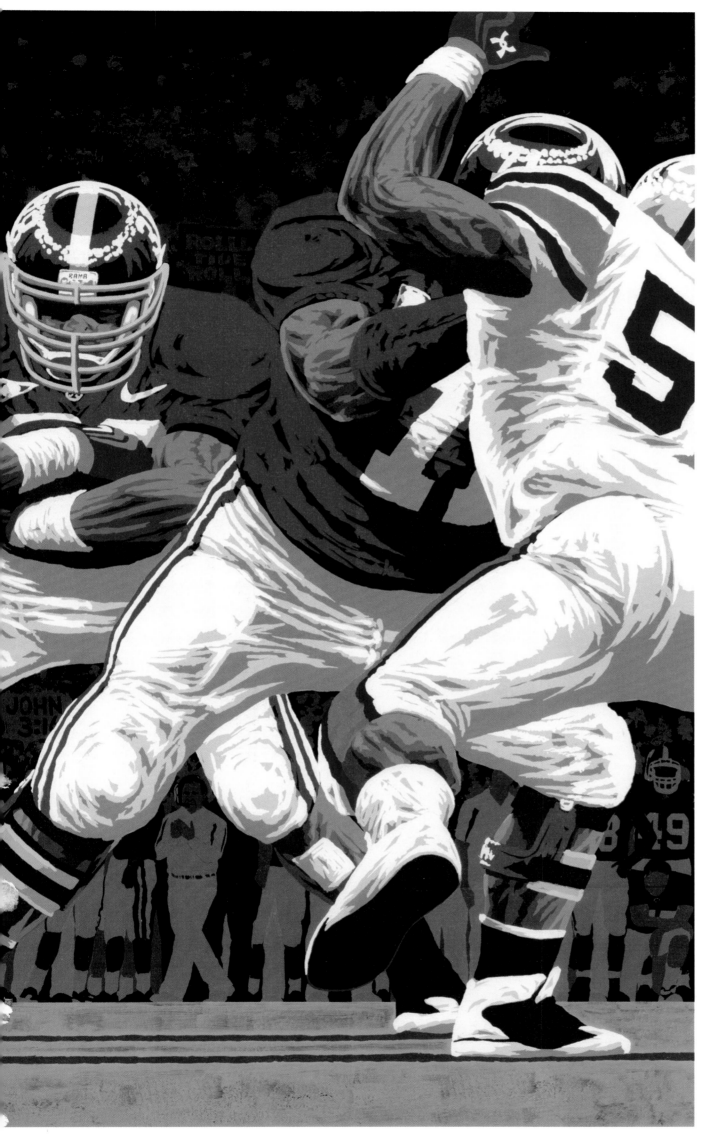

# RETURN TO POWER

Beating Auburn To Win The SEC West

> *Football is the game of the future in college life.*
>
> <> William Little, the father of Alabama football

The Year: 1892

## The Moment:
# The Dawn of Alabama Football

What it was, was tackle football, although William Little had never seen it before and wasn't quite sure why those boys in padded clothes and leather helmets were battling so hard to wrestle a strange-looking, somewhat oval ball away from each other.

It looked more like a street fight.

Maybe a backyard brawl.

But somebody said it was a game, and, to William Little, it was not unlike watching a train wreck.

It was violent, perhaps even brutal.

But, somehow, he couldn't take his eyes off the play unfolding in the dust and grime and ragged grasses of the empty field sprawling before him.

Little had left his homeland down in Alabama and enrolled at Phillips Exeter Academy in Andover, Massachusetts, preparing to enter Yale when classes began again.

He took a detour from his studies late one afternoon and stumbled across football, a sport that had taken the East by storm.

Everyone who was tough enough, bold enough, foolish enough, swift enough, or had nothing better to do than slam heads together was out fighting for possession of a novel and somewhat oval ball.

It kept bouncing in the oddest directions and at the most curious of times.

Someone would throw it, drop it, catch it, kick it, or run with it, and a small war would commence.

No prisoners taken.

Bumps.

Bruises.

A little blood soaked in the grasses.

Pain.

Lord, everyone was playing with pain.

No one surrendered.

No one quit.

A whistle blew, and someone won, and Little had no idea who it was, but he was mesmerized by the scene unfolding before him.

He walked away, shaking his head. He wondered if they played the game at Yale.

William Little never found out.

He never made it to Yale.

Little received word that his brother Jimmy had died, and he took the train back home to remain with his mother while beginning classes at the University of Alabama.

Little did have the good sense to pack away an old football uniform before he left, and, during the spring of 1891, he introduced the sport to other students. It resembled an odd likeness of two desperate armies in the midst of an invasion.

Some played. Some watched.

A few bled.

And the game of tackle football suddenly became the toast of Tuscaloosa.

Just maybe, a few administrators thought, the game might well become a part of the university's athletic curriculum.

For them, it was worth the gamble.

They asked E. B. Beaumont of the University of Pennsylvania to head south and become the first coach to ever take charge of the football program.

He could build his own team.

He could become the man chosen to rule over Southern football.

There was, unfortunately, no salary attached to the job.

Beaumont put together a team that included Bibb Graves, who would one day be elected and serve three terms as governor of Alabama, and William Bankhead, the future Speaker of the U.S. House of Representatives who would sire the famed actress Tallulah Bankhead.

They were "The Cadets," often described as small, quick, and clever in a game where speed was obviously more critical than size.

The average weight of the team was 162 pounds a man, the lightest being 135 pounds.

William Little himself anchored the line as a two hundred and twenty-pound guard.

He was an untamed beast, a Goliath who kept dodging stones.

On the afternoon of November 11, 1892, the fabled era of a grand and glorious game began at the University of Alabama with the ignominious 56-0 defeat of a team composed of assorted high school players in Birmingham.

It had been billed in the press as a reflection of "the great amateur sport in America." It would be played with finesse and power, elbows and blood.

The strong endured.

The last team standing usually won.

The game would change over the years.

The grit and gumption of the players remained steadfast.

The next day, Alabama learned that the thrill of victory was often a prelude to the agony of defeat. The Cadets suffered a stinging loss to the Birmingham Athletic Club, 5-4, racing for a single touchdown, which, in those days accounted for only four points, while allowing a safety and a sixty-five-yard field goal in a game refereed by none other than its own head coach, E. B. Beaumont.

Alabama turned around – it was payback time – to whip the Athletic Club, 14-10, before meeting rival Auburn for the first time.

The lieutenant governor arrived at the field in all of his pomp and circumstance and was told that he would have to purchase a fifty-cent ticket.

He was insulted.

Didn't anyone know who he was?

He refused, turned his carriage around, and drove back home.

Alabama lost 32-22. It was not a good omen.

Coach Beaumont was fired. It was not good to lose to Auburn.

As was written in the school yearbook, "After keeping him for a short time, we found that his knowledge of the game was very limited. We therefore 'got rid' of him."

Tackle football might be a game, but it was a game to be won. Losses would not be tolerated.

Ties were mostly as bad as a loss.

Within the hearts of Alabama resided a tradition of winning even before there was a tradition of football. Neither time no circumstance would change it.

*Coach Wade was like a bloodthirsty army officer. We all wanted to hate him, but when it got down to it, we loved him.*

—<> John Henry "Flash" Suther

The Year: 1923

## The Moment:
# The Coming of Wallace Wade

Alabama Coach D. V. Graves had, perhaps, recognized it first.

In recalling his first Alabama football team in 1911, Graves said, "In September, the squad looked light and of poor physical development. Everything was discouraging. I had not yet become familiar with the Alabama spirit – that indescribable something, which made the effort of a light team bring seemingly impossible results."

His analysis was simple to understand.

Regardless of the odds and regardless of the opposition, don't count out Alabama.

The team would play with the same wild-eyed resolve as Bully VandeGraaff displayed against Tennessee in 1913.

Bull Bayer, a Vols tackle, recalled, "His ear had a real nasty cut, and it was dangling from his head. He grabbed his ear and tried to yank it from his head. His teammates stopped him, and a manager bandaged him. Man, was that guy a tough one. He wanted to tear off his own ear so he could keep playing."

It was exactly the kind of team and the kind of players Wallace Wade expected to find when he stepped on campus in 1923 to replace Coach Xen Scott.

It symbolized him, his character, his personality, his coaching style.

He was a fighter, a strict disciplinarian, blunt, and hard-nosed, a coach who struck fear in the hearts and minds of those players who soon learned the heavy, unrelenting, and exacting price they would have to pay for a championship.

They paid the debt in blood, sweat, guts, and an unwavering devotion to Wallace Wade.

He almost didn't make it to Alabama.

The University of Kentucky had made the first offer, and he was seated on a hard bench, waiting in a cold, dimly lit hallway while the trustees met in the warmth of a conference room and weighed the fate of Wallace Wade.

Was he the right man to guide the Wildcats?

Should they hire him or search further for a new coach?

The trustees spoke favorably of Wade.

Yes, they decided, they would hire him.

They did not ignore him.

They did not mean to be rude to him.

## COACH WALLACE WADE

Blueprint For A Championship

They forgot him.

They overlooked the fact that he was out beyond the big doors, blowing on his hands, trying hard to keep warm as a winter chill drifted down the hallway and bore into his senses.

They were discussing other matters of business.

Wallace Wade waited.

Hour after hour he waited.

The cold dampness began to seep into his bones.

He shivered for the last time and stood.

His muscles tensed. He set a firm jaw.

Wallace Wade stormed into the trustee's meeting and announced, "I have decided to go to Alabama. And I want to tell you that Alabama will beat Kentucky every year."

He was a man of his word.

He would play Kentucky eight times.

He would pound Kentucky into submission eight times. He would have made it nine if he had stayed that long.

Wallace Wade gave Alabama direction. He pointed the way, and his players were in a hurry to gear up and get there.

Xen Scott had been a fine tutor of the game, but he was mild-mannered and easy-going. He was firm, but in a milder sense of the word. Long practices were out of the question.

Wallace Wade was different. If he pointed to a brick wall, he expected his team to run through it.

Not over it.

Not around it.

Through it.

Even if it took all night.

In practice one afternoon, he left the field to answer a long distance telephone call. It was late. The call lasted a long time.

When he hung up the phone, he showered and headed home.

Hours later, he received another call. His assistant coach was on the phone. "What should we do about practice?" he asked.

Wade glanced out the window. "Let them go in," he said calmly. "It's dark now."

His word would always be final.

It would always be law.

Until Wallace Wade arrived, the national press hardly ever took football in the South seriously. It was at the low end of the totem pole if it was even attached to the totem pole at all.

But then, for years, Southern football had been bad and often worse.

The Ivy League had invented the game, or so it claimed, and, for them, it was a pastime for the elite.

And, Lord knows, the elite had never ventured on the southern side of the Mason-Dixon Line, and certainly not to Alabama.

The elitists smiled.

Forget Alabama, they said.

Wallace Wade was not smiling.

He had learned all about tackle football at Brown University, even played on the team that won the first Rose Bowl game.

If Southern football had a savior who would drag it to the precipice of national prestige and honor, the savior was called Wallace Wade.

He was the bloodthirsty army officer with vision.

He wanted players with stamina and endurance, young men who could play tough on defense, then turn around when the ball changed hands and play with the same intensity and tenacity, on offense.

He believed that games were won in the trenches. He worked hard on the lines, but he dabbled with the forward pass.

He loved the forward pass.

His team might run through a brick wall for him, but Wade had no fear of throwing over it.

Hit us.

Stop us.

That was how the game had always been played.

Now, Wallace Wade decided, you'll have to catch us as well.

Those boys in the South might be farm boys.

But, Lord, how they could run.

If the South did rise again, Wade thought, it would rise on the football field.

And it would rise first in Alabama.

> *He's slicker than an eel in a sea of stewed okra.*

The Year: 1925

&#8884; Sportswriter describing Johnny Mack Brown

## The Moment:
## Looking for Roses

Allison Thomas Stanislaus Hubert was a rare breed.

He was a bruising inside runner, a strong lead blocker, and he could cut a team's heart out with the forward pass.

He had played a little fullback, but Coach Wallace Wade moved him to quarterback in the middle of the 1925 season.

On defense, he roamed from sideline to sideline as the Alabama rover, pacing behind the line of scrimmage, a grim scowl etched on his face, always on the move.

Wherever the ball carrier was, wherever the ball might be, there would be hard-nosed Allison Thomas Stanislaus Hubert waiting for them.

He played without a leather helmet.

He played bareheaded.

He wanted the opposition to see his eyes.

He had the eyes of a gunfighter.

*Atlanta Journal* columnist Morgan Blake declared that he was a "Napoleon of football intellect."

Maybe.

His teammates called him Pooley.

Pooley Hubert had been offered a scholarship by Princeton, but he arrived a few days too late to take his entrance exams.

He headed south for Virginia but was not impressed with the way that Virginians played football.

He hung around Georgia Tech for a few days and might have stayed, but Hubert was a freshman, and the Yellow Jackets had a strict rule against freshmen making the team.

Georgia Tech Coach Bill Alexander recognized a flash of potential and suggested that he go to the University of Georgia up in Athens.

"Does the Southern Railway go to Athens?" Hubert asked.

"No."

"What's the next school on the Southern tracks?" he asked.

"Alabama."

Alabama, he decided, would do fine.

"What position do you play?" Coach Wallace Wade asked him the first time he saw Pooley Hubert walk on the field.

"Tackle."

Wade looked him over, watched him run a little, saw him throw a football, and promptly moved him to the backfield.

In 1925, Pooley Hubert and the dashing, daredevil quickness of Johnny Mack Brown led the Crimson Tide to an undefeated season.

Hubert ran and threw the ball with the cold blood of a rattler.

Brown, known as the "Dothan Antelope," ran and caught the ball, and a national sportswriter referred to him as "the gent with the sweet, elusive feet."

Alabama assistant coach Hank Crisp said, "I don't

know what kind of step he has, but it's something to see. He can jump sideways and still not lose forward speed. One man will not hem him in."

Alabama looked to the Rose Bowl.

The Rose Bowl was looking elsewhere.

It was the only bowl game in the nation, and it traditionally lined up a major power on the Pacific Coast to wage a small war against the strongest team from the Northeast or Midwest.

It had prestige.

It had honor.

The Rose Bowl only cared about those teams that were regarded as national powers from schools that were recognized for their giant stature in American academics.

It certainly wasn't interested in the South.

Southern teams might occupy a football field from time to time, but their brand of football had not yet reached the heights of mediocrity.

That was the belief anyway.

No barefoot, redneck, hillbilly Southern team had ever been invited to the Rose Bowl, and the elitists preferred to keep it that way.

Illinois was obviously the team of choice.

Illinois had Red Grange.

All the world had a strange fascination for the exploits of the galloping ghost.

You had to see him to believe him.

He alone would bring the best that college football had to offer to the sanctity of the Rose Bowl.

But it all went awry.

Suddenly, all hell was breaking loose.

Illinois had been a lock for the Rose Bowl.

But Red Grange walked away and signed a professional contract with the Chicago Bears in one of those seedy, back alley, fringe of midnight kind of deals hammered together by the National Football League, which, according to rumors, had serious ties to the underworld and possessed a history of franchises going bankrupt and sneaking out of town, hidden by the darkness of night, and almost always forgetting to pay off their debts.

College football was in crisis.

The University of Washington was headed to the Rose Bowl.

But whom would the Huskies play?

Invitations had been offered to Ivy League elitists Dartmouth, Colgate, and Princeton, and when they refused, the bid went to Michigan.

The Wolverines, however, were in a conference that had been sullied by the despicable shenanigans of Red Grange.

Michigan was embarrassed.

Michigan chose to stay home.

So here came the reluctant bid to Tuscaloosa.

University of Alabama President George Denny accepted the invitation as soon as the envelope had been opened and placed on his desk.

Alabama was headed west.

No Red Grange.

Just some little guy named Pooley Hubert.

No galloping ghost.

Just some smiling hot-shot named Johnny Mack Brown.

What could they bring to the Rose Bowl?

They would come such a long way to find themselves wallowing in embarrassment and probably in shame.

The Rose Bowl would be such a sad and bitter end to a pretty good season.

The Crimson Tide ignored the bad press, climbed on a train, made sure they had their cleats, their helmets, and at least one football, and traveled two thousand miles to play in Alabama's first Rose Bowl.

It would take them sixty-six hours.

For Alabama football, it had taken a lifetime.

As Brown said, "We were nothing but little country boys in our sophomore year, but Coach Wade made something out of us, and to the Rose Bowl we went."

California felt sorry for them.

The University of Washington felt sorry for them.

They were, the press agreed, lambs on their way to a slaughter.

Wallace Wade couldn't wait.

The South had not yet risen.

But it was on its way up.

*Hubert started late, but once he was off – WOW.*

The Year: 1926

⤙ Headline in *The Los Angeles Examiner*

## The Moment:
## The Rose Bowl

Alabama shouldn't be in the Rose Bowl. Alabama didn't belong. That was the general consensus on New Year's Day in 1926.

The University of Washington had expected to face the legendary Red Grange, except the galloping ghost had, in the words of his own coach, been guilty of violating college football's "amateur purity."

Having to occupy the same field as the lowly Crimson Tide was a sore disappointment

Now the Huskies would be looking over the line of scrimmage at a bunch of boys from down on the farm, a motley crew that would probably rather be playing barefoot in the Pasadena grass because – would you look at that? – some skinny little kid they called Pooley, of all names, usually didn't even bother to wear a leather helmet.

Was he that tough? Or was Alabama that poor?

Down in Tuscaloosa, they knew. Crimson eyes were smiling.

Washington, outside of Red Grange, had the most feared running back in the land, a rugged slasher named George Wilson whose bullet passes, the press figured, would cut up Alabama and leave the hallowed surface of the Rose Bowl tattered with white and Crimson ribbons.

Wilson would be the difference maker. He was a one-man power train on offense and a one-man wrecking crew on defense. Alabama had no one to match him.

Probably not.

Alabama had two.

The press, which had a propensity for believing its own written propaganda, got together, voted, and all came to the same undeniable conclusion: Alabama did not have a prayer. Alabama would, of course, spend much of the afternoon on their knees.

The Huskies would knock them there.

Over on the Alabama sideline, Pooley Hubert pulled on a helmet.

Somebody would have hell to pay.

Wallace Wade gathered his team around him, turned to Hubert and said, "I want you to get in there and run the game as you think it should be run, but don't run with the ball yourself against Washington's bigger players or they'll kill you."

These were, after all, the same Washington players who had once knocked out the great Ernie Nevers of Stanford. This was the brick wall, uncracked and unblemished.

Pooley Hubert was not impressed.

Cautious, perhaps.

But not impressed.

Johnny Mack Brown recalled, "I'll never forget coming onto the field and looking up at fifty-eight thou-

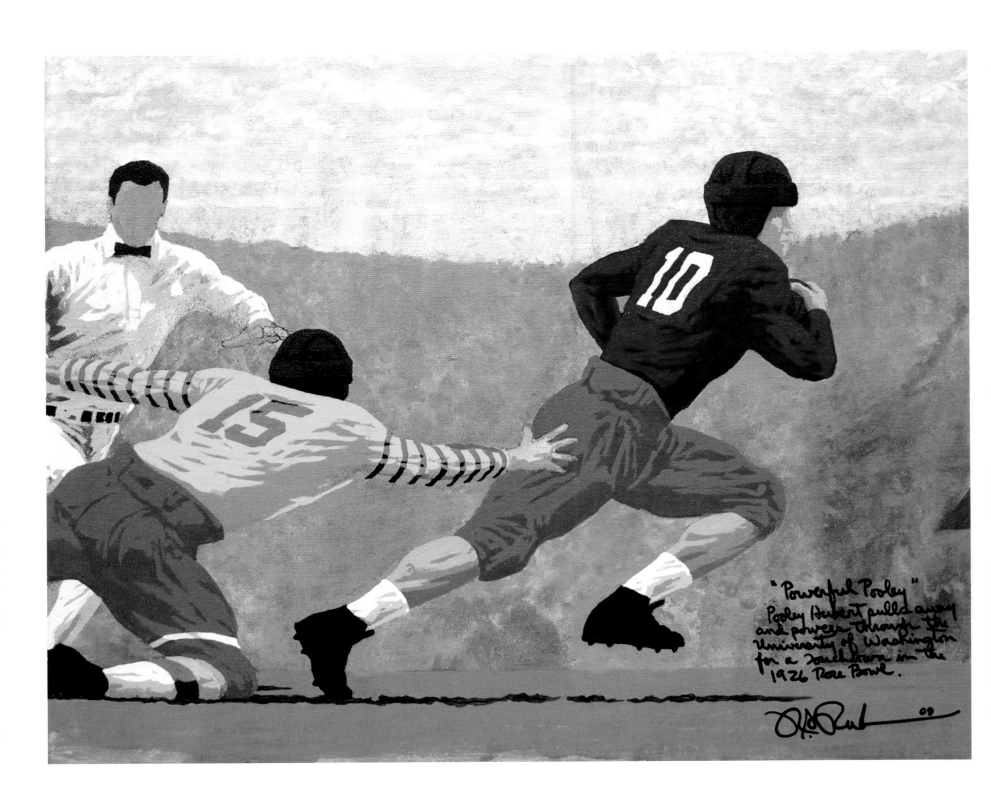

"Powerful Pooley"
Pooley Hubert pulls away
and powers through the
University of Washington
for a touchdown in the
1926 Rose Bowl.

# POOLEY HUBERT

Wizard Of The Rose Bowl

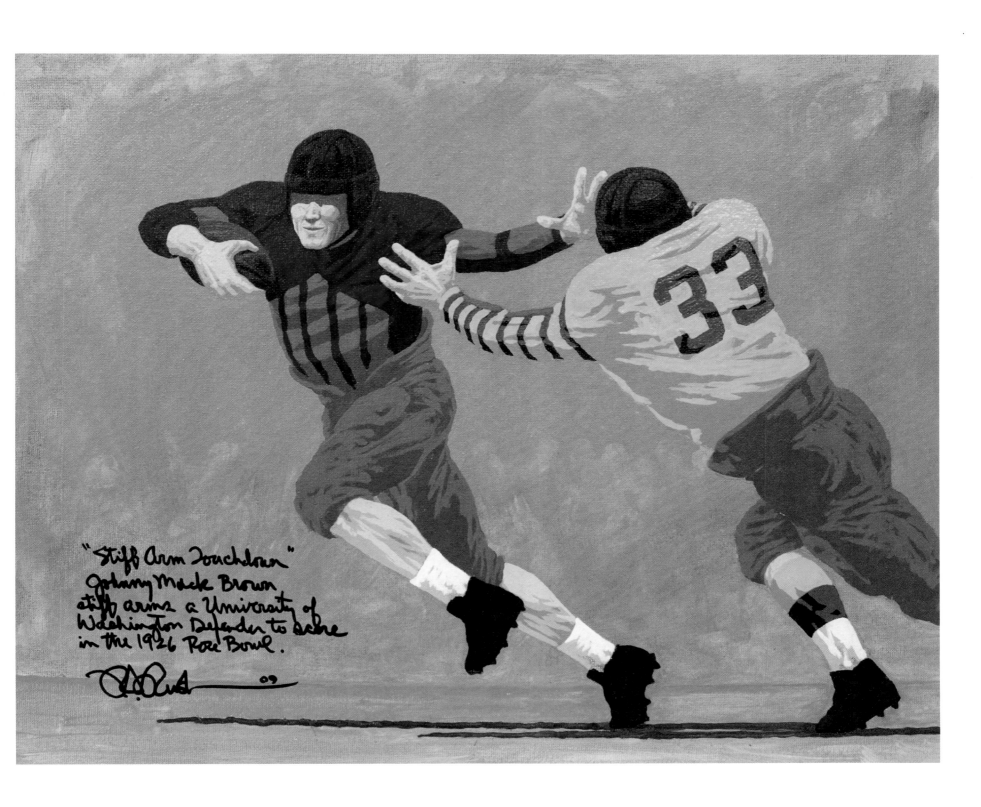

"Stiff Arm Touchdown"
Johnny Mack Brown
stiff arms a University of
Washington Defender to score
in the 1926 Rose Bowl.

# JOHNNY MACK BROWN

The Making Of A Star

sand people. All of Alabama's players were pretty awestruck."

Then Washington struck.

With shock and awe.

George Wilson was as good as everyone had said he was. He triggered a seventy-yard touchdown drive, and ripped off a thirty-six-yard run early in the second quarter before firing a twenty-yard touchdown pass.

A bullet. On target. Alabama was on its heels.

It could have been worse. If not for Pooley Hubert on defense, it would have been much worse.

He made a tackle to save a touchdown, jumped up off the ground, and thought his face had been rearranged. His helmet had been twisted into an awkward position. He was looking through the ear hole. He straightened it, called time out, and marched toward his teammates like a general before the dawn of battle.

They were kneeling on the ground.

They had no idea what they had done or what to do next.

Hubert put his hands on his hips, snarled, and said, "'Now, just what the hell's going on around here?"

His eyes spoke louder than his voice.

And his eyes were irate.

As Johnny Mack Brown said, "We stood, got together, and forgot the crowd."

In the second half, Washington had the glorious George Wilson.

Alabama had "Wu" Winslett. They collided.

And Wilson staggered to the bench. He wasn't on his knees, but he was close.

Wade told Hubert, "Go ahead, Pooley, it's full steam ahead. Run yourself all you want. It's tough out there, but you can handle it."

Alabama scored three times in seven minutes.

Hubert pointed to the great George Wilson, the strongest brick in a strong wall, and said, "We're coming right over you."

He did. He carried five consecutive times and scored.

Grant Gillis, a pretty fair bombardier in his own right, hurled a 63-yard catch-and-run touchdown pass to Johnny Mack Brown, which was the longest pass ever thrown in the Rose Bowl. Wilson would say after the game, "Brown is about the fastest man in a football suit I have ever bumped up against."

On the third touchdown, Hubert looked at Brown in the huddle and told him, "Run as fast as you can toward the goal line."

Brown nodded. He said, "When I reached the three, I looked up. Sure enough, the ball was coming down over my shoulder. I took it in stride, used my stiff arm on one man, and went over carrying somebody else."

Washington was stunned. The Huskies fought back, came within a single point, but George Wilson had bumped against his last stump. He had little left. Grant Gillis intercepted one pass with six minutes left, and Herschel Caldwell swiped another as Alabama watched time run out on the vaunted Huskies.

Alabama, the afterthought, the team that didn't belong, the boys from down on the farm, had shocked the powerful and self-righteous Washington Huskies, 20-19.

The renowned writer Damon Runyon penned: "Suddenly Alabama unleashed a species of human wildcat named 'Pooley' Hubert. Before the Washington lads fully realized what was happening, this Pooley Hubert was all over them, kicking and scratching and throwing forward passes at them. It was a great team that the South sent to California, probably the greatest that ever came out of the South."

And the *Crimson White* newspaper simply wrote: "A continent gasped."

As Ed Danforth published in *The Atlanta Journal*, "The South will outdo itself in welcoming Mack Brown home. It should. He has written Dixie all over California."

Zipp Newman of *The Birmingham News*, reported: "Hubert and Brown will have enough time posing for the cameramen to enter the movies."

Johnny Mack Brown did. He became a star on the silver screen.

Coach Wallace Wade merely shrugged and said, "Well, he has to make a living doing something."

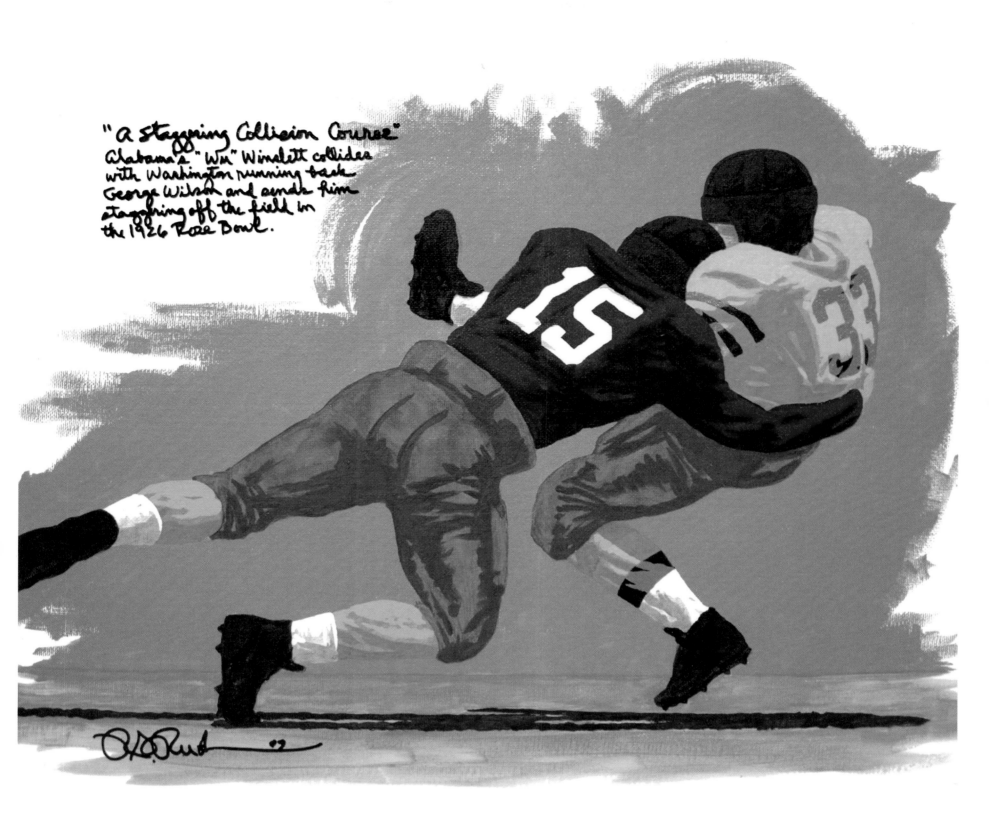

"A staggering Collision Course"
Alabama's "Wu" Winslett collides
with Washington running back
George Wilson and sends him
staggering off the field in
the 1926 Rose Bowl.

## HOYT "WU" WINSLETT

Putting The Hammer On George Wilson

> *The Alabama team brought new glory to the South and southern football.*
>
> <> Fred Digby, *New Orleans Item*

The Year: 1927

## The Moment: Return to the Roses

Zipp Newman had a premonition. *The Birmingham News* sports writer watched Alabama rise up in Rickwood Field and slay mighty Sewanee, 2-0, and he witnessed a test of strong wills and stout fortitude.

Alabama could have faltered.

Alabama didn't.

Sewanee had not lost a game in three years. Sewanee was riding a twenty-five game winning streak and had no doubts about number twenty-six. As Newman wrote, "The Crimson caught the Tigers in an ugly humor. No one but the Crimsons themselves will ever know the amount of punishment they took."

The war did not end with a single shot.

Alabama had brought along is own box of ammunition.

The Tide had its back against the wall. It bore the scars and wounds of brutal combat. But Alabama unleashed its own attack, and Sewanee buckled. Only for an instant. But Sewanee buckled. Newman wrote, "Only a Rainbow Division that saw service in the Argonne could have withstood the pounding the Tide gave the Tigers and Survived."

Zipp Newman had witnessed the terrible storm.

Thunder rolled.

Lightning wore cleats.

For him, it was indeed a premonition of what might lie ahead.

The Rose Bowl wanted Alabama back.

Had the Crimson Tide been that good? Or that lucky?

The Rose Bowl didn't know.

But the Rose Bowl certainly liked the show. California had not been able to forget the farm boys in Crimson who marched at will across the grass of Pasadena and sent the strongest team on the Coast down for the count. Washington was desperately trying to get up at the end, but the body blows had taken their toll.

The Tide's impending duel with Stanford created so much interest across the vast American landscape that NBC radio made the decision to air the first football game ever broadcast nationally.

It began slowly and awkwardly, two teams trying to dance to different songs and tripping over their own feet. They traded mistakes.

Fumbles.

Missed field goals.

They stood eyeball-to-eyeball with sledgehammer defenses. Neither gave an inch. Neither blinked.

The game was a dogfight from beginning to end.

The Crimson wall did not break, but it did crack once, and Pop Warner's Stanford team slugged its way to a 7-0 lead at the end of the first quarter. As one sportswriter said of Alabama, "A football team of less brave souls would have folded up right there."

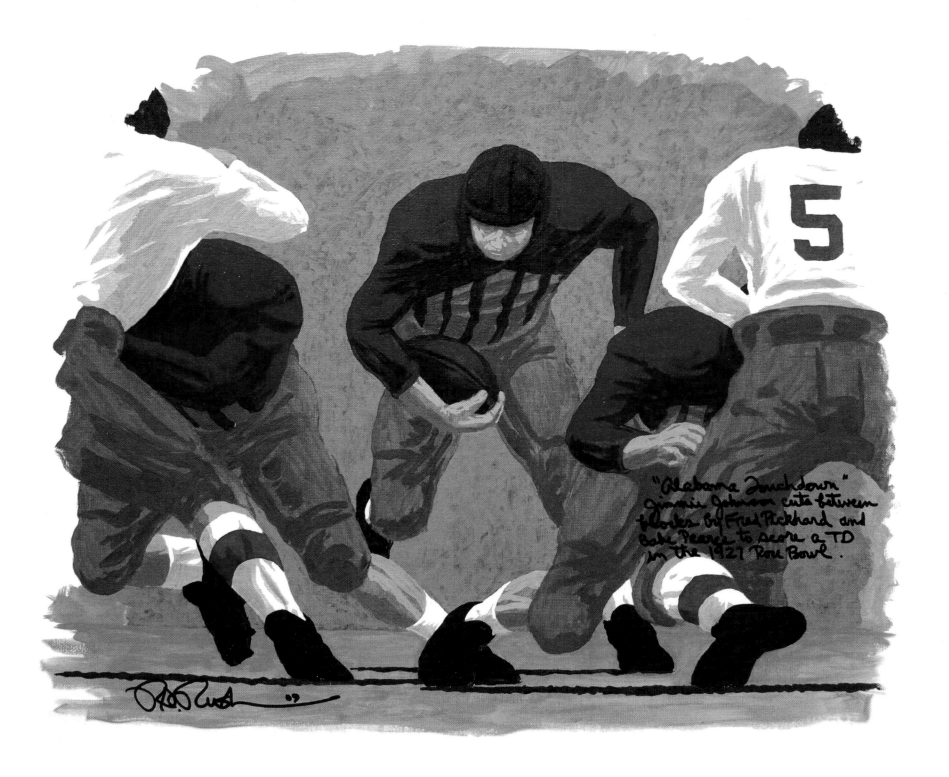

"Alabama Touchdown"
Jimmie Johnson cuts between
blocks by Fred Pickhard and
Babe Pearce to score a TD
in the 1927 Rose Bowl.

# JIMMIE JOHNSON

Running Behind Fred Pickhard And Babe Pearce

Alabama's great backs – Pooley Hubert, Johnny Mack Brown, and Grant Gillis – were all gone. The stars had faded with the night. It was a new team and a new day. The flying feet had flown. Coach Wallace Wade liked it that way. His team had dug down deep all year. He wanted to see how deep the dig would go. Bravery would begin and end on the fifty-yard line.

A man could not coach speed, Wade knew. Speed was a gift.

Wallace Wade coached power. Hit someone before he hits you. Then hit him harder. If he were still standing, you didn't hit him hard enough.

Pop Warner, however, had an attack that, the newspapers said, was "deceptive and mystifying." His backs hid the ball on every play. It was "as if he had four Houdinis back there and did not use a single straight formation all day."

Screen passes.

Reverses.

Illusions.

Maybe delusions.

Backs were running in every direction at once.

Stanford would have made a Chinese fire drill look as staid as a funeral. Every play was veiled behind a now-you-see-the-ball, now-you-don't kind of trick.

It was power versus deception, old-fashioned football against the flash and the dash of the future.

And time for Alabama was beginning to run late.

A recovered fumble put Stanford inside the twenty. A run gained three yards. A sweep picked up one. A dive up the gut chewed up five. And Stanford was standing a yard short of Alabama's seven-yard line.

Fourth down.

One yard to go.

A field goal would have won the game. Pop Warner disdained the field goal.

He wanted six. Ego prevailed.

Stanford ran wide. Stanford ran deep.

Stanford had nowhere to go.

There it was: speed on speed, might on might.

Alabama held but could not move the ball.

The Tide punted.

Stanford bogged down.

Again.

On the punt, Wade called for an all-out rush. Time had become an enemy as deadly, as relentless as the Cardinal.

Babe Pearce broke free up the middle. He hit the Stanford line like a whipsaw with none of its teeth missing.

A block. The ball struck him in the face, and it kept bouncing backward, kept rolling, kept turning end over end until it foundered precariously close to the end zone. Stanford's punter, Frank Wilson, grabbed the loose ball and dashed back to the fourteen-yard line.

It was the best he could do. Stanford had lost the ball, and the clock was wearing down.

Alabama could do.

Or die.

All afternoon, Jimmie Johnson had been sitting on the Alabama bench, suffering from a shoulder injury. He had not broken a sweat or played a down.

Wade nodded, and Johnson was in the backfield. It was his time. It might never come again.

Johnson broke for eleven yards. It was first and goal. The shoulder might be hurting. It would have a lifetime to heal. Johnson cut right behind the defiant blocks of Fred Pickhard and Babe Pearce. He didn't, but he could have walked the ball into the end zone.

As Morgan Blake of *The Atlanta Journal* wrote, "Then came the most nerve-wracking moment in this sportswriter's career. If Caldwell failed to kick the goal, all of that fierce linebucking would have been in vain. You could have heard a pin drop in that vast stadium as the teams lined up. The kick was perfect, and several thousand Southern fans did a war dance. Alabama tied the game on sheer courage and a fighting spirit that refused to quit."

The 'Bama boys, however, were a disgruntled bunch as they walked off the Rose Bowl field. At the end, they believed they had Stanford on the run, and, to them, nothing had been decided or settled.

It had been a long afternoon, brutal and wasted.

As one said to whomever was listening, "I wish they'd let us go to the finish."

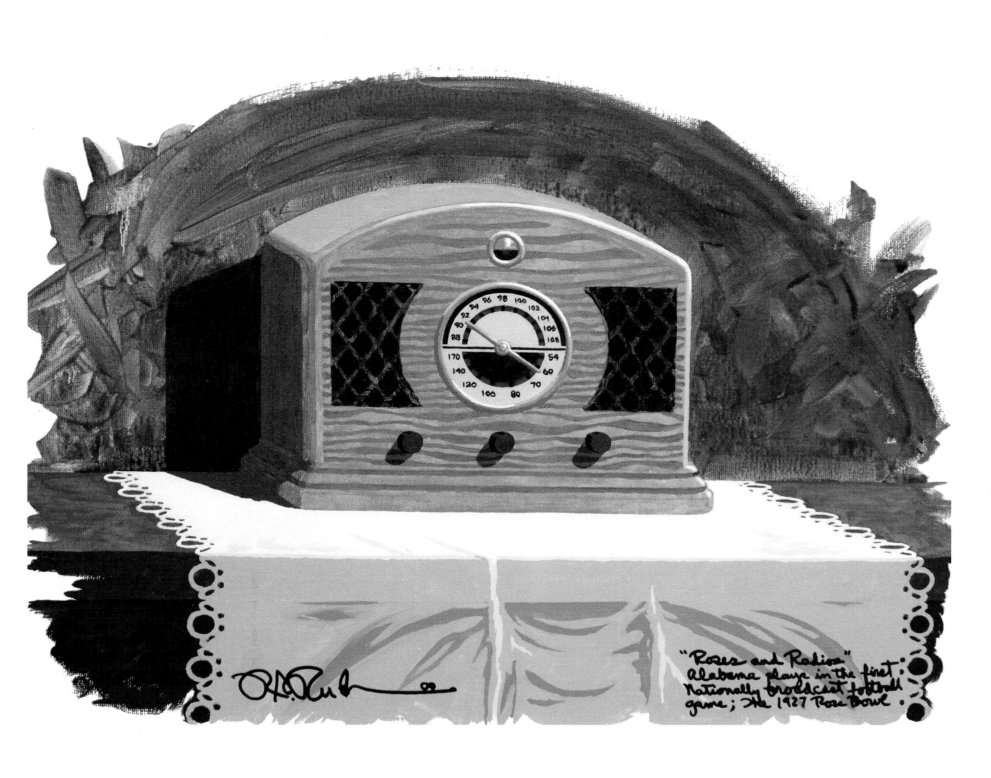

"Roses and Radios"
Alabama plays in the first
Nationally broadcast football
game; The 1927 Rose Bowl

# ON THE AIR

Radio's First Broadcast Of The Rose Bowl

*You never know what a football player is made of until he plays against Alabama.*

—Bob Neyland, Legendary Coach of Tennessee

The Year: 1930

## The Moment:
# The Final Challenge

Wallace Wade stunned Alabama. On the eve of the first game of the 1930 season, he called his team together and quietly announced that he was beginning his last year as head coach of the Crimson Tide.

A hush pervaded the locker room.

Not a sound was heard.

No one dared breathe.

A legend had walked into their midst, and now the legend was on his way out the door to serve as head coach and athletic director of Duke University.

Why? he was asked.

The stoic Wallace Wade never blinked. "Some of the radicals in the state don't care for the way I'm running things."

The hush was so loud it was deafening.

In seven years, Wallace Wade had taken his rightful place among the most feared and respected coaches in America.

He had won three straight conference championships from 1924 through 1926.

He had taken his Alabama team to two Rose Bowls.

His Tide had soundly thrashed national football powers, and he had coached two national champions. Wallace Wade had restored pride and perhaps even arrogance to Southern football.

He was even being hailed in some circles as a football genius.

Now he was already as good as gone.

Wallace Wade had found that it was so hard to stay on top.

College football had become a shooting match.

And everyone was shooting at Alabama.

Injuries had caught up with his teams during those trying seasons of 1927, 1928, and 1929.

Graduation had exacted a heavy toll.

He could always figure out a way to beat the opposition, but a team loaded with inexperience just had to suffer through losing pains.

There was not much he could do about it but patiently wait and let the players grow and grow up.

Growing pains were hard.

And difficult.

Wade persisted.

His team fought hard.

There were black clouds.

But they had silver linings.

Alabama was not as patient.

Wallace Wade heard the distant rumblings of criticism dogging his every footstep, and a dark, ominous shadow fell brusquely across the football landscape of Tuscaloosa.

Maybe Wade had lost his touch.

The game was changing.

Maybe Wade was in a rut.

Wallace Wade up his own mind.

It was definitely time for him to go.

He decreed it so.

He never lied to his team.

He would not lie to himself.

Other roads awaited him.

Year after year, he had turned down lucrative contracts, some offering to pay him as much as twenty thousand dollars to coach elsewhere.

He did not turn down the last one.

Wallace Wade was leaving on his own terms.

He had brought respectability to Alabama.

He would do the same at Duke.

There was no doubt in his mind.

His bold and unexpected statement had left Alabama in shock.

His team was bewildered.

They felt orphaned.

And alone.

Wade abruptly ended their confusion.

He was leaving.

He had not yet gone.

There was still work to be done.

He vowed to give Alabama a year to remember.

He turned to the boys wearing Crimson jerseys and said with a voice that had the resolve and resonance of a low growl of faraway thunder, "Gentlemen, I am going to win this damn championship this season, and if you want to be a part of it, you can. If not, get out of here right now."

No one moved.

No one left.

He had his troops.

Their eyes burned fiercely.

They would follow him anywhere.

And Wallace Wade was ready for war.

As John Henry "Flash" Suther said, "His remarks lit a fire under us. We really buckled down and worked for him."

In ten games, Wade's defense, behind a vicious charge led by his All-American tackle Fred Sington, gave up a mere thirteen points.

The team was as unyielding as it was unforgiving. Its eyes were streaked with a strange concoction of fire and blood.

When the Tide pounded Mississippi, 64-0, Zipp Newman of *The Birmingham News* wrote that Wade "had to throw heavy wraps over his Crimson to keep them from being charged with manslaughter."

Everett Stupper officiated the game, and he wrote in *The Atlanta Journal:* "The 'Thin Red Line' is a thing of the past, existing no more. The Red Elephants have replaced it at the Capstone. Their every move reminds one of this mighty animal of the jungle. First their size, then their stampede charge reminded me of pictures that I had seen of this beast on wild charges in the jungle when he merely runs over by brute strength anything that might get in his way."

After a win over Vanderbilt, Nashville sportswriter Blinky Horn wrote that the Commodores were "pulverized by power, struck down by strength, swept aside by speed, and crushed by cohesion. These Redmen are roguish people. They strike with venom."

The Tide was on a roll.

It was a fearsome march through conference.
It was a fearful sight to behold.

Teams lay shattered by the wayside.

They weren't merely beaten.

They were dismantled and left in shambles.

Wallace Wade had said he would win a national championship.

He wondered who on his team would go with him. He looked around and smiled. The Red Elephants were behind him. Everyone was still there.

As John Henry Suther would say, "By the end of the year, those radicals were begging Coach Wade to stay."

His decision had been struck in granite.

He would have his last say.

But the season would not be Wallace Wade's last hurrah.

The day he drove away from Alabama, he was only thirty-eight years old.

> *The game wrote the finis on the career of Wallace Wade, a man who has dominated Dixie football.*
>
> <> Maxwell Stiles, *The Los Angeles Examiner*

The Year: 1931

## The Moment:
## The March of the Shock Troops

They were Wallace Wade's shock troops. Plain and simple. Wade had always been an innovator, and the shock troops may have been his most potent invention.

When the season began, no one expected them. When the season ended, everyone feared them. They never gave ground. They attacked as though there might not be a tomorrow. They applied pain where rubbing alcohol couldn't heal and bandages couldn't hide. They would knock you down and dare you to get up. After awhile, you didn't want to get up.

The shock troops took no prisoners. If they did, they threw them back. The shock troops were Wallace Wade's second team.

The reserves.

Those boys not quite good enough to start.

The shock troops started almost every game.

Wallace Wade explained his creation this way. It gave his first unit a chance to sit back and figure out the strengths and dissect any weaknesses in the schemes being run by the opposition. When the first team finally ran onto the field to start the second quarter, it had eleven fresh players ready to line up against a weary and worn-out ball club that had already been battered, bruised, and probably bloodied.

The fight was gone by the time the fight began.

The Rose Bowl had heard about Wallace Wade's shock troops. The rugged bunch of second-stringers had no doubt been fairly effective against those weak, struggling, and overmatched teams down South.

But Wade would never dare run them out on the field to face a powerhouse like Washington State, the pride of the Pacific Coast.

He was far too smart for that.

The game began. And, sure enough, Wade ran his shock troops out to face Washington State.

The Rose Bowl gasped.

The Cougars groaned.

The bruises piled up before the points did.

Sportswriter Royal Brougham said of Wade, "The freckled-neck Southern gentleman won the game with his noodle. He sat there on the bench and out-figured the lads from the North all afternoon long. First, he dispatched his shock troops into the fray at the outset, and while his second stringers were holding the fort, he analyzed the weakness and strength

of his opponent."

Wade would say of his reserves, "They wore down the Cougars more than most people suspect."

It was a daring gamble that few, if any, had ever tried before. No other coach had the guts. No other coach had the shock troops.

The starting unit for the Crimson Tide, fresh legs and all, raced on the field to begin the second quarter, manhandled a weary Washington State defense, and scored three times in seven minutes. Jimmy Moore connected with John Henry Suther on a sixty-four-yard touchdown pass. Quarterback John Campbell plunged for one yard and sprinted for forty-two yards as he scored twice.

Wade believed in power football. That had not changed. His basic game plan did not change. But Wade dazzled Washington State with a new bag of tricks he kept hidden beneath his hat, inspiring one West Coast writer to report, "There was deception and sleight-of-hand hokus pokus going on that mystified the Cougars."

Sportswriter Paul Duncan had written: "Flat-footed men are rejected from the army, but, luckily, Coach Wallace Wade places no such restrictions on his football players. If he did, his four varsity backfield men, two of whom have been named on various All-Southern and All-American elevens, would be barred from the field. With feet as flat as a stockbroker, Alabama's regular backfield has trampled roughshod over the outstanding teams in the South. Johnny Cain, Monk Campbell, John Henry Suther, and Ralph McWright all run on their heels. But every one of them is a speedster."

Cain was not elusive, but he ran with more power. As one newspaper said, "When he is tackled, he digs in and drives for some kind of gain. Only once has he been thrown for a loss." And the gait of Monk Campbell was described as that of "a dray horse."

Washington State had been coached to stop Johnny Hurry Cain, who passed with either hand, ran with more might than speed, blocked and tackled, the newspapers said, like a demon, and punted whenever fourth down rolled around. It was said that he dug in and drove for some kind of gain on every play.

The Cougars should have worried about Monk Campbell – the Mississippi Rabbit, the whirling dervish – who ripped off a hundred yards on eleven carries. No one had ever seen a dray horse run that fast. As Frances Powers wrote, ""He raced – forty-two yards to the Cougars' goal line without a protesting hand being laid on his white sweater."

Royal Brougham wrote, "The vaunted defense of the Western Conference champions crumbled like the walls of Jericho before an amazing passing attack. The 'Bammers unleashed a passing and cleverly masked running offense which the cunning Wade had kept in the cooler all season long. And before it, the touted Cougars were just corn pone and possum pie."

The "amazing passing attack" of Alabama wound up with two completions. They went for ninety-two yards.

It was not a bad average.

Maxwell Stiles of *The Los Angeles Examiner* watched Alabama "slipping, sliding, and passing to victory by artifice and design, by trickery and decoying – by deception rather than power. Alabama lured Cougar players out of position, double-crossed them and thus crossed the goal line."

To Ed Danforth of *The Atlanta Journal*, "The giants who slaughtered the champions of the Pacific Coast with such a dazzling, merciless display of offensive power and bottled up their foes with a such a stout defense, are a strangely innocent sort. They are just a lot of country boys. To them, it was a lark – just a lark."

Wallace Wade, strong and silent, grim and determined, had done it again.

Maxwell Stiles watched him walk briskly away from the Alabama side of the Rose Bowl field for the last time. Stiles knew who ran, passed, and caught the ball, who made the hard blocks and the tough tackles up front.

He ignored them. Instead, he wrote, "Credit victory to Wallace Wade. It was the parting handiwork of a great football coach."

*Alabama tacklers "would leave their feet as though shot from cannons and sweep the Commodore backs off their underpinnings".*

<> Sports story after Tide's 14-6 upset of Vanderbilt

The Year: 1931

## The Moment:
## The Coming of Frank Thomas

Wallace Wade held no grudges when he left Alabama.

Sure, he had grown weary of the criticisms that haunted him from afar during the difficult years that sprawled between Rose Bowl games and national championships,

But he understood expectations. None were loftier than his own.

His leaving wasn't about the money. It wasn't about the disappointments. The so-called radicals might be after him, but he had faced tougher opponents before. They were simply a nuisance. That's all. The time had simply come for him to walk away, his head held high, and maybe teach a few kids over at Duke a thing or two about football.

When he departed, Wallace Wade wrote in his resignation letter to University President George Denny, "There is a young backfield coach at Georgia who should become one of the greatest coaches in the country. He played football under (Knute) Rockne at Notre Dame. Rock called him one of the smartest players he ever coached. He is Frank Thomas, and I don't believe you could pick a better man."

A recommendation from Wallace Wade was not one to be ignored or spurned.

Dr. Denny invited Frank Thomas to Tuscaloosa, sat down with him, and said, "Now that you have accepted our proposition, I will give you the benefit of my views, based on many years of observation. It is my conviction that material is ninety percent, coaching ability ten percent. I desire further to say that you will be provided with the ninety percent and that you will be held to strict accounting for delivering the remaining ten percent."

He was blunt. He was emphatic. His words were, Thomas said, the "coldest and hardest" he had ever heard. A dagger would no have been as sharp.

At Alabama, the bar was high. Wallace Wade had brought conference and national championships. His last year had been his best.

Just what could the Crimson Tide expect from a short, little, rotund coach who grew up in Chicago, of all places, had quarterbacked the Fighting Irish of

# COACH FRANK THOMAS

The Championship Tradition Rolls On

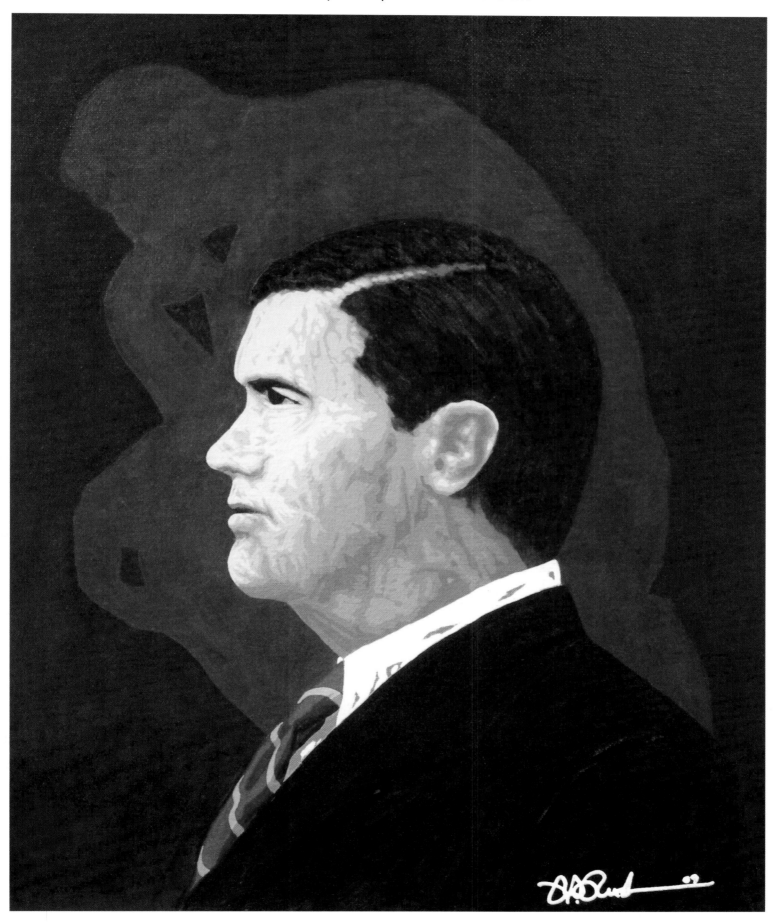

Notre Dame, roomed with the great George Gipp, and cast his fate with football simply because he had never been able to escape or outdistance the broad shadow of Knute Rockne?

Frank Thomas had been advised by close friends to either stay at Georgia or look for another coaching job at another school, one that did not expect to go to the Rose Bowl every year. Alabama would bleed you,

they said. Alabama could be the death of a man.

Don't follow Wallace Wade at Alabama, they said. Don't follow the Wizard.

Alabama just may be the hardest coaching assignment in the country.

He heard them. He did not listen to them.

Their words did not frighten Frank Thomas.

They inspired him. After all, Rockne had once said, "It's amazing the amount of football sense that Thomas kid has."

He would need every speck of it.

Frank Thomas was not troubled by the pressure. He was not worried about the legacy of Wallace Wade hovering over his shoulder. He was not concerned with either wins or losses. Frank Thomas simply liked a good challenge, the tougher the better.

Wallace Wade's cycle at Alabama had run its course, he said.

It was time for new ideas, new innovations, new schemes, and, of course, time to scrap the old, outdated single wing and install the famed Notre Dame Box on offense.

No one could teach it better. No one had ever run it better.

He was smart. He would field a smart team.

He recruited brawn.

He would beat you with his brain although Bill Braucher, the senior editor for *NEA*, once wrote, "He was a round, chunky chap, resembling more a butcher boy than Rodin's 'The thinker.'"

Looks could be deceiving.

Frank Thomas demanded the best and expected the best and did not tolerate any player who gave less than his best on every play. In the game. On the practice field. It did not matter. For Frank Thomas, football was mind over matter, and his mind was all that mattered.

*The Birmingham News* reported, "Thomas is genial everywhere except on the football field. There he demands the utmost of his players. He drives his men. The game is harder. He is harder."

Frank Thomas had to replace ten seniors.

He did it with size.

Alabama lined up with the largest team in the South. The famed "Thin Red Line" had indeed faded into memory. Official Everett Stupper had been right in his observations. Those big Red Elephants were on the move again. They roared through the Southland.

There were those who said Wallace Wade could not be replaced.

Maybe not. But his wins were.

Frank Thomas began the year with a 74-7 massacre of Clemson, which became more of a foot race than a football game, and he closed out the Southern Conference season with a scandalous 14-6 upset of Vanderbilt, described as a "drama steeped in grim determination and reckless, wild, scorching play ... leaving Vanderbilt in a debris of two touchdowns and murky gloom."

Throughout the length and breadth of the year, he watched Johnny "Hurry" Cain run with heady abandon. And Leon Long played, the press said, "like a demon possessed of destruction."

The power was Clemson. The glory was Vanderbilt. In between was a defeat – called heartbreaking and devastating – by Tennessee. Alabama's ability to come back after the loss was defined by one newspaper as a "tribute to courage and fine coaching."

The Crimson Tide wrapped up the season with a win over Chattanooga, which gave Alabama the nation's scoring title.

The Notre Dame Box had spilled points all over the South.

Freddie Russell of *The Nashville Banner* summed it up best when he wrote, "All around the conference, they were sympathizing with 'poor old Frank Thomas.' But what did Thomas do but take Hurry Cain and a bunch of subs and come through in his first year with eight victories and one loss. It's a splendid job of coaching."

Frank Thomas wasn't so sure. He was at Alabama. But Alabama was not in the Rose Bowl. Frank Thomas knew what it would take to get there. Keep the wins intact and wipe the loss off his slate.

The mathematics really weren't that difficult.

*I got clear, I never left the sidelines.*

—✦ Johnny "Hurry" Cain

The Year: 1932

## The Moment:
# Running to Judgment

It was not the Rose Bowl.

The game would not be played for a national championship. But the battle was slated for California.

And California was laughing.

Again.

It was more like a snicker.

Why in the world would a bunch of small-town, small-time, plowboys from the southern cotton patches go the trouble of traveling two thousand uncomfortable miles by train for the privilege of losing a football game?

That's what everyone in California wanted to know.

It just didn't make sense.

Nobody was giving the Crimson Tide a chance at all against St. Mary's, billed as "one of the strongest teams ever produced on the West Coast."

Odds makers had made the Gaels a strong 10-7 favorite to win behind the punishing gallops of its All-American halfback/fullback/quarterback Angie Brovelli, known in mysterious corners of the press box out west as "The Dark Angel of Moraga." The university itself sat perched near the glorious walls of the Moraga Valley.

Frank Thomas shook his head in disbelief. He would have smiled, but Frank Thomas never smiled. Wouldn't California ever learn, he wondered?

Hadn't anyone west of the Black Warrior River and possibly Tallulah heard about Johnny Cain?

Zipp Newman of *The Birmingham News* wrote: "He is one of the South's all-time long and accurate punters – a coffin corner specialist. He is a fine, deceptive left-handed passer. He runs with a hip-swinging motion – terrific in the broken field. He is a fine power runner. I never saw a more deadly tackler."

Maybe the Coast just didn't know.

But then, how quickly the Coast had forgotten those New Year's Day afternoons when the boys from Bama stood stout against the best teams that the West had to offer and left them twisted and broken like fractured pretzels.

The Crimson Tide had never lost in California, and, as Johnny Cain told the press, 'We did not travel seven thousand miles to take a beating."

California readied itself for a bloodletting.

There was sympathy for Alabama, but no pity.

Lord, have mercy on them all.

Will Steves of *The San Francisco Chronicle* couldn't wait. He did not know why, but somehow he knew that the game would be special.

He wrote: "They will roll up all that California sunshine and Alabama moonshine in one package. Anybody knows that can't last and that nigh on to two o'clock, the cork will blow out, flood All-American fullbacks, Frank Thomas, long gallops, fifty-yard passes,

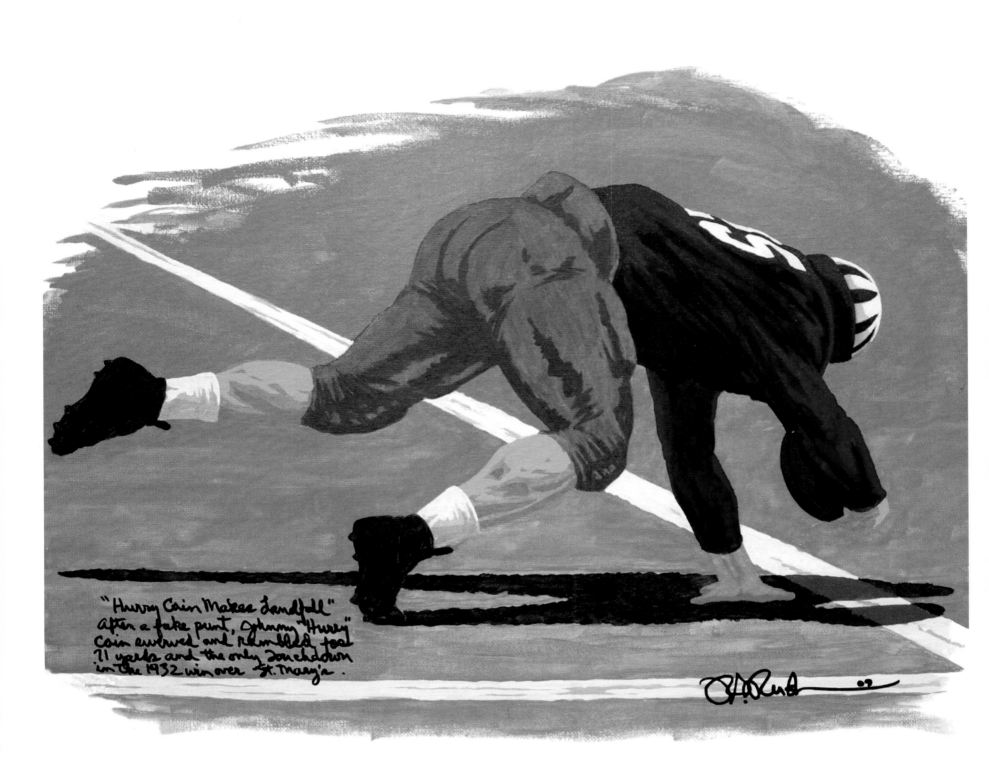

"Hurry Cain Makes Landfall" after a fake punt, Johnny "Hurry" Cain evolved and rambled for 71 yards and the only touchdown in the 1932 win over St. Mary's.

# JOHNNY "HURRY" CAIN

Creating His Own Storm

touchdowns, Red Elephants, and Marauding Morgans just about all over Kezar Stadium."

He expected explosions.

But Alabama and St. Mary's did not come armed with bottle rockets.

They brought their ball-peen hammers.

It was going to be that kind of a day.

The game was barely three minutes old, however, when Cain lined up in punt formation, which didn't particularly mean anything, certainly not a punt.

He slashed savagely through a hole between right guard and tackle and swerved sharply toward the near sidelines.

The sidelines, he said, were a straight line, the shortest distance to the goal line.

Cain shook off three tacklers, dodged two more, stumbled at the three-yard line, and plunged into the end zone.

The press, as a whole, said he did not appear to be running particularly fast.

Maybe not.

But no one caught him.

The dash carried him seventy-one yards, and Alabama had bolted to a lightning quick 6-0 lead.

That was enough.

Frank Thomas stood back, folded his arms, and turned the game over to his defense.

*Time Magazine* reported, "After fifty-seven more minutes of bruising, grunting, thumping, kicking, and pounding, the score still remained Alabama 6, St. Mary's 0."

It could have been different.

Disaster was always one play away.

A stray Alabama pass was picked off by "The Dark Angel of Moraga," and Brovelli thundered downfield.

It was the moment St. Mary's had been waiting for, the moment when a break would decide the final outcome of the game, the moment when victory would waltz away wearing a Gael jersey.

Brovelli was picking up speed.

A lumbering giant.

Headed for glory.

No one stood in his way.

He was running for a definite tie.

Maybe even a win.

The goal line was coming nearer with every step.

He never made it.

Alabama's Dixie Howell ran him down from behind and angrily slammed Brovelli to the ground at Alabama's seventeen-yard line.

Howell had no choice.

He had to make the tackle.

Dixie Howell had thrown the pass.

All St. Mary's needed was seventeen yards.

It might as well have the distance between San Francisco and Tuscaloosa.

It was a journey St. Mary's couldn't make.

Alabama's stone wall stood in the way.

Not a rock moved.

Maurice Smith, the Santa Clara coach, who had no doubt been scouting St. Mary's Gaels, wrote in *The San Francisco News*: "The temple bells of Tuscaloosa toll benediction tonight to the Red Elephants of Alabama. And through the soft, Southern evening, you can hear the bells whisper the story of a great argosy of Red Elephants who refused to be trapped in the stockade of Kezar Stadium. And you can hear the bells tell an epic story of a gallant, languorous Alabama halfback named Cain who, with legs swathed in adhesive tape, sent his great body hurtling through the St. Mary's line, maneuvered this body into intriguing steps of diabolical order, side-stepping, swerving, burning the grass with his tremendous speed and running to judgment as he moved seventy-one yards for a touchdown."

Everyone wanted to talk about Johnny Cain.

Frank Thomas preferred to talk about his seven mules up front.

No glory.

No headlines.

They were simply the first line on offense and last line of defense.

Johnny Cain had one run.

It was a good one, Thomas said.

But only one.

The mules gutted it out on every play.

> *It was Millard Howell who did the eking on his hands and knees on fourth down.*
>
> ≺≻ Ed Danforth, *The Atlanta Journal*

The Year: 1933

# The Moment:
## A Conference Championship

It was the day Frank Thomas had been waiting to see. He knew it would come. He just didn't know when. Frank Thomas was not a patient man.

Nerves were frayed. And ragged.

Millard "Dixie" Howell was the only man in the stadium who had managed to remain calm in the midst of a slugfest where precious yardage was given and taken away an inch at a time, traded with bloodstains, and every piece of new ground was holy.

The first quarter had been a bitter debate where voices were silent and only the sharp, relentless crack of helmet-on-helmet echoed above the stadium floor.

Dixie Howell looked for a crack in the Vanderbilt defense. He found none. He made one.

He looked as though he would pass. His armed was cocked, his eyes searching downfield for a receiver, any receiver.

Vanderbilt thought he would pass.

Maybe he even tried to pass.

But Dixie Howell tucked the ball under his arm and thundered for another sixteen yards, just as he had done to beat Georgia Tech ten days earlier. A team could scout him, and everyone did, but teams still never quite knew what Dixie Howell would do.

Neither did he. He played on instinct.

He was like a hot knife through butter – smooth, quick, decisive. He could hit, then thread the eye of a needle before anyone knew he was on his way.

Now, the ball lay at the three-yard line.

Vanderbilt buckled down. Alabama buckled up.

Three times the fullback crashed into the Commodores' proud black line, and all he had to show for his trouble were aches and pains in the strangest of places. No gain. Nothing lost. But no gain.

The signal caller looked at Howell.

Three yards might as well have been a mountain.

Dixie Howell was ready to climb.

He drove just inside the Vanderbilt end, stumbling toward the goal. Inches seemed like miles. He almost fell but kept his legs churning as he twisted his way into the end zone.

Vanderbilt protested. Loudly and bitterly. His knee had hit the ground far too early, the Commodores said. Howell came up short. He had not scored.

The referee shook his head.

As Ed Danforth dutifully reported, "Whether Howell crawled across or charged across, the touchdown was engineered with his own indomitable spirit, quick-thinking, and driving run. He deserved to score."

Alabama had its win, 7-0. Frank Thomas had his first conference championship.

The day had not come a minute too soon.

*All Don Hutson can do is beat you.*

⎯◇⎯ Georgia Tech head coach Bill Alexander

## The Moment:
# Hutson Comes Out of Hiding

No one had known quite what to do with Don Hutson.

The folks in Arkansas thought he had been a pretty good pass-catching end. But mostly, he ran track and played a little baseball.

He walked onto the football team at Alabama with little fanfare and without a scholarship, not quite big enough or strong enough to match up with that rugged band of ends who wore Crimson, all of them endowed with the inalienable right to catch anything thrown their way.

Don Hutson stood six feet tall, weighed a smidgen over a hundred and fifty pounds, never ran particularly hard, more of a lope than anything else, moved with the grace of a ballroom dancer, but the music was always being played a beat too slow, hardly ever broke a sweat, and Frank Thomas did not trust him.

He was quiet and laid-back. He was an outstanding sprinter and played a tough centerfield for the Tide baseball team, but it appeared to all who watched him as though Hutson took life and football just a little too easy and lacksadaisical to suit the coach.

Frank Thomas liked to light a fire under his players just to watch them burn.

Don Hutson didn't burn.

He rode the bench most of his freshman year and barely played enough to earn a letter during the 1932 and 1933 seasons.

The Arkansas boys – Paul Bryant, Foy Leach, and Happy Campbell – were as frustrated as their coach. They believed that their honor was at stake. A home-grown boy should never let them down. They called a private meeting with Hutson, only the four of them, looked him squarely in the eyes, and with voices as gruff as gravel told him, "Look, you'd better get your butt in gear. You're not going to embarrass the guys from Arkansas."

The fire wasn't lit, perhaps. But maybe it had begun to smolder.

He didn't have to figure out football. Football had to figure out Don Hutson.

He ran with so much ease. He ran with so much grace. Frank Thomas thought he was loafing.

He didn't run hard, but he always stayed a step ahead, and no one had ever been able to look inside his soul and see the fierce determination beating in his heart. Loafing? He had no idea what it was, what it meant, or what it had to do with him.

The season was four games old during Hutson's senior season when he suddenly exploded against Tennessee, catching a thirty-three-yard scoring pass from Dixie Howell, then bolting for another touchdown on an end-around.

He was running with so much ease.

He was running with so much grace.

# DON HUTSON

## The Grace Of A Gazelle

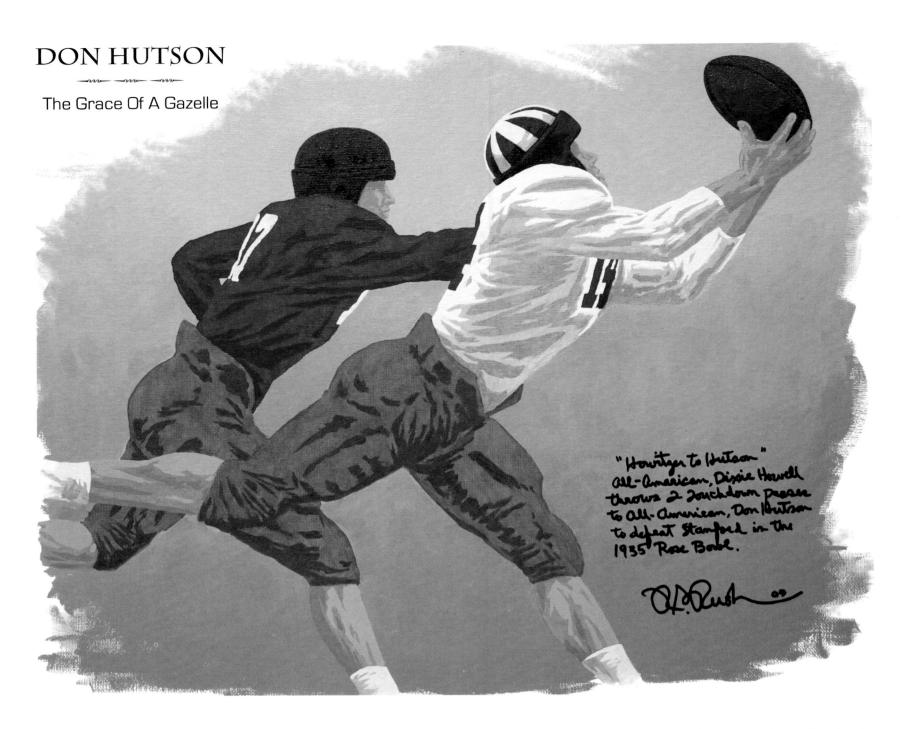

"Howitzer to Hutson"
All-American, Dixie Howell
throws 2 touchdown passes
to All-American, Don Hutson
to defeat Stanford in the
1935 Rose Bowl.

And he was running alone, a sprinter in cleats, gaining ground with every step he took. Once he hit the open field, he changed to a new and frightening gear, and it was all over but the shouting. Bryant said, "Don had the most fluid motion you had ever seen when he was running. He had great hands, great timing, and deceptive speed. He'd come off the line like he was running wide open, and just be cruising. He looked like he was gliding, when all of a sudden he would put on an extra burst of speed and be gone. He'd reach for the ball at the exact moment it got there, like it was an apple on a tree."

Hutson grabbed three touchdown passes against Clemson.

And he splintered the Georgia Tech defense with three more.

Wherever Don Hutson happened to be loping along downfield, he and Dixie Howell's passes always seemed to arrive at the same place at just about the same time. Even when the passes went awry, Hutson had a knack of finding them, running them down, and running away with them.

As assistant coach Harold "Red" Drew said, "It turned out that he could catch any ball thrown near him. He had big hands. He was relaxed at all times. He was hard to notice."

Red Drew shrugged and sadly shook his head. "We made a mistake on Don Hutson," he said.

Four years at Alabama. Three of them wasted.

Don Hutson never complained. But he had a lot of catching up do, and time was short.

All he would need was one game for the roses.

*I would have gone out there and killed for Alabama that day.*

— Paul "Bear" Bryant

The Year: 1935

## The Moment:
# The Human Howitzer Strikes

Roses.

They grew all over Alabama.

Frank Thomas only cared about the ones blooming on New Year's Day in California.

The Rose Bowl had been Coach Wallace Wade's enduring legacy.

He had gone three times and never lost. For Alabama, finding its way back to the Rose Bowl had always been the quest for the golden ring.

In 1935, Frank Thomas and the Crimson Tide were back on top, back on the train, and bound for the roses.

In California, Stanford Coach Tiny Thornhill was quietly setting his trap. The ambush, he thought, would be sudden and decisive as the snap of a bullwhip.

His Stanford Cardinal team was making its second straight appearance at the bowl and was armed with three All-Americans: tackle Bob "Horse" Reynolds, end Monk Moscrip, and Bobby Grayson – who ran Pop Warner's famed invention, the high-flying double wing, from his fullback position, which meant that Grayson handled the ball on virtually every play.

They were part of the notorious "Vow" boys. They had been beaten by the University of Southern California their freshmen year and vowed to never lose again to the Trojans. They hadn't, winning three straight years. They knew Southern Cal, and Alabama was no Southern Cal.

They were right.

USC had the glory.

Alabama had Millard "Dixie" Howell.

Stanford would pose a formidable threat.

Advance reports out of California said the game would be a laugher at best, a yawner at worst.

The best team in the West had passed on Minnesota to pick a soft touch for the storied game.

The Cardinal wanted to line up against a team whose undefeated record rested somewhere between mediocre at best and inferior at worst.

The Cardinal wanted to win.

The Cardinal wanted Alabama.

Lights out.

The Cardinal got Alabama.

Frank Thomas did, of course, have his concerns.

In games where pride and prestige were t stake, all coaches knew that worry was merely part of the game plan.

But he had three All-Americans of his own: tackle Bill Lee, end Don Hutson, and Dixie Howell – who ran Alabama's famed Notre Dame Box from his quarter-

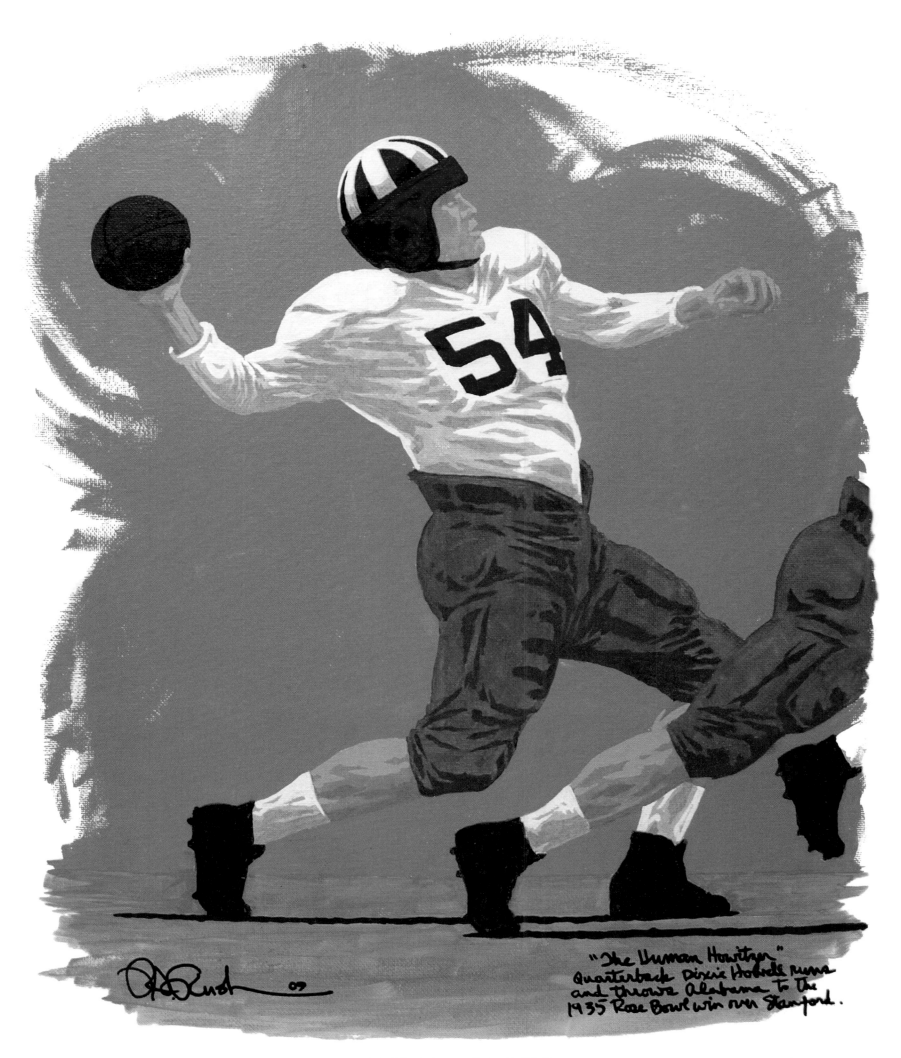

"The Human Howitzer"
Quarterback Dixie Howell runs
and throws Alabama to the
1935 Rose Bowl win over Stanford.

## DIXIE HOWELL

The Man With The Golden Arm

back position, which meant he handled the ball on virtually every play. The punt was no exception.

Frank Thomas developed a simple scheme free of any complications. He told his team, "Your only chance is through the air."

He handed the ball to Dixie Howell.

Some players had talent.

Dixie Howell had the gift.

No one knew quite what it was or could ever explain it, but Kavanaugh Francis, Howell's center, did tell the press, "He could do it all. Even when we got behind, and we were taking some lumps, we knew he could pull it off."

His head coach put it this way: "Howell's mental reactions were the thing to my mind that made him great. He had the ability to see and realize the situation a split second ahead of the usual player. Howell had something that few athletes possess – a touch of genius in his makeup."

From the beginning, Thomas always knew that Dixie Howell had great speed and was a top-notch punter.

For whatever reason, he never thought that Howell showed any promise at all as a purveyor of the forward pass.

Dixie Howell broke his leg during his first season at Alabama.

He didn't play much.

But one back, then another, went down with an injury. Dixie Howell had his chance,

He took it.

Alabama never looked back.

Dixie Howell played with a cool arrogance.

As the Crimson Tide practiced for the Rose Bowl, newspaper reporters began gathering around the field, as tight as ticks on a hound's back.

They were often close enough to feel as though they were part of the huddle.

They became a nuisance, and assistant coach Hank Crisp grew weary of them and their constant barrage of questions.

He couldn't take it any more.

He quietly told his players in the huddle, "I'll give

two dollars to anyone willing to knock over one of those newspapermen."

Dixie Howell nodded to Paul Bryant.

Bryant grinned.

No problem, he thought.

Nothing to it.

The big, rugged end went deep, cut sharply as the pass settled down over his left shoulder, and plowed headfirst into a band of reporters.

They went down and bounced along the ground like splintered and scattered tenpins in a cheap, back lot bowling alley.

Crisp paid off, and the next morning, Howell handed one of the dollars to Paul Bryant.

On the morning of the game, Crimson Tide players gathered on the bus.

One was missing. Dixie Howell was nowhere to be seen.

Coaches and players began a frantic search.

He was found back in his hotel room.

The players were nervous and on edge.

The butterflies were humming in their gut.

This was the biggest game of the year, the biggest game of their lives.

This was the Rose Bowl.

The pressure was so great that some could hardly breathe.

Millard "Dixie" Howell had forgotten the time.

He was firing dice instead of a football.

Millard "Dixie" Howell was shooting craps.

The game began, and Stanford struck first.

The Cardinal recovered a fumble at the Alabama twenty-five-yard line, and the great Bobby Grayson plunged for the final yard and a touchdown.

The humorist Will Rogers would write, "Stanford made a mistake scoring first. It just made those Alabama boys mad. That first score was just like holding up a picture of Sherman's March to the Sea."

Maybe so.

Paul Bryant had taken his place on defense and looked down at the grass at his feet. In the dirt, he saw a silver dollar, two half-dollars, and a quartet of quarters. In the heart of the Great Depression, those

three dollars looked like the short end of a fortune.

He picked them up and decided he would casually ease on over to the sidelines the first chance he had, probably at the end of the next play while the field was still rife with a certain amount of chaos and confusion, and hand them to someone to keep for him.

He never had a chance.

"I looked up," Bryant said, "and here came Grayson, running around end right at me."

Grayson's legs were churning, he had cut past the line, his eyes were burning like coals, and he was picking up speed.

"I had a decision to make," Bryant said.

He could hold onto the coins, and, Lord, three dollars was a lot of money. Or he could nail Grayson.

Bryant took a deep, decisive breath, squared his shoulders, tossed the silver aside, and uprooted the free-running and notorious Bobby Grayson, throwing him unceremoniously to the ground.

Both were chewing dirt and spitting dead grass by the time the whistle blew.

Bryant looked once or twice.

He never found the coins again.

Dixie Howell, the sharpshooter, went to work, and Alabama scored twenty-two quick points that West Coast writers called "one of the greatest offensive displays in football history."

Howell threw his body to the mercy of the line and dove for one score, passed to Don Hutson to set up a field goal, and sprinted around right end for sixty-seven yards on the way to his second touchdown of the second quarter.

His jersey was still clean.

Stanford had not yet touched or stained it.

The Cardinal was already down, doomed, and waiting for the knockout punch by the time Riley Smith connected on a long pass to Hutson for a touchdown with eight seconds left in the first half.

Before the game ended, Howell would wind up and throw another scoring bomb, a fifty-nine-yard strike to Don Hutson, sending Alabama to its third Rose Bowl win, 29-13.

Somewhere, along about the first quarter, Stan-

ford had stopped laughing.

Somewhere, along about the second quarter, Stanford was ready for Alabama to go home.

Somewhere, along about the time the clock was running out, Stanford wanted to go home.

The Tide, some believed and others wrote, could have rung up as many points as Dixie Howell wanted to put on the board..

He was firing bullets.

He might as well have been shooting craps.

Everything was coming up seven.

Howell jogged off the field with nine completions in twelve attempts, piling up a hundred and sixty yards at a time when most teams only threw in self-defense and usually never at all.

Those twelve passes, one sportswriter said, practically made Dixie Howell "the Charles Lindbergh of the day."

When he wasn't throwing the ball, Howell found time and space to travel another hundred and seven yards on the ground.

Bill McGill wrote in *The Atlanta Constitution*, "No team in the history of football, anywhere, anytime, has passed the ball as Alabama passed it today. And no man ever passed as did Dixie Howell, the swift sword of the Crimson attack."

The legendary sportswriter Grantland Rice reported: "Dixie Howell, the human howitzer from Hartford, Alabama, blasted the Rose Bowl dream of Stanford with one of the greatest all-around exhibitions of football ever known. Howell, teaming with the incomparable pass catching end, Don Hutson, electrified the crowd of 84,474 with twenty-two points in the second quarter.

"In those fifteen minutes, Alabama amassed 159 yards on passes and 106 on the ground. Howell himself gained 96 yards in the air on four completions to Hutson and three to Paul Bryant, the other end."

Bryant read the article and laughed.

His destiny had been sealed, he thought.

From that day forward, whenever anyone asked, he always referred to himself, politely enough, as "the other end."

# PAUL BRYANT

## Scattering The Sportswriters

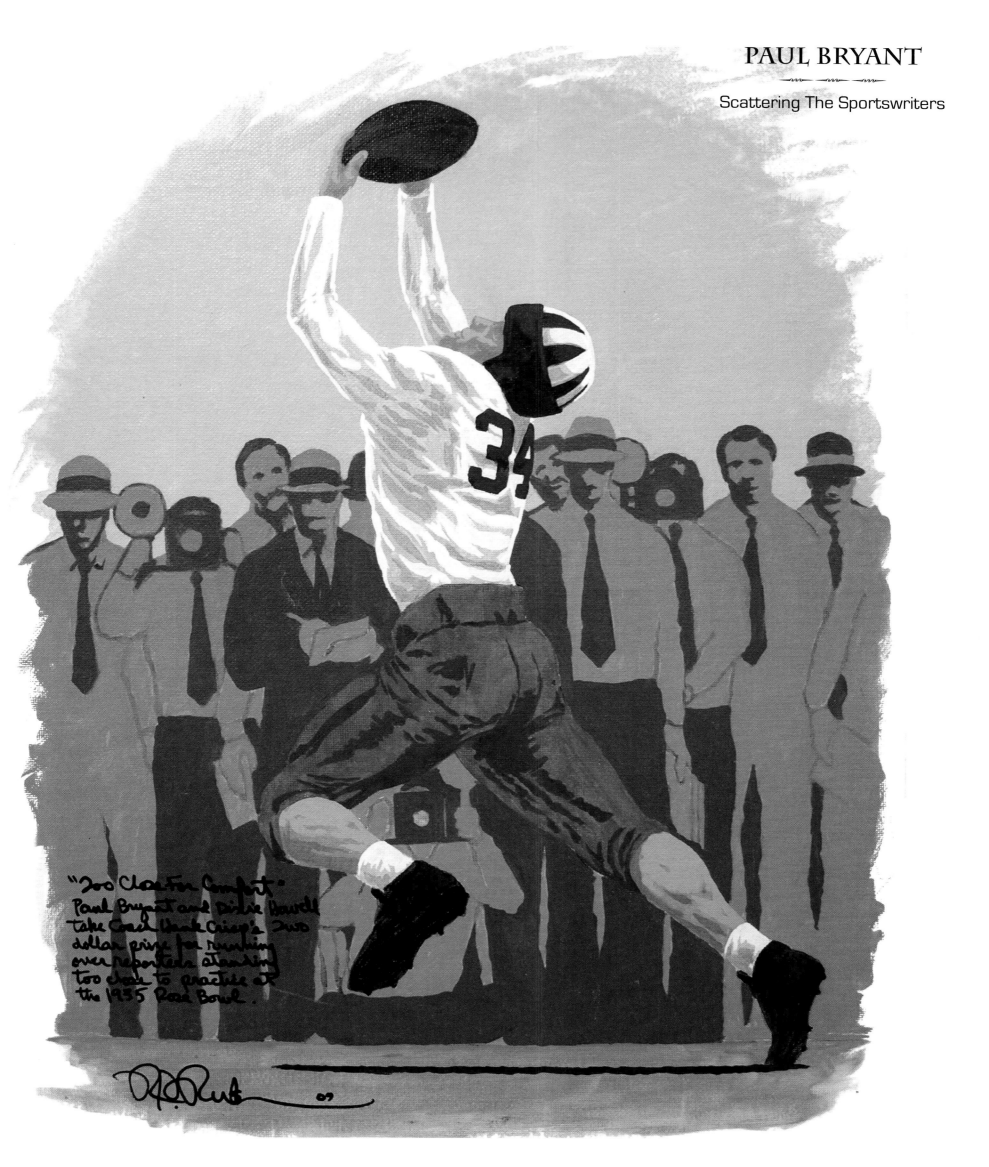

"Zoo Cleston Comfort" Paul Bryant and Dixie Howell take Coach Hank Crisp's two dollar prize for running over reporters standing too close to practice at the 1935 Rose Bowl.

*show class, have pride, and display character. If you do, winning takes care of itself.*

—❯ Paul "Bear" Bryant

The Year: 1935

## The Moment:
# Playing with Pain

Paul Bryant couldn't walk.

There was no way he could play football.

He had a break in his shinbone, and Coach Frank Thomas had fire in his eyes. It amazed Bryant. Always did. Thomas looked so much like a cherubic, sawed-off little round-faced social studies professor, or maybe a door-to-door pots and pans peddler, but he could raise the hair on a player's neck by just walking into the room.

He had won a Rose Bowl. He had already forgotten the Rose Bowl. His thoughts, day and night, were on General Bob Neyland's troops up in the Smoky Mountain haze of Tennessee. Lord, how he wanted a win over Tennessee.

Thomas glanced down at Bryant, his eyes focused on the thick bandages wound tightly around his big end's calf. "How does the leg feel?" he wanted to know.

"Hell, coach," Bryant answered, "it hurts."

Deep inside, Frank Thomas may have even cared, but, at the moment, he was more concerned about Tennessee.

His message to the rough-hewn boy they called "Bear" was simple and direct to the point, "You're tough, son," he said. "You've been through a lot."

Bryant nodded. "Yes, sir," he said.

Thomas did not care if Bryant could or could not walk. He did not particularly care if the sharp daggers of pain were too great for him to play football. He would be taking Bryant with the team to Knoxville, just in case. He said, "That leg of yours will somehow get to feeling a lot better once you get there and take a look at those orange jerseys."

A blue haze thickened atop the crest of the Smokies as Alabama rolled into town. There was a chill in the air.

Paul Bryant carefully eased his way into the locker room on crutches, a one-legged end with a bone that had not yet healed. The pain was as intense as the mood inside.

The pressure was suffocating. Assistant coach Hank Crisp stood and said, "I know you veterans are going to get after them. You seniors ... this is your last chance to beat this bunch. And that includes old Number 34. I don't have any doubts about him. He'll

# GAME DAY CRUTCHES
## The Bear Threw Them Away

be in there, scrapping and fighting until there ain't a drop of blood left in his body."

Paul Bryant glanced down at his jersey and saw the numbers: Three. And four.

For the first time, he felt the chill. He was wearing Number 34. He had no idea. The numbers changed every week so universities could sell new programs.

Bryant wondered for a moment if Coach Crisp had the foggiest notion that a man with a broken shinbone was wearing Number 34?

Bryant suddenly rose to his feet, threw open the locker door behind him, pulled out his crutches, and threw them down on the cement floor. A man didn't need crutches to play football. Guts would do just fine. If Coach Crisp, God bless him, thought he was able get in there amongst the big boys and do a little scrapping and fighting, well, he did, too.

A dull ache throbbed in his leg. A sharp pain felt like an ice pick in the bone. He grimaced once. Then he forgot about the pain. Or maybe he just ignored it. Even the thought of those orange Tennessee jerseys had done the trick. Bryant shrugged. Hell, he thought, he might even be healed.

Frank Thomas turned to him on the sideline and asked, "Bryant, can you play?"

"Yes, sir."

That was all the confirmation that Thomas needed, but he wanted to see for himself. On Alabama's first play, Bryant cut sharply downfield and caught a pass for a first down. A few plays later, he grabbed another pass and, as tacklers swarmed in close to gang tackle him, perhaps even leave his remains in repose at the foot of the Smokies, he pitched the ball to Riley Smith, who broke wide open for a touchdown.

Tennessee never recovered.

Ralph McGill, sports editor of *The Atlanta Constitution*, doubted seriously that Bryant actually had a bone broken, fractured, or splintered. He demanded to see the X-rays. After all, Alabama would be playing Georgia the next week, and he was growing a little suspicious. He was ready to expose the little scam that Frank Thomas was running.

He studied the X-rays and frowned. He saw the break. He turned and apologized to Bryant.

"You don't have to," Bryant said. 'It's just one little bone."

Only one little bone, perhaps, but a bone was a bone, and it was cracked. No doubt about it.

McGill would write, "Paul Bryant is first place in the courage league."

*We could have picked a lot of teams easier to beat than Alabama.*

— Texas A&M head coach Homer Norton

The Year: 1942

## The Moment:
# Amidst the Sounds of War

A nation was in grief. A nation was angered. A nation was at war.

Less than a month earlier, on a calm Sunday morning, Japanese warplanes had dropped out of a clear, peaceful sky and dove beneath the clouds above Hawaii to leave Pearl Harbor's Battleship Row in ruin and devastation. More than two thousand lost their lives. It was indeed a day that would live in infamy, and American boys were on their way to foreign shores. Not all would be coming home.

No one's mind was on football.

But Alabama had a game to play.

Frank Thomas felt the heavy burden that clouded a nation, but he said, "Football is really good for the nation in wartime. It helps balance out some of the grimmer news we receive. Football teaches young men discipline, leadership, how to think quickly under stress, and it builds them up physically."

Football prepared them for battle, and the sudden reality of war had not escaped anyone. Those who played a game on New Year's Day would no doubt trade uniforms before another new year arrived.

Fatigues would replace the color of Crimson.

Black leather helmets with chin straps would be turned in for metal pots.

They would face bullets instead of bullet passes.

War was a game played for keeps.

And the playing field stretched farther than the eye could see and the mind could envision – across Europe, beyond the beaches of Normandy, on the far side of the Rhine, atop Mount Suribachi, along the dead rocks of Guadacanal, and into the mysterious rice paddies of Japan.

Football was a game, hard and demanding.

War was life and death.

Yet, on a crisp afternoon in Dallas, Texas, Alabama and Texas A&M had a game to play in the Cotton Bowl.

For pride.

For honor.

For prestige.

For the Aggies, it would be a grim, yet glorious, day, win or lose. Texas A&M was a military school. Its students and its players alike were trained to fight. They were eager to fight. None were oblivious to the consequences. Some would die before they ever met again. They brought with them banners that proclaimed: "Cotton Bowl, January 1. Tokyo, January 2."

Frank Thomas had never been a striking or colorful figure on the sidelines. He was not a showman. And in

1942, he was deadly serious about the game.

In reality, he had not expected to be invited to a bowl. He was still wallowing in the misery of two defeats, including a 7-0 loss to Vanderbilt in a driving rainstorm and a game made even more miserable by ten fumbles. Alabama had reached the Commodore two-yard line once, but close didn't count for anything unless the boys were on a date. Bowl talk had slacked off when the Tide lost to Mississippi State and faded altogether with the defeat in the rain.

The Tide had been the early favorite to win the Southeastern Conference in 1941, but Alabama had lost a dozen players to graduation, the draft, and academics. Its starting quarterback even had the audacity to leave the team and get himself married. Thomas' number one fullback departed to become a wartime pilot. Long before someone had written "Remember Pearl Harbor," he did.

Alabama had regrouped, played a rugged ten-game schedule for the second time in its history, won eight of them, and received word at the last minute that the Tide had been invited to the Cotton Bowl despite its two losses. Most teams would have been quite happy to end the season with a mere two defeats. For Frank Thomas, they were as annoying as a chicken bone lodged in his craw.

When the call came with the invitation, it was ten o'clock at night. Frank Thomas was adamant. He told the Cotton Bowl official that he could not officially accept the kind offer without first talking to Dr. Denny.

"Well, call him up."

"I can't. He's asleep."

"Not even for fifty thousand dollars?"

"I'll call him in the morning."

Why the delay, Thomas was later asked?

The coach only shrugged nonchalantly. "I thought the man from the Cotton Bowl said fifteen thousand dollars," he said.

Dallas on New Year's Day lay in the brutal grip of a deep freeze. Temperatures were bouncing low, then lower. Ice was in the air. Thirty thousand frigid fans wrapped themselves in blankets and gunnysacks. Long before the game ended, many of them had left their choice seats and were huddling together in the north end of the stadium to escape the cold, harsh winds.

Frank Thomas had prepared the Tide for the Cotton Bowl classic with his same basic philosophy of coaching: "Keep the players high and make practice a pleasure but not a lark. Be a disciplinarian but not a slave driver."

He had his team ready. Don Salls, the press said, had the God-given talent to crack any line that bowed up against him. Jimmy "Tater Head" Nelson moved like an express train, only faster. And Holt Rast was generally acclaimed to be the best end in America. Nelson, in fact, had been favorably compared to Georgia's Heisman Trophy winner, Frankie Sinkwich. But Thomas said, "Nelson may not make as many yards, but he will win more games for you."

The Aggies had their own reputation to uphold. They were considered to be, without doubt, the most feared passing team in the nation. Alabama assistant coach Red Drew looked at Texas A&M and said, "They are more dangerous than any team we have played," and many in the press expressed their belief that the Aggies were a single win away from claiming the national championship.

Dallas would tell the tale.

Football expert Oswin K. King recognized its importance. He said, "If national ratings mean anything, you can bet that the Texas A&M and Alabama game overshadows any other bowl game."

Alabama's pass defense had been notoriously bad and filled with gaping holes all year. The pass defense hadn't effectively stopped anybody, and Texas A&M was armed with six different spread alignments, as well as the traditional single-wing, double-wing, short punt, and Notre Dame Box formations. Texas A&M had a new look every time the ball was snapped.

Frank Thomas had his game plan already designed. We can't stop them, he thought. We'll just have to score whenever they score and maybe get one or two more. "It will be a free-scoring game," he told the press. "There should be a lot of touchdown making out there."

# WAR SIGNS

A Day Of Defiance
And Patriotism

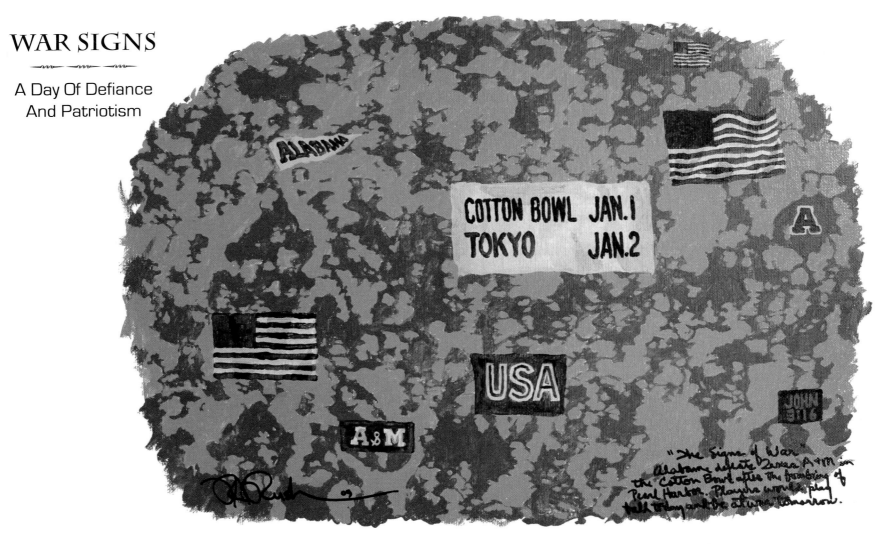

Alabama just didn't have the horses to waylay or stop a hostile Aggie passing attack.

That's what the press kept telling Alabama.

The press didn't wear Crimson.

The so-called hostile Aggie passing attack fizzled like a bottle rocket with a burnt out fuse.

The Tide intercepted seven passes. A porous pass defense had plugged its holes.

The Texas A&M defense spent the whole afternoon searching, but not finding, any way to bottle up, slow down, hem in, rein in, button up, corral, or take Jimmy Nelson to the ground and keep him there.

Red Webster wrote in *The Dallas Journal*, "To Nelson, a beautiful runner and a heady strategist, belong a major portion of the winner's glory."

The score was tied, 7-7, when the punt came his way, and Nelson broke the game open with a seventy-two-yard return.

He scored again on a twenty-one yard burst off tackle even though he was hit five times at the line of scrimmage.

Webster wrote that Nelson "flashed his magic hips and five Aggies hit the dirt."

Alabama won 29-21 although the game hadn't been nearly as close.

The Tide dominated. Said Frank Thomas, "It was the best game Alabama played all year. We got the breaks and accepted them."

The Aggies managed to score twice in the last minute just to make the final and decisive outcome a little more bearable and respectable in the next morning's headlines.

Then the Aggies marched away to parts unknown. Tackle Mort Ruby had been sworn into the naval air corps at halftime.

January 1, Dallas.

January 2, Tokyo.

Alabama watched them leave. Then Alabama looked hard at its own players.

Thirty-six of them were eligible for the military draft, and both Jimmy Nelson and Holt Rast had said they would enlist in the army. More in Crimson would follow them.

When the day ended in Dallas, it was not a time to celebrate.

It was a time to salute.

> *Harry Gilmer is the only passer I've seen who could throw both long and short passes when completely off balance.*

The Year: 1945

— Steven Owen, New York Giant coach at the Sugar Bowl

## The Moment:
# Coming of Age

Coach Frank Thomas had never seen a team so young.

The war had taken its toll on college-age football players. They were dug in on some foreign shore amidst a barrage of bullets, bombs, and shrapnel that left them lonely, homesick, courageous, and probably afraid.

Thomas was left with a team of seventeen-year-olds and 4-Fs, those who had a various assortment of injuries, illnesses, ailments, and deformities that did not allow them to pass their military physical examinations.

They were boys. But they were different somehow. They wore Crimson.

Frank Thomas had his gunner, Harry Gilmer. But he was only eighteen years old, weighed a hundred and fifty-five pounds, looked frail, suffered from an ulcer in his gut, had a strict diet of milk, cream, cereals, and strained vegetables, and was sturdy as a rock with big powerful hands and legs as strong as gate-posts. No telling how strong he would have been with a little meat on the plate every now and then.

Harry Gilmer had never thrown a pass in either anger, frustration, or desperation until he was a senior at Woodlawn High School in Birmingham.

He had been banned to the bench while others – older, more experienced, and not so frail – ran the offense.

But when he finally had the football in his hands, Harry Gilmer was as deadly as a sniper. Even while still in high school, Zipp Newman of *The Birmingham News* wrote that "Harry is as fine a passer as there is in football. This goes for the pros."

Frank Thomas wanted him for Alabama. Harry Gilmer had no interest in college.

Frank Thomas wanted a left halfback to direct the Notre Dame Box. Harry Gilmer wanted to be a carpenter and build boxes.

Frank Thomas hired Gilmer's high school coach, Malcolm Laney, and Laney packed up his hometown passing magician and brought him along to the Capstone. He knew what Gilmer could do.

Thomas only suspected it.

Thomas hoped he was right.

Gilmer was not quite like any of those offensive artists who had come to Alabama before him.

They may have sometimes rolled to the right or slipped away to the left, or even dropped back in a moving pocket, but they almost always threw with their feet planted solidly on the ground.

Harry Gilmer, on the fly, always on the fly, would find his target, cock his arm, and jump before he released the ball.

He was the daring young man on the flying trapeze, high above the ground, working without a net.

He was surgically precise when he fired the ball, and they weren't necessarily short passes.

They came out of his hand like deadly bolts of lightning, and, with both feet in the air, he could throw seventy yards with deadly accuracy.

Frank Thomas had never seen anything like it.

Gilmer would always say, "I never liked to pass moving backward or with my feet on the ground. I discovered I obtained better range and better control while moving forward and leaping from the ground. In jumping, I can get partly away from a tackler, and in the air I seem to have more freedom of motion. After all, passing is largely hand and wrist action."

His hand and wrist had the power of a rifle.

Thomas pointed out, "On occasions, after he had jumped seemingly to hit a target on the left side of the field, I've seen him, in that split second in mid-air, suddenly reverse his arm and hit a receiver on the right side. In that brief moment, while off his feet, he saw that one receiver was covered, and the other was not."

Gilmer doubted he would ever play for the Crimson Tide.

He figured he was bound for the army.

And Europe.

A doctor thought otherwise.

He examined the eighteen-year-old, wrote down that Gilmer was afflicted with a serious case of stomach ulcers, and sent him home.

Home became Tuscaloosa.

Harry Gilmer was quiet, unassuming, had narrow shoulders, and possessed eyes as cold as a swamp rattler. He was a fighter, had an uncanny knack for running with the ball when a sudden and unexpected hole in the line presented itself, and led a bunch of boy soldiers wearing Crimson through the Southeastern Conference and into the Sugar Bowl, of all places.

Thomas referred to the team as his "War Babies." As a whole, they were much too young, too small, and too fragile to wind their way through the demanding rigors of college football, but they persevered, against all odds, and won five games, lost two, and tied two.

It wasn't the greatest of seasons.

It was a season to remember.

The storied Red Elephants had traded uniforms and marched off to war.

In Tuscaloosa, the famed Thin Red Line had returned to action.

Harry Gilmer made the difference.

He had an iron will, possessed a rocket launcher for an arm, and never let the frantic moments of a frenetic game bother him.

He was in control, cool, poised under pressure, and absolutely fearless.

Thomas watched him all year and said, "He can have five men grabbing for him or chasing him without being bothered. He doesn't mind running back fifteen yards before he turns to throw because he knows he can hit a receiver fifty to sixty yards away as well as one twelve yards away."

Harry Gilmer may have been a daredevil with the football in his hands, but only once had he been victimized.

Only once all year had he thrown an interception.

For the most part, however, he was leading boys and 4-Fs against teams whose rosters were filled with boys and 4-Fs. The 1945 Sugar Bowl would be different.

The Tide, if the prognosticators could be believed, was over-matched, out-weighed, and, for all intents and purposes, outclassed by the Duke Blue Devils, who were older, bigger, more experienced, and loaded with U.S. Naval trainees.

They were the cream of the crop, a collection of outstanding college football players from teams scat-

# HARRY GILMER

King Of The Jump Pass

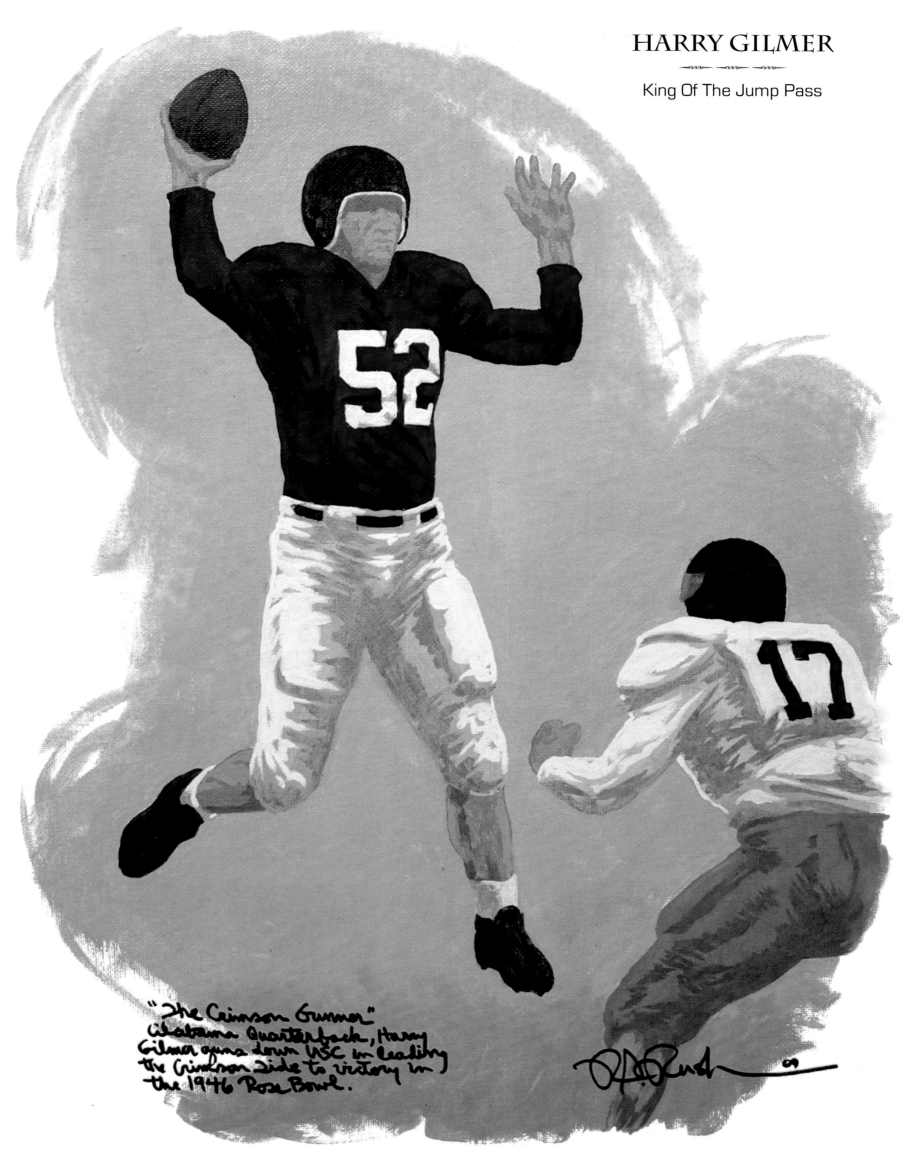

"The Crimson Gunner" Alabama Quarterback, Harry Gilmer guns down USC in leading the Crimson Tide to victory in the 1946 Rose Bowl.

tered throughout the nation.

The feeling in the press was all the same.

Alabama had a good little ball club.

Alabama had a nice little passer in Harry Gilmer. Alabama had made a nice little run in a season where college teams had been decimated by the war.

The Crimson Tide looked more like a bunch of high schoolers and probably should have stayed home. The beating and the humiliation those poor little Tide players would face and endure might scar them and their psyche forever.

The scars were left by Harry Gilmer.

Duke won, 29-26, but the Blue Devils had been in the midst of battle all afternoon.

No peace.

No break.

No relief.

No cease-fire.

It was four quarters of hell.

Late in the final period, Duke had been knocked off-balance and was facing the real threat of defeat and dishonor after the Crimson Tide struck for a 26-22 lead.

The Duke outlook, according to one sportswriter, "was even darker blue than the uniforms they wore."

The powerhouse kept running short of power.

Grantland Rice wrote, "The amazing Gilmer completed eight out of eight passes in the face of a hard-charging Duke line that attempted in vain to hurry his rifle arm. It required the savage, hard-hitting running of Tom Davis to dam up and finally stop the flowing Crimson Tide."

Duke, staring hard into the face of defeat and not liking what it saw, came surging back, the press said, "like a pack of hungry timber wolves."

Harry Gilmer and big Norwood Hodges led one last violent assault.

The Blue Devils did not stop Alabama.

The Blue Devils could not stop Alabama.

Time did.

Zipp Newman of *The Birmingham News* wrote, "Duke was more than willing to call it quits with a hair-raising victory over an Alabama civilian team that gave its all in a game where Alabama had the razor and Duke had the meat cleaver ... Never has Coach Thomas gotten more out of a football team than his child team that never was afraid of a powerful Duke eleven that led with punches started from the floor, and it was fitting that Duke players rushed to Alabama players after the game to congratulate them."

The Blue Devils knew they were a better team.

But never had they been forced to fight any harder, any longer, with any more intensity.

Duke had hammered out five hundred and sixty-seven yards of offense, five hundred and thirty-five of it on the ground.

And still the Blue Devils almost lost.

Grantland Rice called it one of the great thrillers of all time, "a game packed with football melodrama from the first play." He wrote, "Alabama had to ride the greater part of the way on the deadly right arm of eighteen-year-old Harry Gilmer, the greatest college passer I ever saw, barring neither Sammy Baugh nor Sid Luckman. This young Birmingham boy can hit a squirrel in the eye at fifty yards. He was the Davy Crockett of the Crimson Tide.

"It was a see-saw, whirlwind, wild and woolly contest in which the lead changed hands with such a dizzy speed that only the scoreboard could give the big crowd the story. There was one pass Gilmer threw in the second quarter that no one who saw it will ever forget."

He was rushed. Swarmed. Almost tripped. Almost caught by two other tacklers.

"But in the midst of this turmoil," Rice wrote, "he suddenly spun away, leaped high in the air over another Duke tackler and whipped the ball to [Ralph] Jones forty-one yards away. And the ball spiraled directly into Jones' waiting hands, where the betting could have been twenty-to-one that Gilmer would never get the ball away."

In the end, Duke had too much. But, as Rice wrote, "The Blue Devils had to go all out to finish on top."

Alabama's "War Babies" lost. It may have been the Tide's finest hour.

*Never, say the oldest historians, has the Rose Bowl witnessed a more convincing shellacking.*

<>— *The Associated Press*

The Year: 1946

## The Moment:
# A Day for Mercy

Alabama was upset.

No.

Alabama was irate.

And Alabama had a right to be.

They were on their way west, and some holier-than-thou columnist for *The Los Angeles Times* did not think they deserved the right to cross the Mississippi River, much less square off against the powerful Trojans of Southern California.

The game, he wrote with a poison pen, would be a travesty.

Dick Hyland wrote: "Columbia or Pennsylvania would make a much better game with the Pacific Coast Conference representative for the 1946 Rose Bowl than would Alabama ... Such a game would have that intangible thing called 'class,' something it can never have with a southern club being one of the participants ... Me, I'm kinda tired of hillbillies and swamp students in the Rose Bowl."

Perhaps Dick Hyland merely held a grudge.

Perhaps he had never been able to forget the 1927 Rose Bowl when, as a scatback for Stanford, he had tried to show off with a little fancy footwork down near his goal line and was caught in the middle of a vicious Alabama cross-block.

Hyland had been carried off the field.

Alabama had pulled his stinger.

He wanted the last word.

Or, at least the next word.

When Alabama played Washington State in 1931, Hyland personally scouted the Tide and secretly gave the Cougars every scrap of information he had been able to piece together from his personal observations of the practice.

Wallace Wade heard about Hyland's spying tactic and laughed.

He made a few subtle but critical changes in his game plan and said, "Now, his information is about as useful as a snail in a tank battle."

Zipp Newman of *The Birmingham News* read Hyland's vitriolic column and promptly responded by writing, "What he really wants is to make Pacific Coast teams safe from taking a beating from southern teams."

Hyland had taken his shot.

Alabama would fire when ready.

For the Crimson Tide, the "War Babies" were a year older, a year larger, and a year wiser.

The loss to Duke in the 1945 Sugar Bowl had taught them a valuable lesson.

The impossible was never really impossible, not if they believed in themselves and stuck together.

They had a lot of grit.

And gumption.

They had something to prove.

And they still had Harry Gilmer.

Southern California did not know a lot about Harry Gilmer.

All USC had were just a few assorted press clippings, which were no doubt the somewhat illiterate handiwork of prejudiced southern sportswriters.

And what did they know?

Alabama had gone undefeated in 1945, beating South Carolina, 55-0, Kentucky, 60-19, and Vanderbilt, 71-0.

It had been quite a run.

Touchdowns came in bunches.

The defense stood tough.

Mean when necessary.

But always tough.

However, as Morris McLemore wrote in *The Atlanta Journal*: "Without Gilmer, the Alabama Rose Bowl team would be a carriage without a horse and not too strong a carriage at that. The threat of Harry's passes has made him a great runner. When he cocks his right arm and Rebel Steiner and Lowell Tew are in a position to receive, the defense takes off like a covey of quail in a fox den. They are scared silly. Whereupon Gilmer has the engaging habit of tucking the ball under his appendages and loping off for great chunks of yards."

Southern California was neither impressed nor overly concerned.

Gilmer had a little promise, the Trojans thought.

He wasn't bad for a kid.

But Harry Gilmer had not yet turned twenty.

He was a teenager, for God's sake.

Alabama would be throwing him to the wolves.

The Trojans were on the threshold of becoming the first team to ever record three straight Rose Bowl victories.

They had gone undefeated for the year, and since the third game of the 1942 season, no college team had scored as many as two touchdowns against Southern Cal.

USC was a dynasty.

Good.

And getting better.

No one could penetrate its defense, not even the gifted Mister Gilmer.

Alabama had lost the war long before the train crossed the Mississippi River and reached Texas.

It was all over but the shouting.

Only Southern Cal was shouting.

For Frank Thomas, the worries had begun to pile up in staggering proportions. He had some control over the game, but he was and always would be at the mercy of fate and bad fortune.

His talented end, Lowell Tew, had broken a jaw in practice. His face was buried in hot and cold packs. He was on a liquid diet, sucking his meals down through a straw, and had lost eight pounds. On the field, he was wearing a helmet that had been wired together like a makeshift birdcage. Between plays, Thomas said, Tew would run to the sideline and get breath of fresh oxygen, provided, of course, he could run that far and that often.

For newspapermen, it made good copy.

None of them expected Lowell Tew to play.

Alabama was already in trouble, and the sick and afflicted had left their Crimson turning pale.

Frank Thomas walked onto the Rose Bowl field as the general in charge,

He wore a long face and had a short temper. He was, one writer said, "a solid chunk of mood indigo."

Tew was ailing, and it wasn't getting any better. The broken jaw was bad enough, but now his gums had begun to bleed, and they wouldn't stop. He was weak. He was losing blood with every beat of his pulse, and he had to drag himself across the field.

Thomas had always called Tew another Doc Blanchard, Army's "Mr. Inside," and the coach had no one to replace him.

Now he was smitten with other worries as well.

Southern California wanted to rip Alabama's head off. That was no secret. And he had eight members of his team in bed, on their backs, with the flu.

He had a football team.

He needed a medical team.

Thomas was a coach, not a shaman or a healer.

The only prescription he had was in the hands of Harry Gilmer.

The game did not quite go as USC had planned. Only six minutes had elapsed when Alabama scored.

For the first time.

Thirty-nine minutes passed before Southern Cal made a first down.

Fifty minutes went by, and Southern Cal still had minus yardage.

The Trojans would fumble six times.

And wind up with forty-four yards of total offense.

Alabama lined up against a storied and stalwart defense and nailed together thirty-four points.

The rubber-legged Harry Gilmer, who ran with a deceptive gait, could not be stopped either in the air or on the ground.

His sub, Gordon Pettus, broke for thirty-eight yards the first two times he carried the ball.

Gilmer had USC shell-shocked.

Pettus supplied the *coup de grace.*

Lowell Tew even lowered his birdcage helmet, squared his shoulders, and busted up the gut for a touchdown.

He had already lost a lot of blood.

A little more, he decided, wouldn't hurt any.

Dick Hyland swallowed his pride.

In a column after the game, he wrote: "Gilmer (Norman) Hodges, and (Corky) Corbett, each a ball carrier who knows how to take advantage of a hole, aided their blockers by beautiful faking up to the line of scrimmage. Beyond it, when on their own, they continued to drive when hit and pulled away from the Trojan tacklers again and again."

*The Associated Press* reported, "With all due credit to the stiletto-sharp backs that Coach Thomas threw at the befuddled Trojans, it was the line that made the contest an old-fashioned Alabama barbecue."

Hyland, although it hurt him, pointed out, "On defense, the Trojans were bowled over or suckered out of position on every play ... Ends and tackles were backing away from the charges of the Bama boys as if they were too hot to handle."

Jack Geyer of *The Los Angeles Times* smiled as he wrote: "Vaughn Mancha was hitting the Trojans so hard that Southern California's dental students were combing the field after the game, looking for specimens, cracked."

For Alabama, the guards and tackles never let up, and Frank Thomas played a lot of them.

If they rode the train to California, they played.

He sent all thirty-four players into the game, including Clem Gryska, a hard-hitting, never-say-die young man who traveled from West Virginia to play football for Alabama even though he had lost a hand in an accident, and Nick Terlizzi, who had broken a foot and just came along to California for the ride.

"In the final analysis," wrote Fred Russell of *The Nashville Banner*, "it was Alabama, sharp and aggressive, and Southern Cal, big, slow, and bewildered."

The final score was 34-14, but, as Vincent X. Flaherty of *The San Francisco Examiner* wrote: "The hard-hitting southerners might have made it 50-0 if Frank Thomas hadn't proved himself an exemplary member of the Humane Society by pulling his punches." He benched his starting unit early and starting playing everyone who fit into a Crimson jersey. USC had trouble telling the difference.

Southern Cal Coach Jeff Cravath found Frank Thomas after the game, shook his hand, and said, "Thanks, Tommy. I appreciate it. I don't know of another coach in the country who would have done it."

Thomas allowed himself a smile.

At Alabama, it was about class, he thought.

Even those so-called hillbillies and swamp students had class..

He wondered if Dick Hyland had noticed.

*Alabama executed Auburn as painlessly as possible.*

<> Ed Danforth, *The Atlanta Journal,*

The Year: 1949

## The Moment:
# A Rivalry Begins Anew

It had been forty-one years. And not once had Alabama and Auburn met face-to-face on a football field.

A rivalry had faded.

Games had been cast aside and left in the dark.

Generations had never felt their hearts bleed for either team.

For forty-one years, Alabama and Auburn had maintained a quiet disregard for each other.

It was as though the other school did not exist, regardless of who the other school might be.

Fans had never quit demanding a game. Students had continued protesting. Year after year, decade after decade, their protests had fallen by the wayside as though swept away by hot winds.

No one heard. No one was listening.

And between the two schools?

Silence.

It was all about to change.

Alabama and Auburn had not played since 1909 when the game ended in a 6-6 tie.

The next game had never been postponed, delayed, suspended, deferred, or even placed on the back burner.

It had been cancelled. No one knew why.

If they did, no one was saying.

Those who had not seen the game in 1909, who may not have even been born in 1909, kept saying that the long, insufferable hiatus had no doubt been caused by a rash of violence, or at least by a game that managed to get rough, rowdy, and out of hand.

This was, after all, Alabama and Auburn.

But Chick Hannon, Alabama's captain who had played in the last game, said, "It was not the players who caused the break. I wasn't heavy, you know, and when the game was over, I was sort of black and blue. We played hard and fought hard that day, and I can truthfully say that the sportsmanship was never cleaner."

There was no mention in any of the newspaper accounts about a feud, fisticuffs, course, crude, or brutal play, or anything out of the ordinary – only the casual mention of fans rushing the field, cheering wildly, and embracing each other, which certainly did not ignite an imbroglio.

No blood exchanged hands.

The game simply stopped.

An alliance was broken.

And nobody had been able to put the pieces back together again.

The schools refused to even think about the faint possibility of a rivalry, but the protests grew louder, and the demands became more, well, demanding.

Both schools, who by now should be ancient rivals, swore that a football game between them would never happen again.

They couldn't agree on a date.

They couldn't agree on a location.

They couldn't agree to agree.

One newspaper feared that it would "take an act of Congress to force Alabama and Auburn into becoming intrastate rivals again."

Congress didn't act.

The Alabama legislature did, passing a joint resolution that, as a newspaper reported, "brought rumors, dreams, and pressures to reality."

In effect, the legislature decreed that a state appropriation bill would defiantly withhold funds from Alabama and Auburn until their boards agreed "to inaugurate a full athletic program between the two schools."

Lawmakers did not particularly care about the date or the location.

They were simply adamant about one thing: Play the game.

Reporters called it a shotgun wedding.

In 1948, the rivalry began anew.

Surrounded by balmy weather and beneath a sky described as the color "of diluted milk," Alabama and Auburn played again.

The rain had stopped, sun and clouds fought for the same spot in the sky, and the field was soggy.

One reporter said that it "bore the aspect of the back of a wet Airedale dog."

The anticipation ran high.

Enthusiasm at both schools ran rampant.

It would be a duel in the sun.

Or rain.

No one knew for sure.

Only one thing was certain.

Football throughout the state would never be the same again.

It would be a civil war.

Primarily uncivil.

The rivalry after forty-one years was tenuous.

It would turn fierce.

Alabama and Auburn showed up for an old-fashioned, hang-on, hold-on, and lace the shoes on tight afternoon of football.

The game would go down to the last second.

Everyone was sure of it.

Auburn never knew what hit the Tigers.

Only that it was quick.

And powerful.

Alabama won, 55-0, with Ed Salem completing eight passes in ten attempts for a hundred and fifty-nine yards and three touchdowns.

He scored another on a sweep around the end.

Ed Danforth of *The Atlanta Journal* simply wrote,: "The 46,000 gathered under sunny skies saw Eddie "Suitcase" Salem turn on the gas, and it was over in a hurry."

The win was not surprising. The score was.

One reporter wrote: "It appeared that with every touchdown, the red elephants became more savage. The penalties for clipping picked up, the tackling was harder, as were the plunges, and once or twice I saw a fist swishing."

He turned to an attorney friend and said, "It looks like they're getting meaner, or is it my imagination?"

"No," the attorney answered. "Back in 1900, Auburn worn 55-5, and I guess Alabama is just trying to even up the score."

One sportswriter had been told to cover the game strictly from Auburn's point of view.

His game story consisted of a short note to his managing editor.

It said: "Auburn was defeated, 55-0, by Alabama here today. That's all unless you want some of the gruesome details."

Out in California, an elderly gentleman from Alabama had long ago made one request.

He wrote, "If my body is still warm, take me back when Alabama plays Auburn again."

It had taken so many decades.

He was ready to come home again.

> *This Alabama team had a decisive edge and fire. It was cruel and somewhat heartless.*
>
> —◇— Morris McLemore, *The Atlanta Journal*

The Year: 1953

## The Moment:
# Massacre in The Orange Bowl

For Harold "Red" Drew, it had been a season of turmoil, inner turmoil maybe, but turmoil nonetheless. The wins were plentiful. There had been nine of them. And the wins were decisive.

But Coach Red Drew had not been at peace with himself since the ragged 20-0 loss to Tennessee, and he could not forget that Georgia Tech had beaten him 7-3. Neither should have happened, and he knew it. Teams won, and teams lost. Coaches paid the price.

Rumors were sweeping though the near and far reaches of Alabama. The gossip persisted. Everyone knew that Red Drew had not yet been given a new contract. Maybe his job was in jeopardy.

The university president was asked if he had any intention of extending Red Drew's contract.

"No, I'm retiring," he said. "I'll step aside and let the next man chosen to lead Alabama make the next decision on the head coach's contract."

"But Red's taking Alabama to the Orange Bowl."

"I wish him luck."

Red Drew was left hanging isolated, alone, and in limbo as he led the Crimson Tide on a precarious journey into Miami, where Syracuse was waiting.

Coach Ben Schwartzwalder had brought his big Orange troops down early from the ice fields and snowbanks of New York so they would have a chance to acclimate themselves to an environment already overwrought with such odd peculiarities as heat, humidity, and the sun.

They were big, tough, and rumored to be junk yard dogs that had chewed through their owns chains.

It had been written in sacred stone that Syracuse reigned as the mythical champion of the East. Lesser men quaked when Syracuse walked by.

As one player told a reporter, "Nothing on earth seems more desirable or important than to murder the representatives from Alabama."

Stanley Woodward was caught up in the snare of Orange braggadocio. He wrote in *The Miami Daily News*. "It is reasonable, and perhaps with logic, that no Eastern team can meet a Paladin of the hog-and-hominy belt on equal terms.

"The Syracuse warriors hail largely from the Pennsylvania coal mine area, and, though they have no discernible connection with Harvard and Yale, the pantywaist label has been applied. In consequence, they are under oath to be the toughest, hardest men to shave in North America.

# THE SYRACUSE CANNON

## No Reason To Fire

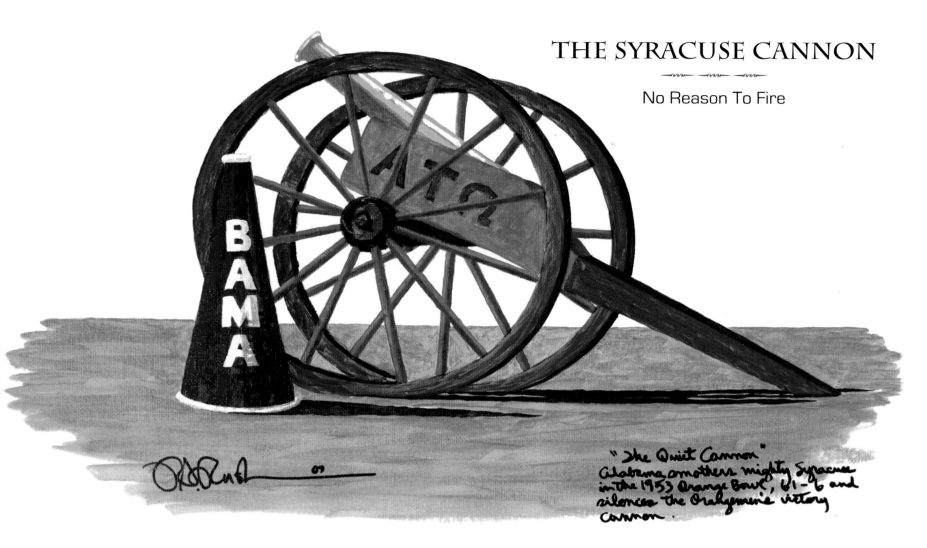

"The Quiet Cannon"
Alabama smothers mighty Syracuse
in the 1953 Orange Bowl, 61-6 and
silences the Orangemen's victory
cannon.

"I predict a smashing Syracuse victory."

The victory was smashing all right.

Red Drew knew he had a potent offense. He cranked it up, placed the ball in the hands of Bobby Marlow, Bobby Luna, Tommy Lewis, and Clell Hobson, and turned it loose. It was a frightening sight.

The toughest, hardest men to shave in North America had their faces cleaned.

Most of the afternoon, they were looking up at the sun. Flat on their backs. Their chests were numb. Too many cleats had run up and down their jerseys.

The final score was 61-6, and Alabama was fighting desperately to keep the ball out of the end zone in a futile effort to avoid embarrassing Syracuse any further. But the holes were so large and the pursuit was so slow, and the end zone was always so close, always within reach, never more than a scant fifty or sixty yards away.

The long, precision strikes from Clell Hobson to Marlow and Luna, *The Associated Press* wrote, "dealt a disastrous blow to the already faded football power of the East."

The Crimson Tide attack had been devastating,

its defense rugged and aggressive. One sportswriter penned: "Alabama is a big, snorting, ground-running football team which has a walloping offense line adept at cross blocking."

Morris McLemore of *The Atlanta Journal* summed the massacre up by writing: "The trampling had ceased. The last bodies were safely in the meat house. The Syracuse players – sick to their stomachs, beaten to quivering jelly – fought intelligently if not ferociously and fell sprawling before as fine a college football machine as the nation has."

A Syracuse fraternity, full of vim and vinegar from the coal mines, had brought down an old Civil War cannon, packed with wadding, to herald the Orange touchdowns.

It fired twice.

Once, when Syracuse scored on a fifteen-yard Pat Stark touchdown pass. And again, in a fit of frustration, when the final whistle blew. It had a lot of wadding to waste.

By the time the old cannon fired the last time, work had almost been completed, and the ink was drying on a new two-year contract for Red Drew.

*I left Texas A&M because my school called me. Mama called, and when mama calls, you just have to come running.*

<div align="right">—⟨ Paul "Bear" Bryant</div>

The Year: 1958

## The Moment:
# The Bear Comes Home

The glory days had faded. Alabama wanted them back.

During the past three years, the Crimson Tide had won only four times. The losses crept up to twenty-four, including seventeen in a row, and Alabama had only managed to snag a pair of ties, which, in the overall scheme of a self-proclaimed football power, did not account for much. To make a bad run worse, Auburn had walked away victorious on three straight Iron Bowl afternoons.

Alabama demanded a change.

It would begin with a man whose deep, Southern drawl, as definable as thunder before a storm, had been mistaken on more than one occasion for the voice of God. The university already had more than a passing acquaintance with the one coach out in the hinterlands who, it believed, could lead Alabama's football fortunes out of the wilderness and back to the promise land.

He had worn Crimson. According to the whispered rumors that raged among the restless alumni, he had been a damn good pass-catching end on a damn good football team that won a lot of damn important games, even a Rose Bowl.

He was an even better coach.

Alabama went calling on Paul "Bear" Bryant. He had the rare ability to take bad teams and turn them around. Overnight. He was a savior. He could save a program, even one gasping its last breath.

Bryant was possessed with the talent to find the heart of a football team, hear it beat once or twice, then mold it into a winner. As he would say, "I'm just a simple plow hand from Arkansas, but I have learned over the years how to hold a team together, how to lift some men up, how to calm others down, until finally they've got one heartbeat, together, as a team."

When Paul "Bear" Bryant walked on the field, a face chiseled from granite and eyes smoldering like embers from a Birmingham steel mill, his teams were afraid to lose.

They might not win them all.

But fear cut through them like a terrible swift sword when the scoreboard wilted, as it seldom did,

# THE LEGACY BEGINS

Forever Beneath The Shadow Of The Bear

and turned upside down. They might be outscored but never outfought. They believed in what he told them, taught them, and trained them to do. His word was gospel, his retributions final.

Alabama did not care that Bryant earned his nickname as a young man when he crawled into a makeshift ring to wrestle a traveling sideshow bear for a dollar. Alabama wasn't interested in myths.

Alabama simply cared that Bryant had served as an assistant under the legendary Frank Thomas and learned the intricacies of a game called football from the master. Even Bryant would later say, "We thought then, and I know now, that Coach Thomas was ahead of the game. There wasn't a whole lot he didn't know about it, and there sure isn't much we do now that he didn't know then."

Bryant accepted the head coaching job at Maryland after World War II, recruited a bunch of boys right out of the navy – figured their size, age, and toughness were more important than their ability to run, throw, or catch a football – and carved a 6-2 record his first and only year with the Terrapins. He might have stayed for a longer time if he hadn't gotten into a power struggle with the president of the university.

Bear Bryant wanted to keep an assistant coach.

President Curly Byrd fired him.

Bear Bryant kicked a player off his team.

President Curly Byrd brought him back.

Bear Bryant packed up and drove away. He would run his program his way, or he would leave. It was not up for discussion or debate. Bryant was defiant and obsessive about football. He was strong-willed and stubborn. He smoked too much and drank too much and could put the fear of God in a player's soul with nothing more than a sharp look or a cutting word.

He did not tolerate mistakes, mental or otherwise. He did not tolerate President Curly Byrd.

One year. One solid record. And Bear Bryant was on the streets, out of work, out of coaching, and one paycheck away from being broke.

He did not stay that way for long.

Almost immediately, a telegram came from Kentucky. The Wildcats just happened to be in the market for a new football coach. Would the honorable Paul "Bear" Bryant be interested?

He headed straight for Lexington and promised a "fire and brimstone style of play on the football field." He delivered. In eight seasons, Bryant won sixty games, earned invitations to four bowl games, won an SEC Conference championship, and, in the Sugar Bowl, engineered an upset of the powerful Oklahoma Sooners, ranked as the nation's number one team.

When famed Kentucky quarterback George Blanda saw him for the first time, he thought, "This must be what God looks like. He'd walk into the room and you wanted to stand and applaud."

Paul "Bear" Bryant might have stayed at Kentucky for an even longer time if he hadn't gotten into a power struggle with the legendary basketball coach, Adolph Rupp.

Bear always wanted the power. He never minded the struggle. Or, the odds. He could beat the odds.

Adolph Rupp, rightly so, wanted basketball to reign, as it always had, as the number one sport in Kentucky.

Bryant, rightly so, wanted football to occupy the top spot.

The two men may have respected each other. They certainly did not like each other.

Bryant was told privately that the basketball coach would possibly be released from his contract. According to a barrel of rumors floating about the land, the basketball program might be involved in a few NCAA rules violations.

Then came the word. Rupp had received an extension. He wasn't going anywhere.

Adolph Rupp won a conference championship and was given a Cadillac.

Bear Bryant won a conference championship and was given a cigarette lighter.

He lit a cigarette, but it had lost its taste.

To hell with Kentucky, he thought.

He carried hell with him to Texas A&M.

The Aggie football program had fallen into the dust of mediocrity. It had a few promising football

players but no direction – a team that had not stumbled across its heart, a bunch of good old boys, at least the older ones anyway, who had grown far too accustomed to losing.

For them all, life would never be the same again.

Bear Bryant loaded the team on three busses – a hundred and three players of all shapes, sizes, and ages – and hauled them out to a Godforsaken little patch of Texas desert near the town of Junction. They practiced in cactus, sandspurs, goathead thorns, and stifling heat. In the fierce heat and fevered heat of battle, Bryant found a bunch who would one day form the backbone of his Aggie football team.

He came back with the survivors. Some couldn't take the heat, the pain, the brutal practices, the dust that caked their dry throats, or the man who drove them to the outer edge of their limits, then pushed them one step beyond.

The Aggies had gone to Junction in three busses. They came home in one. Only twenty-seven boys – lean, haggard, beaten, and battered – were still on the team. The others had skulked away in the heat of August and in the dead of night. Bear Bryant did not miss them. As he told his team, "In life, you'll have your back up against the wall many times. You might as well get used to it."

In 1954, Bryant had his only losing season as a head football coach. His Aggies won one game. But the future had been built upon the goathead thorns of Junction. Two years later, Texas A&M won the conference championship. In 1957, his running back, John David Crow, would be awarded the Heisman Trophy. The Aggies had risen to become a formidable power in the Southwest. They bore the unmistakable brand of Bear Bryant.

But, far away, he heard a faint voice. Mama was calling.

On Tuesday before the Thanksgiving Day game with Texas, Bryant drove around campus with NBC's television broadcaster, Mel Allen. The Bear was perplexed. He had an offer to return to Alabama, but he had not yet made up his mind. He felt a strong and undying attachment to Texas A&M. The team was molded in his own image.

But mama was calling, and her voice was louder now. He told Allen, "I'll feel bad no matter what decision I make. I hate to let anybody down."

"Well, Paul," Mel Allen replied, "it seems to me that what Alabama's doing is asking you to come home. You may never get the chance again."

This time, the power struggle was within his own heart. Twice earlier, Alabama had offered Bear Bryant the coaching job. Twice earlier, he had refused.

To accept, he knew, meant that he would be replacing Hank Crisp as athletic director as well. He could not tolerate any level of authority standing between himself and the president of the university. Yet, Crisp was the old assistant Alabama coach who had once recruited Bryant, driven him from Arkansas to Tuscaloosa for the first time, and made sure he always had a few dollar bills in his pocket when he was broke. Crisp was like a father to him, and Bryant would never be able to look at himself in the mirror if he thought he was guilty of hurting the man who had been his coach, his mentor, his friend.

Now, Hank Crisp was sitting across the table from Bryant at the Shamrock Hilton Hotel in Houston. "Bear," he said as he grew serious, "get your ass to Tuscaloosa where you belong so we can start winning some football games."

Crisp said he had been given a new job at the university. Crisp was fine with the transition. He was not hurting. He never had been. He had brought the torch with him, and the torch was being passed.

Bryant would tell Mickey Herskowitz of *The Houston Post*: "When you were out playing as a kid, say you heard your mother call you. If you thought she just wanted you to do some chores, or come in for supper, you might not answer her. But if you thought she needed you, you'd be there in a hurry."

Alabama needed him.

A few weeks later, he loaded his wife Mary Harmon, his son Paul Jr., and a crippled old dachshund named Doc into a white Cadillac, left Texas in his rearview mirror, and struck out for Tuscaloosa. Paul "Bear" Bryant, at long last, was homeward bound.

*If you believe in yourself and have dedication and pride – and never quit – you'll be a winner. The price of victory is high, but so are the rewards.*

—<> Paul "Bear" Bryant

The Year: 1960

## The Moment:
# The Comeback in Atlanta

Paul Bryant had been disappointed. No.

He was outraged.

And it was never good when the Bear was discontented or upset.

He stood rigidly on the sidelines, ramrod straight, and, for the first time, watched his Alabama football team walk, jog, and stumble out of the dressing room. He did not like what he saw. As he would say, "The team I inherited was a fat, raggedy bunch."

That would change.

There was no Junction in Alabama. The Bear didn't need one. The practice field in Tuscaloosa, was as hot, even more humid, and the ground, chewed with cleats, just as hard, even it was devoid of rocks, cactus, and goathead thorns. He could be just as heartless, as ruthless, as regimented, if players were

to be believed, on the mezzanine floor of a grand hotel. And he began the slow, grueling process of turning boys into men. He had a few athletes. But as he said, far too often "the best players, the ones with ability, quit us."

He wanted them to quit now. Not on the goal line. Not in the fourth quarter. Not with time running out. Never when the pride of Alabama was at stake.

The Bear told them, "I don't care who you are, where you come from, whether you played last year or not. I don't care if your folks are rich or whether they don't own the farm they live on. I want people who want to win and who want to be part of the tradition of Alabama football."

Those words had been spoken three years ago, and they were chiseled into the heart of every player.

Now the Bear and his Alabama team were gathered deep in the heart of enemy territory, huddled on Georgia Tech's Grant Field, and the day was taking a heavy toll.

The Yellow Jackets were heavily favored. That did not bother the Bear.

He had already beaten Georgia Tech twice since

his return to Alabama. The year before, Bryant had beaten Auburn, and Alabama had gone to a bowl game for the first time in six seasons. The tunnel did indeed have a light at the far end. But that was then. The Bear was worried about now.

Outwardly, in a voice laden with wet gravel, he had said that he didn't think the Crimson Tide had a chance. Inwardly, the Bear believed that the Crimson Tide always had a chance.

He glanced at the scoreboard.

Tech led, 15-0, Alabama had not yet set foot on Tech's side of the fifty-yard line, and the second half was just beginning.

Today, the Bear knew, he would find out what kind of mettle his Alabama team really had. It would be easy to scrap a little, give out a few bumps, absorb a few bruises, take a beating like a man, go home, and try to get ready for the next game.

Bryant wasn't concerned with the next game.

The sun had risen on this day. It would fall on this day. The next thirty minutes of football was the length of life. His face was calm, even placid. The anger down deep in his gut was nearing the boiling point. Disappointment hung in his throat like a chicken bone at Sunday dinner.

He waited for Alabama to explode. Or implode.

He kept waiting.

And the embers in Alabama's belly caught fire. After a bad Tech punt, Alabama went to work from the Yellow Jacket forty-nine yard line. Ten plays later, staring fourth down squarely in his face, Leon Fuller crashed over for the final yard, and the Tide was on the scoreboard.

Was it too little? Too late?

Alabama wasn't through.

With Mike Fracchia driving up the gut, time and again, and Bobby Skelton racing wide, always reaching the corner first and fastest, Tech tightened up its defense, filling every crack in the line with helmets and muscle. Tech dared Alabama to throw the ball.

Skelton obliged. He passed twenty-eight yards to Jerry Spruiell, then tossed eight yards to Norbie Ronsonet for the touchdown, and the Tide only trailed by two, 15-13.

Thank God for Bobby Skelton, Bryant thought.

The boy had taken such a sudden dislike for football when the Bear arrived on campus that he left school. Too hard? Too tough? Too disciplined? It was all new to Skelton. But lost in the shadows, far from the Saturday crowds, he had a sudden change of heart. Maybe football wasn't so bad after all.

The Bear had made him pay a heavy price. No pity. No slack. But Bobby Skelton was back, tough as nails, as durable as rawhide. Tech tried desperately to stop him and failed miserably.

Alabama, however, was no longer fighting Georgia Tech. Alabama was fighting the clock. It could keep Tech from moving. There was no defense against the clock.

With a scant 3:31 remaining in the fourth quarter, Alabama began its last march, with Fuller doing the damage on the ground, and Skelton firing bullets overhead. It took twelve plays. After a twenty-six yard pass from Skelton to halfback Butch Wilson, the Tide found itself camping on the eight-yard line.

Tick.

Tock.

No time-outs were left. Only seconds remained on the clock. Richard O'Dell had never before kicked a field goal in college. But the game was on his shoulders. Or rather, it rested with his foot.

The kick was high. It wobbled. It drifted aimlessly like a misplaced dove in the face of a strong wind.

It might as well have been a rifle shot.

One newspaper reported, "It was a strange, unreal sort of game. Tech ran the joint in the first half. Alabama was arrogant and dominated the second half. All Georgia Tech could do was retreat. Then O'Dell kicked Tech into the darkest recesses of hell."

Said Bob Kyle, writing in *The Birmingham News*: "No blood was spilled, no cannons roared, no tears were shed. But you can bet your bottom dollar no louder rebel yells were ever echoed through these beautiful foothills of the Blue Ridge Mountains than broke loose when Alabama pulled this one out in the last second."

> *Coach Bryant pays me to have players on the practice field — not in the training room feeling sorry for themselves.*
>
> <-- Trainer Jim Goostree

The Year: 1960

## The Moment:
# A Fight Among Kinfolks

The tenacity of the battle was not unexpected. Alabama and Auburn were on the field. Face to face. Eyeball to eyeball. Pain was not an option. Blood would be spilled before the day ended. It was a game that could have just as well been played with jackhammers, axe handles, chain saws, and maybe even pitchforks.

All year, Alabama had run a sold 6-3 defense.

Auburn prepared to attack the 6-3 defense.

All day, Paul "Bear" Bryant kept running a 4-4 and 5-3 defense.

The change confused, bewitched, and bewildered Auburn's offense.

In the first half, both teams rolled up their sleeves, crawled down low in the dirt, and slugged it out on the ground. Yards were tough to earn. Points were impossible. Draw a line in the dirt and see who crossed it first. No one did.

Alabama had two chances to score.

It would take only one.

In the first quarter, Tommy Brooker hobbled out on the field and missed a thirty-three-yard field goal. He had been out of the lineup for weeks with a severely injured knee.

Just being able to walk without dragging a bad leg behind him was a test of fortitude and courage.

He hadn't known if he would play. Tommy Brooker wasn't even wearing shoulder pads.

In the midst of the second quarter, he had his last and final chance.

It was a twenty-three yarder fired straight.

And true.

Alabama desperately held on to a 3-0 lead.

Bear Bryant knew it wouldn't last. Bear Bryant was seldom wrong.

This time, he was.

When the second thirty minutes of play began, Auburn had a surprise of its own. The game plan abruptly changed. The Tigers swaggered out, the quarterback unlimbered his passing arm, and he put the ball in the air.

Why not?

Auburn had been averaging more than two hundred and seventy yards a game with its passing attack, and Alabama had not given its running backs an inch of hard ground. The quarterback readied himself

to tear off huge chunks of yardage in the air.

It was a daring tactic. It backfired.

Alabama's Lee Roy Jordan, Leon Fuller, and Bobby Skelton each picked off a pass, adding insult to injury, and *Tuscaloosa News* sportswriter Charles Land wrote, "Most of the day, the Tigers tasted their own medicine. It wasn't pleasant."

The Tide finished with only three points. Three points were enough.

Bryant told the press, "Jerry Claiborne (Tide assistant head coach) kept telling me all along that if we didn't give them anything, they wouldn't score. Now, I respect Jerry's opinion as much as anybody in the country, but I just didn't believe we could keep Auburn from scoring."

Alabama did not make mistakes, none that were critical anyway.

Auburn did not catch a break. Alabama did not give them one.

The Bear went back into the past, his own past as a player, and dusted off the old quick kick. Lord, how he loved the quick kick. He used it twice. He kept the Tigers tied down, buckled up, and penned deep. A long field was simply too far to go. Fifty yards would take a train, and Alabama had torn up the track. Said quarterback Pat Trammell of his offensive line, "They weren't blocking anyone, so we thought we'd see if they could play defense."

On the bench, the renowned Auburn placekicker, Ed Dyas, kept waiting for a chance to tie the game, maybe even win it, but Auburn needed to get closer. Auburn never did.

Bob Kyle of *The Birmingham News* wrote: "There never was a fight harder than a kinfolks fight. It took a stout heart to stand the pressure. They fought each other like hungry hounds battling over a squirrel hide."

Alabama left the Iron Bowl with the hide.

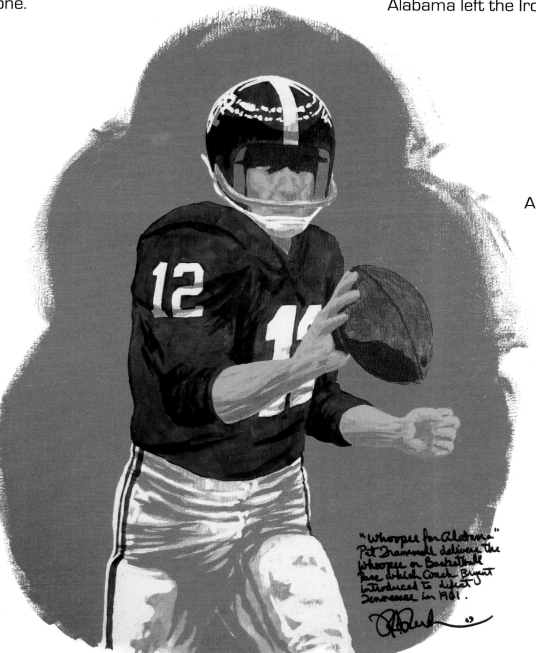

## PAT TRAMMEL

### All He Could Do Was Beat You

> *I said early in the season that they were the nicest, even the sissiest, bunch I ever had. I think they read it because later on they got unfriendly.*

<div align="right">

⟨⟩ Paul "Bear" Bryant on his 1961 team

</div>

The Year: 1961

## The Moment:
# The Basketball Pass

Paul "Bear" Bryant had always respected but never feared Tennessee.

His respect went far deeper than a football game.

He abhorred the thought of playing any team associated with the venerable Bob Neyland, and, as he looked across the field, he saw the general staring back at him.

Two men at a poker table.

Both with winning hands.

Both ready to raise the stakes.

Each waiting for the other to fold.

Bear Bryant and Bob Neyland were too stubborn to ever throw their hands away.

They always wanted to see the last card dealt them.

Sometimes, it just took one.

On a football field, both men were innovators. General Neyland, it was reported, became the first coach in America to use sideline telephones and study game films in an effort to find and exploit an opponent's weakness.

He believed in speed, rather than strength, and ran out teams wearing lighter pads and tear-away jerseys.

You don't have to necessarily plow over anybody, he said. Just run past, around, or away from them.

It was the gospel, according to Bob Neyland.

Bear Bryant had a few tricks of his own.

Before the game, Bear Bryant walked into the hotel dining room, shoved the tables aside, and locked the door.

A hush fell.

Players held their collective breaths.

Hell had no fury like Bear Bryant on the loose with a burr under his saddle.

For the next few minutes, he had his linebackers practice throwing little Billy Richardson high into the air like a "human projectile."

Why?

Alabama might need to block a field goal, he said.

Tennessee did have an awfully good placekicker.

But could he kick the ball higher than the out-stretched arms of a human projectile?

The practice went for naught.

During the first few minutes of the game, Tennessee sophomore placekicker nailed a fifty-three-yard field goal, the longest ever kicked in the history of the Southeastern Conference.

The linebackers threw little Billy Richardson high, but not nearly high enough.

Nor early enough.

The Volunteers led 3-0.

They might as well have gone home.

Tennessee struck first blood.

Then the bleeding stopped.

Assistant coach Howard Schnellenberger had scouted the Volunteers, and he told Bryant, "The best way to move against Tennessee is to use something they haven't seen before. Their coaches work real hard on play recognition."

Bear Bryant nodded.

He would give Tennessee something new, something that neither its coaches nor his players could recognize until it was too late.

It would be a different wrinkle, right out of the blue, puzzling and unexpected.

Neyland had no doubt been up at night, studying game film, and, by now, the General probably thought he knew which play Alabama would be running just by the way his players stood, lined up, breathed, squinted, or spit.

Bear Bryant installed the "basketball pass."

It wasn't new.

Washington and Jefferson University, up in Pennsylvania, had unveiled it back in 1914 in an encounter against Oregon.

It had worked then.

It just might work now, the Bear thought, provided that Bob Neyland didn't know a lot about good old Washington and Jefferson, or much of anything that happened on a football field in 1914.

He probably did,

But maybe, just maybe, the general, in all of his wisdom, had forgotten.

Quarterback Pat Trammell realized that the Tennessee line would come charging hard, full bore, eyes blazing, backs bowed, and bellies low to the ground, swarming so close he would be able to tell who had bathed, who hadn't, and who had eaten onions with their eggs for breakfast.

He grinned.

He couldn't wait.

Pat Trammell took the snap and dropped back to pass, as he always did.

The mad rush closed around him like a chain link noose drawing tighter with each step.

The high.

And the mighty.

Alabama's halfback on the far side spun and cut from the slot, running laterally close to the line.

He edged past the center.

Trammell kept waiting.

He kept looking downfield.

Tennessee was all over him.

He suddenly brought his arm down and pitched to the halfback, threading the ball though the flailing arms of Tennessee's defensive line.

The Volunteers never glimpsed the ball. Their eyes were blinded by their fierce and relentless desire to bury Pat Trammell either deep or shallow in the Birmingham dirt.

The halfback cut back behind the block of All-American tackle Billy Neighbors and broke into the open. As Trammell said, "The beauty of the pass is that linemen can go down and hit the secondary quickly."

The play unfolded slowly.

It struck quickly.

It struck like a dagger.

Alabama backs were running free all day on the one play Tennessee did not and could not recognize.

The Tide raced away with a 34-3 victory, and the press was quick to give credit to a brand new innovation from the mind of Paul Bryant called the "basketball pass."

The Bear frowned. He had no idea what they were talking about. He called it the "whoopee pass."

*They play like it's a sin to give up a point.*

⤝ Paul "Bear" Bryant, discussing his 1962 Sugar Bowl team

The Year: 1962

## The Moment:
# Back to Glory

The rain and mist fell like a gray funeral shroud and draped itself around the backwater bayous edging against the marshlands just beyond New Orleans.

The weather was bad. And growing worse.

Paul "Bear" Bryant was becoming more intolerant by the day.

Intolerant of the rain.

The bad luck.

And Arkansas, particularly Arkansas.

The Crimson Tide had rolled through the 1961 season without a loss. It had taken four years for Bryant to climb the mountain, but Alabama was back where it belonged.

On top.

The Tide was one win away from a possible national championship. Only Arkansas and the Sugar Bowl stood in its way.

And, of course, the rain. In a big game, the rain could be a killer.

Bryant fretted and fumed.

Practice was virtually worthless.

Too much slipping.

Too much sliding.

Never enough traction.

And the ball was as tough to grasp as a handful of hog lard.

"You can't build up momentum in a hotel room," he said.

Before the game, he had met with Arkansas Coach Frank Broyles. The two men were enemies for a day. They would be friends for a lifetime.

"Bear," Broyles asked, "how old were you when your Kentucky team upset Oklahoma when it was the number-one team in the nation?"

"Thirty-seven."

Frank Broyles grinned.

"Why?" Bryant asked.

"Well," the Arkansas coach answered, "I hope that's an omen. You're the number one team in the land. And I'm thirty-seven."

He laughed. The Bear didn't.

During an Arkansas practice, the great LSU running back Billy Cannon drove across the bridge from Baton Rouge and asked a Razorback player, "Have you boys ever played a Bear Bryant team?"

"No, we haven't," came the reply.

A flicker of amusement etched its way into Cannon's eyes. He shook his head. "Then you're in for a real experience," he said.

Bryant's players already knew about the experience. They had suffered through the experience.

When the Bear first met with his team, when he and his demanding ways were still unknown and mostly a myth, he looked at his team – his eyes meeting theirs in an ominous stare – and he told them:

"Look around at the guys sitting next to you. Chances are, four years from now, there's probably going to be no more than a a double handful of you left. But if you work hard and do things I ask you to do, you can be national champions by the time you are seniors."

Alabama was on its way.

Bryant had his team in the Sugar Bowl.

He had not yet reached the top.

He had it dead in his sights.

The day was frigid for New Orleans, even for January. Temperatures dipped to the low side of forty, and it was a wet cold, a numbing cold. It seeped into the bones.

The first time Alabama touched the ball, the Crimson Tide marched methodically for seventy yards.

Mike Fracchia, who ran, so one sportswriter said, "like he had steel in his legs and fire in his eyes," rambled for forty-three yards, and quarterback Pat Trammel weaved his way into the end zone from the twelve-yard line.

Bear Bryant said of his quarterback after the game, "Pat wasn't fancy or anything, but I'll take him in the clutch when the ball game is on the line."

With the first half winding down, Tim Davis booted a thirty-three-yard field goal, and Alabama forged ahead, 10-0.

The offense had done its work.

Alabama had the lead.

The defense had only one challenge.

Hold it.

Arkansas did manage a field goal, after missing one and having another blocked by Billy Richardson, but the Crimson Tide defense, according to Frank Broyles, was too quick and too aggressive.

Lee Roy Jordan played like the cowboy who jumped on his horse and rode off in all directions at once.

He left footprints all over the field. He had shoved his motor into a higher gear, rammed the accelerator to the floor, and never touched the brakes.

Wherever an Arkansas player happened to be, he would look up and be staring into the stone face of Lee Roy Jordan. The hit was only a second away, and it was like a man being knocked out of his shoes by a runaway freight train.

Butch Wilson, who had earlier been victimized and charged with a critical thirty-seven-yard pass interference penalty, intercepted an Arkansas strike at the Alabama goal line with ninety seconds hanging in the balance.

He had his redemption.

He had the ball.

Pat Trammel carried twice more for a yard.

He was simply killing time.

He knelt before third down and watched the final seconds tick off the clock.

Said Bryant, "I was as happy as if the score had been a hundred to nothing. Our kids rose up in clutch situations. They did what they did all season long. They did what they had to do to win."

Mickey Herskowitz wrote in *The Houston Post*: "That's exactly the way Bear Bryant loves to win, by scoring early, then daring the other team to cross the goal line. No one has done that since Vanderbilt on the second Saturday of October, seven games and twenty-nine quarters ago. The Red Elephants played defense as if their next meal depended on it."

Just before the kickoff, alone and within the sanctity of the locker room, Frank Broyles had prayed, "Lord, if you can't help me today, please don't help the Bear."

The Lord stayed neutral.

Broyles was thirty-seven years old. He thought he might have an outside chance to upset the number one team in the country. After all, that was the Bear's age when he did it.

But when it was all said and done, when the final whistle had blown, when the lights had dimmed and then darkened upon the Sugar Bowl, about all Broyles had left to brag about was being thirty-seven years old.

It wasn't much of a consolation.

*Our job was to get a good recruit on campus. That's all it took. The Bear would figure out a way to keep him there.*

⤙ Clem Gryska, assistant coach

The Year: 1963

## The Moment:
# Fighting Back

Howard Schnellenberger glanced at the young man from Beaver Falls, Pennsylvania, and the Alabama assistant coach knew he was looking into the face of a rebel who may or may not have had a cause. He was definitely a rebel.

Joe Namath was wearing a checkered sports coat, a pocket watch and chain. He had long hair in an era when most players wore crew cuts or flat tops. His quiet smile – or maybe it was a sneer – had once graced the faces of James Dean and Elvis Presley.

"He looked like a street hustler," Schnellenberger said, "But he could flat throw a football. and Bear Bryant wanted him."

The University of Maryland was knocking on Joe Namath's door and Howard Schnellengerber knew he had to smuggle the quarterback out of Pennsylvania regardless of the cost. He said, "I'd rather face charges for a hot check than go back and face Coach Bryant without Joe Namath." He was out of money, so he wrote a hot check for plane fare to Birmingham. When they missed their plane in Atlanta, he wrote another hot check to pay for a hotel room.

Schnellenberger was taking no chances. He brought Joe Namath to Tuscaloosa. The bad boy with the golden arm, for better or worse, was in the Bear's hands now.

The Tide was struggling in a game it was not supposed to lose. Mississippi State had roared to a 12-3 lead, and Bryant gave the football to Namath. Win or lose, it all belonged to him, which was pretty much the way Namath wanted it.

With time being exorcised off the clock during the first half, Namath struck back with a forty-yard touchdown pass to Jimmy Dill, then led Alabama back downfield for a Tim Davis field goal with twenty-three seconds left  Alabama had regained the lead, but glory was short-lived. The Bulldogs stormed ahead 19-13.  But in the final stanza, Namath stared defeat in the face, sneered, stuffed his long hair in his helmet and fought his way into the end zone. The extra point from Davis was automatic, and Alabama had survived a post-Halloween, November fright, 20-19.

In the locker room, Bear Bryant did not mince words. He told the press, "Joe called the play that went for the touchdown. I called the other one."

"Which one?"

"My play," the Bear said, "lost fourteen yards."

The bad boy had been awfully good.

*To play linebacker, you've got to have that sixth sense. Lee Roy Jordan had that sixth sense and no fear.*

<~> Darwin Holt, Alabama Linebacker

The Year: 1963

## The Moment:
# Clash of the Titans

It was a study in styles, a contrast of personalities. "Paul 'Bear' Bryant," UPI sportswriter Oscar Fraley penned, "lives up to his nickname. He is a burly, craggy man with a vitriolic tongue who looks as if he could bite a nail in half. Don't bet against it either."

Oklahoma's Bud Wilkinson, said Fraley, "is an aesthetic appearing Lochinvar with wide-spaced blue eyes whose most explosive expletive is 'gee whiz.'"

When Wilkinson commented on a player, he said something like, "He is an exceptionally fine young man."

When the Bear was asked about a player, any player, he usually replied by growling, "Well, he's nice to his momma and pappa."

Wilkinson's players would die for him.

Said Fraley, "Bryant's players might have to."

But both men were winners.

Big winners.

Bear Bryant had been coaching for thirteen years, and he had a hundred and thirty wins under his belt. Wilkinson had been running the Oklahoma football program for three years more and had one more win. No one had ever forgotten that, back during the 1950s, he had guided the Sooners to forty-seven consecutive victories. Over the years, he had become the face of Oklahoma, the university and the state. He was as big as the legend.

On a warm Miami night in 1963, however, with the Orange Bowl at stake, Bear Bryant was quick to mention that neither he nor Wilkinson had suited up for the game. They would not be playing each other. "I may make a few calls," the Bear said, "but the quarterback makes most of them. His usually work better than mine."

As Oscar Fraley wrote, "Nobody wins without the horses. You got 'em, you run. Don't get 'em, and you stay home. Bryant and Wilkinson's got 'em."

President John F. Kennedy flew unexpectedly into Miami. Surrounded with the proper amount of pomp and more than a little circumstance, he conducted the coin toss before the game, and he took his rightful seat among the Oklahoma faithful. Bud Wilkinson had been named chief consultant for the president's national physical fitness program, and JFK had come to support his man. Since his man had a team on the field, he would cheer for Oklahoma as well.

No Place To Run Or Hide

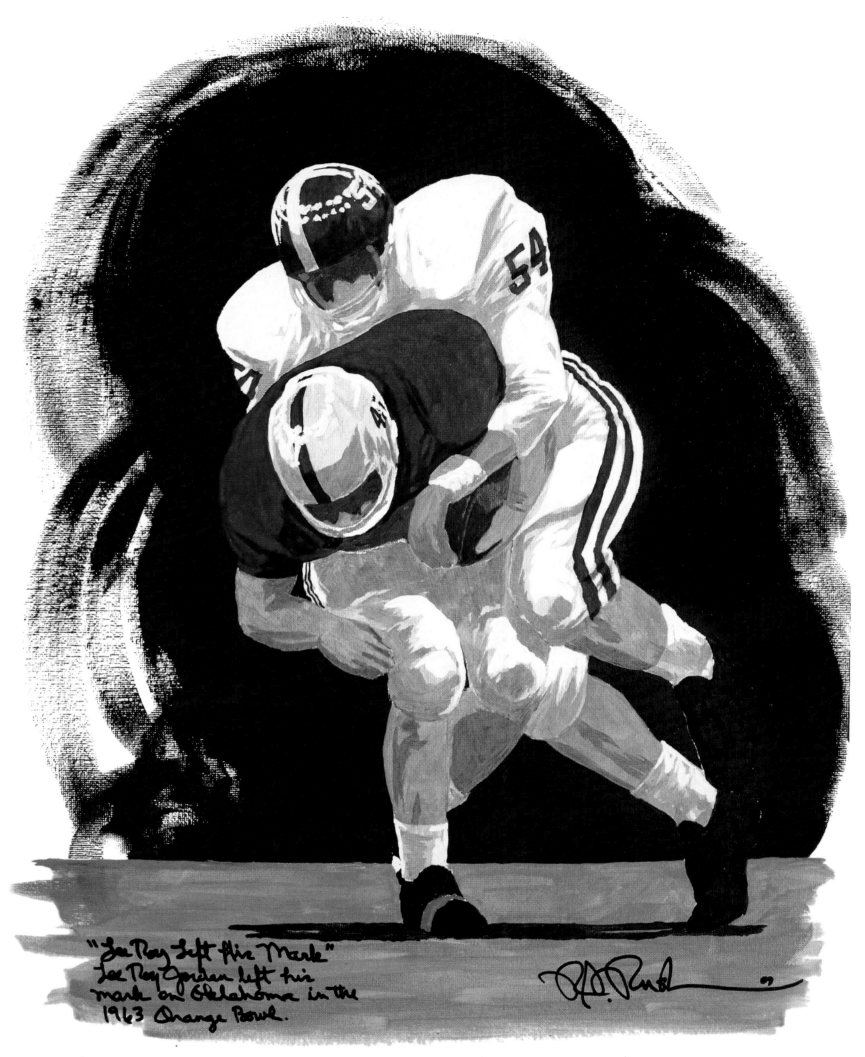

"Lee Roy Left His Mark"
Lee Roy Jordan left his
mark on Oklahoma in the
1963 Orange Bowl.

## LEE ROY JORDAN

No Place To Run Or Hide

Bear Bryant didn't miss a chance. He glowered. His eyes raged. He gathered his team around him and said, "I guess you know that the whole world's against you tonight. Even the President of the United States is sitting on the wrong side of the field. He's sitting with Oklahoma."

Bear grinned to himself. He did not need the President.

He had the horses.

Oklahoma's horses may have been physically fit. They never left the barn.

Running the Crimson Tide attack was Joe Namath, a lanky, cocksure Yankee from up in Pennsylvania – arrogant, brash, a swashbuckler.

He could easily have been one of the three musketeers if he hadn't had to bother with the other two. Bryant would say of him, "He's the greatest athlete I ever coached."

Joe Namath never believed he was in danger of losing a game. He might be a touchdown or more behind, but he always knew down deep: "Once I get the football in my hands, it will be a different story."

He could beat a team pretty.

Or ugly.

It didn't matter. He knew how to win.

Even back in high school, he took a bone-crunching hit one night and crawled back to his feet with a shoulder dangling awkwardly at his side.

It was nothing, he said.

Just a dislocated shoulder.

He would be fine.

Joe Namath refused to leave the field, stayed in the game, kept the ball in his hands, and threw two more touchdown passes.

Bud Wilkinson and Oklahoma had seen a lot of great players in their time.

They had never seen the likes of Joe Namath. He threw one touchdown pass to Richard Williamson, then pitched to Cotton Clark who swept left end and bolted fifteen yards into the end zone.

A field goal gave Alabama a 17-0 victory as a vicious defense, led by Lee Roy Jordan, hammered Oklahoma into submission.

As assistant coach Clem Gryska said, "When Lee Roy made a hit, it just sounded different. He hit through people."

Jimmy Burns wrote in *The Miami Herald*: "They should put markers all over the Orange Bowl field, reading 'Lee Roy was here.' Only an octopus using all of his tentacles could make more tackles than Lee Roy Jordan."

Said Bryant, "If they stay between the sidelines, old Lee Roy will get 'em."

The Sooners made a terrible mistake.

They stayed in the playing field.

They met Mister Jordan.

They met him more than once.

They met him under the worst of circumstances.

They had the ball.

He wanted it. It was tough to say no.

When he couldn't take the ball, he walked away with their heads. At least, that's the way it felt when they were conscious enough to feel anything at all.

Every chance he got, the Bear, who had never been afraid to break or at least tamper with age-old traditions, kept pushing Lee Roy Jordan for the Heisman Trophy.

"But Coach," he was told, "an interior lineman has never won the Heisman Trophy."

"You're right," the Bear said softly, "but there has never been a Jordan before."

Bear Bryant had once upset Wilkinson and Oklahoma in the Sugar Bowl.

He had changed cities. And bowls

The Bear did it again.

President Kennedy had ventured into Miami to watch Bud Wilkinson's horses get left at the gate.

Gil Brandt of the Dallas Cowboys, on the other hand, had come to see Mister Jordan.

After the game, rumors began to circulate throughout the stadium, the locker room, Miami, and the whole of Alabama.

Gil Brandt was prepared to offer Lee Roy Jordan a bonus of fifteen thousand dollars to play for the Cowboys.

No one could believe it. Lee Roy was rich.

> *I can reach a kid who doesn't have any ability as long as he doesn't know it.*
>
> — Paul "Bear" Bryant

The Year: 1964

## The Moment:
# The Unexpected

Nothing felt right.

The Sugar Bowl certainly didn't.

On the final December day of 1963, Paul "Bear" Bryant and his Alabama team trudged toward the field, kicking their way through patches of ice that lined the streets of the Big Easy. A light snow was falling upon their shoulders, leaving New Orleans trapped in the bitter grasp of a winter storm.

A tarpaulin covered the field. That would be fine if the snow stopped.

The snow looked as if it had no intention of slacking off.

The weather was bad enough.

But Alabama would be going into the game against Mississippi with a new quarterback, and the whispers ricocheting throughout the stadium had become as loud as a shout:

*Where was Joe?*

The faithful looked.

They could not find him.

Joe Namath was missing in action.

Then the words began to drizzle among the faithful like a cold rain striking them in the face with the like sheets of numbing ice.

Namath had broken a training rule.

The Bear wasn't saying which rule.

He never did.

He simply suspended Joe Namath, saying, "Son, if you come back and work hard enough , we'll see what happens."

Bear Bryant might or might not win without his star. Regardless, he had no regrets.

The Bear built Alabama as a team.

Stars came and went like the night when daylight cleared them from the sky.

A team, however, was his bedrock.

He would do nothing to crack his bedrock.

Two Alabama players lay awake on the night before a new year, burdened by the sudden realization that they were being thrown into the great unknown.

Tim Davis was the placekicker.

And he wondered if the field would be wet, or dry, covered with ice, littered by patches of snow, crusted over, or a quagmire of mud.

A slippery football.

A false step.

Loose footing.

It was a recipe for disaster.

Before rolling into New Orleans, he had practiced until his leg grew weary, then he didn't kick again.

The days passed slowly by.

He would not put a ball on the tee.

He was saving himself for the game.

The Bear might need him.

Then again, he might not.

Tim Davis locked his mind on the crossbar.

Don't worry about the distance.

Keep your head down and kick.

He had never kept his head down and stared into a carpet of snow.

His leg was loose. A kicker's mind was always loose.

Steve Sloan was a smart, savvy quarterback, a gifted passer, a quick study, a young man who knew how to run the Alabama offense.

All he needed was a chance.

Joe Namath had been a gambler.

He shot from the hip.

He shot on the run.

He never shot in self defense.

Steve Sloan played a steady hand.

He kept the odds in his favor.

He was poised under pressure.

He threw a tight spiral.

Sloan's passes were as precise as a surgeon's scalpel.

He did not doubt his ability.

But he knew when he stepped onto the Sugar Bowl field to confront the Rebels of Mississippi, regardless of the weather, the giant, ominous shadow of Joe Namath would be hovering over and around him like a gathering storm.

Steve Sloan had not yet turned twenty years old.

But today was his day.

It belonged to him.

It belonged to Tim Davis.

And to a frightful Crimson Tide defense that ran roughshod over Mississippi like an avalanche on a downhill run, knocking down nine passes, intercepting one, and falling on six Rebel fumbles.

The defense was outweighed twenty pounds a man, and Mississippi had swaggered defiantly into the Sugar Bowl undefeated.

They would not leave that way.

The rugged, unflinching rock wall of the Crimson Tide gave ground grudgingly if or when at all.

The staggered Rebels managed to snatch a hundred and seventy-one yards through the air, most of it while playing catch-up, but only a scant seventy-seven yards on the ground.

And Sloan did make one mistake.

It cost him.

It cost the Crimson Tide a touchdown.

It was the first, last, and only Rebel score of a cold, damp afternoon.

One mistake was enough.

He did not make another.

Steve Sloan kept driving Alabama close, running when he had to, passing when he needed to and the routes were open, plugging away, a yard at a time.

Cool and steady.

He was patient, never greedy, never reckless, never ambitious, never had any reason to be.

He had the one weapon that Mississippi did not possess.

He had Tim Davis.

The former quarterback from Tifton, Georgia, the young man who had torn his knee so badly in high school that he was forced to give up football, calmly lined up five field goals.

The field was cold.

As hard as a block of ice.

But dry.

His worry had been for naught.

Five field goals.

It was a placekicker's dream.

It was the reason Tim Davis had chosen to play for Alabama and the Bear.

He nailed four of them.

High.

Straight.

And into a bank of snow.

The only miss came from fifty yards.

And Alabama throttled Mississippi, 12-7.

Somewhere, Joe Namath was watching. Bryant wondered if the boy had repented for his sin.

It was all up to Joe.

> *When you make a mistake, admit it, learn from it, and don't repeat it.*
>
> — Paul "Bear" Bryant

The Year: 1965

## The Moment:
## The Longest Yard

Joe Namath was back. Bear Bryant knew he would be.

The boy was a maverick. He marched to the beat of his own drum. He probably owned the drum. But deep within his chest, there lay the heart of a champion. Bear Bryant had heard it beating long ago.

He said, "I always admired Joe for taking his punishment like a man when I had to suspend him. His comeback proved he's a credit to Alabama."

Namath did not complain. He was never bitter.

He simply said, "Rules are rules, and they're not to be broken."

He didn't like the price. But it had to be paid.

There had never been any doubt about Namath's ability. There was never any doubt in Alabama that he was the chosen one. He had charisma. He had style. He was, said Lee Roy Jordan, "the real deal."

From the time Joe Namath drove away from Beaver Falls High School in Pennsylvania, from the time he walked on campus, from the time he first pulled on a Crimson jersey, everyone knew that he was the rightful heir to the quarterback's job.

It was just a matter of time. It took such little time.

Mal Moore, who would one day become athletic director at the University of Alabama, remembered, "I was a backup quarterback to Pat Trammell until my senior year when I had a shot at being the quarterback. I was the starter for about a week until Joe Namath got the snap count down."

Alabama rolled through the 1964 season like a juggernaut with razor blades, running wild but never out of control.

Namath was the triggerman behind a lethal offense, then he went down with a knee injury against North Carolina State.

Lightning had struck him twice.

It was bad both times.

As he had done in the Sugar Bowl, Steve Sloan came trotting off the bench, and all cylinders kept firing. Sloan preserved the victory over North Carolina State and carved out wins over Tennessee, Florida, Mississippi State, and LSU. It had been a punishing and grueling run. Sloan had met the challenge.

Joe Namath did not return until November when he led Alabama past Georgia Tech. The Crimson Tide was undefeated but ensnared in a twisted web that only the national polls could untangle, and they were in awe of Notre Dame. The Fighting Irish was ranked number one. The Fighting Irish stood in the way of a national championship, and there wasn't a thing Ala-

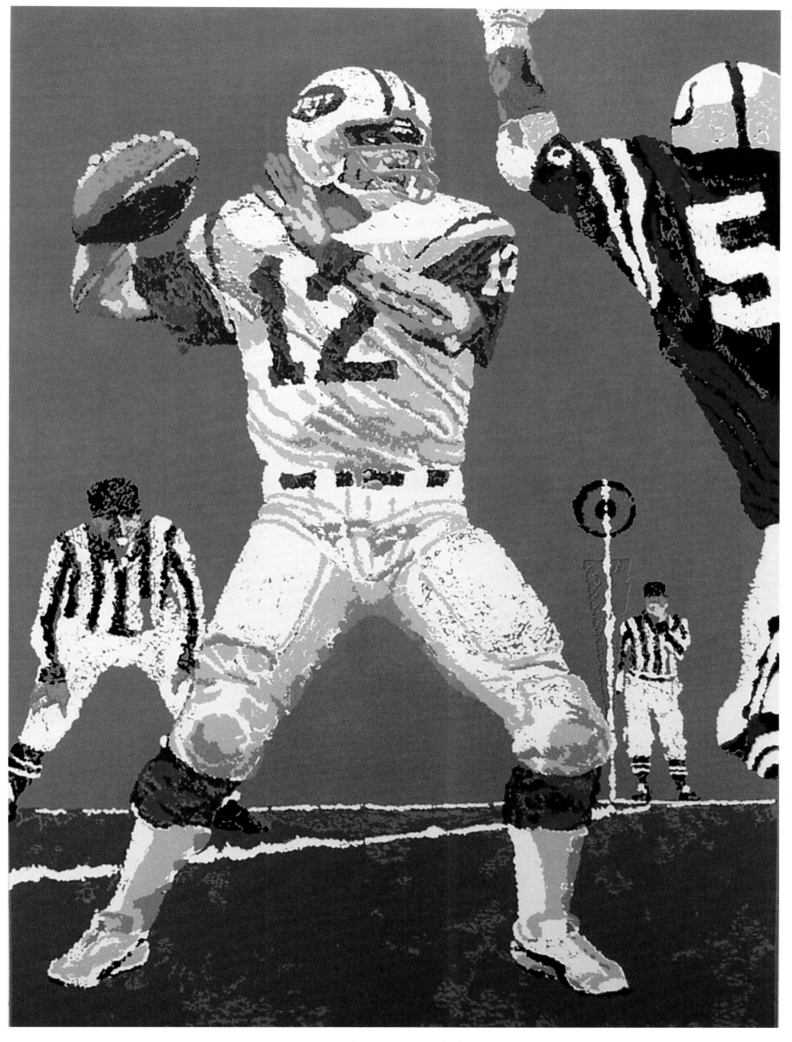

## JOE NAMATH

From Alabama To The New York Jets

bama could do about it. As long as the mystical Notre Dame kept winning, the Tide remained ignored, overlooked, and mostly forgotten.

Alabama dangled in limbo. The Tide might go down, but Bryant's boys would go down clawing, scratching, and fighting.

The Auburn game in 1964 had a familiar yet unsettling resemblance to all wars in the Iron Bowl. It was odd. It was out of the ordinary.

It was littered with unforeseen twists and unpredictable turns of fate.

When Auburn's center snapped the ball over the punter's head, fullback Steve Bowman raced downfield and leaped on the loose ball bouncing crazily through the end zone for a Tide touchdown.

After the Tigers surged on top, 7-6, Alabama's Ray Ogden gathered in the second-half kickoff and tore loose on a weaving, swerving run that carried him a hundred and eight yards for a touchdown.

Namath later hooked up with the sure-handed Ray Perkins for a twenty-three-yard scoring pass, and the Crimson Tide departed Birmingham without a single blemish on its record.

Alabama's fate now lay in the hands of Southern California. The Trojans did not give a damn about Alabama. But USC rose up, dusted off its pride, and took the fight out of the Fighting Irish.

The Bear sat back with a certain degree of satisfaction when word filtered down that the Crimson Tide had once again been crowned national champions. It was a surprise to him, and yet it wasn't totally unexpected.

A pre-season review had said that Alabama was not possessed with a great deal of exceptional talent, but the team did have "great dedication and oneness of purpose."

So it did.

The Orange Bowl should have been anticlimactic. It wasn't.

It was steeped in controversy, consternation, and heartbreak.

Alabama only needed a yard, nothing more, a single yard, thirty-six little inches, against Texas, with time running out and the Longhorns fighting desperately to hold onto a 20-17 lead.

The Bear could have chosen to kick a field goal and go home with the final score knotted at 20-20, but he said, "When you're number one, you don't play for a tie."

The ball on third down went instead to Steve Bowman, a bruising fullback who had led the Southeastern Conference in rushing.

No gain.

It was time for Joe Namath to unlimber his rifle arm and pass. The Texas defense had become as strong as the Rock of Gibraltar. It would be difficult to crack that final yard with a stick of dynamite. Everyone in Miami knew Namath would throw the ball.

He didn't. He kept it, lowered his head, and fought his way forward.

There may have been a crack. If so, it was only a hairline fracture.

A whistle, and the Orange Bowl suddenly lost all sound.

Slowly, the referees began to remove players from a twisted and mangled pile.

Alabama was jubilant. A touchdown.

Texas was jubilant. A stop.

The call – so close, so controversial, so disputable – went the way of the Longhorns.

Namath looked down amidst the chaos that surrounded him. He saw the goal line. His arms were sprawled across it. The ball lay on sacred ground. He was stunned.

Steve Bowman would say, "I didn't think I had scored, but I'll always think Joe did."

And Namath?

He told Bryant, "I'll go to my grave knowing I scored."

After the Orange Bowl, Namath signed a contract for four hundred thousand dollars with the New York Jets. He would become known as "Broadway Joe."

There were days when he would have rather had the last yard, the longest yard, the touchdown that he always said had been taken away from him.

It was a bittersweet time.

*Coach Bryant challenged us just when we needed it.*

<~> Quarterback Steve Sloan

The Year: 1965

## The Moment:
# Only the Strong Endured

It had been hell week. Paul "Bear" Bryant was upset, which meant his team was under the gun, and he was searching for a bunch of good old boys wearing Crimson and White who were strong enough to play Alabama's brand of hardnosed football.

The Tide had lost to Georgia in the season opener, 18-17, on a disputed Bulldog touchdown – everyone knew Pat Hodgson's knees were already on the ground when he pitched the ball for six points with time running down – and the Bear was preparing his troops for a pivotal game with the powerful Mississippi Rebels.It was a game that could re-ignite the Alabama season, or ruin for all time.

The Bear was pushing hard. Practices were grueling. They began long before the crack of dawn, and Bryant kept driving his boys like a team of mules under the relentless crack of a bullwhip.

Some players quit that week. They couldn't take it anymore. That was all right. The Bear would play with the ones rugged enough and hardy enough to wear Crimson.

David Ray would say, "Our practices were tough.

We were scared to death. When we scrimmaged, we were scared because we didn't know how long it was going to last, and sometimes they kept us out there forever."

Alabama had fewer faces and fewer numbers when the Tide ran on the field against Mississippi. But the Bear would tell his players, "You can still win the national championship if you think you can ... unless I have misjudged you."

The Rebels struck for a 9-0 lead at halftime, and after Steve Sloan slashed for  five yards and touchdown, Mississippi came roaring back to score again. The Tide was dangling precariously on the ledge of another loss.

Another loss would be  disaster,  they all  knew it.

The Tide, however, had not yet begun to fight. David Ray banged through a thirty-seven-yard field goal, and Steve Sloan began a methodical eighty-nine-yard, fourth-quarter march that stopped a few hearts and frayed a few nerves along the way.

Three times, he faced fourth down, and three times, he found a way to keep the drive moving. Sloan was known for his accurate passing arm. He won with his feet, racing the final nine yards for the tying touchdown, then watching while David Ray's extra point won it, 17-16.

The search for a title had finally begun in earnest, and those who had endured against all odds stepped up to lead the way.

The Year: 1966

*Coach Bryant's philosophy was built on the idea that if he made things tough on you, it would help you deal with adversity.*

—∽— Steve Bowman, Alabama Fullback

# The Moment:
## Throwing Caution to the Wind

**P**aul "Bear" Bryant won with defense. He always had, and no one disputed it. Give him a stout defense, and he could generally win with whatever offense he happened to put on the field.

That's the way he had played. That's the way he coached. The Bear was having second thoughts.

Alabama in 1965 was once beaten and once tied. Yet, the Crimson Tide still had a chance to win its second straight national championship.

It was a long shot. The Bear didn't dwell on it. But the old football could take some awfully strange bounces, he knew, and there were days when he thought he had seen them all.

Two obstacles rose up defiantly before Alabama:

The 1966 Orange Bowl. And Nebraska.

The Bear did not like the looks of Nebraska. He certainly recognized raw power when he saw it. The

Cornhuskers were much larger than Alabama. Broad shoulders. Thick legs, more like tree trunks wearing cleats. Not very fast, perhaps, but they attacked like a runaway freightliner heading downhill on a narrow and dead-end road.

Teams generally were faced with two choices:

Get run over. Or, get out of the way.

Nebraska was undefeated and roared into the Orange Bowl favored by seventeen points.

No one had yet derailed the Cornhuskers.

No one had even threatened.

On the sidelines, as the clock worked its way toward kickoff, Bryant turned to Steve Sloan, and said, "Son, I want you to throw anytime you want to."

Sloan frowned. Those words, he knew, could not be coming from the gravel throat of Bear Bryant. They disputed everything he believed, and the Bear never wavered or strayed from his core beliefs.

The pass was definitely a weapon.

He had won a lot of games with it.

But Bryant wanted his quarterbacks to throw the ball judiciously and sparingly, never on first down, and hardly ever on third down unless the Tide had stalled

more than a half dozen yards away from the wrong side of a first down.

"You can throw the ball from your own one-yard line or their one-yard line," he said. "We'll have to score more points than we usually do to win this game."

"Why?"

"I don't think we can stop Nebraska."

Before the game, in the Miami press, the rumors were running rampant.

*Bear Bryant had suffered a stroke.*

He hadn't.

*Steve Sloan was injured.*

He wasn't.

*Sloan had already and illegally signed a secret contract to play for the new Atlanta franchise in the National Football League.*

He hadn't.

The odds makers were nervous.

They took the game off the board.

Steve Sloan had been up much of the night, telling reporters, "No, I was not in a car wreck. No. I did not break a leg." Bryant finally cut off all phone service to his quarterback's room.

Darkness descended on Miami. A brilliant half-moon dangled in the sky. The temperature had leveled off at a sultry seventy-one degrees.

The Bear had planned to run Steve Bowman and Leslie Kelley hard in the middle, then turn the passing arm of Steve Sloan loose. He told the press, "You look at those Nebraska linemen – and their backs – and you've got to believe that the only way we can live through this thing is to keep them off balance, and we're not about to knock them off balance. So we'll go overhead. If we don't, give my little boys a nice funeral. We're going to pass more than any Alabama team has ever passed before in the history of football. We've got the thrower – Sloan – and we've got the receivers – (Ray) Perkins, (Tommy) Tolleson, and (Dennis) Homan. And I believe they've got holes on the other side of that big, mean line. So we're going to shoot for the holes from every part of the field, for every part of the game, from the first gun to the last

gasp." No one believed him.

In the first quarter, Sloan was hit and dropped to the ground with a torn cartilage in his rib cage. The pain jolted him like the blows of a razor-edged, ball-peen hammer when he walked, when he ran, when he threw, when somebody's helmet nailed him, when he breathed. He gritted his teeth.

No, he told Bryant. He wasn't coming out.

His first two pass completions went to Jerry Duncan, a tackle. Nebraska was rocked back on its heels. No team in its right mind covered a tackle on a pass play, and no team in its right mind had the audacity to throw to one.

Said Bryant, "We've been lining up for that tackle eligible pass all year, but we passed it to him only once. Old Duncan grabbed those passes like an end."

The Bear had been right. Alabama never did completely stop Nebraska.

But the Tide outscored them, winning, 39-28.

Three times, Alabama tried an onside kick. Three times, Alabama recovered its onside kick. Three times, Alabama scored.

Even with his ribs hurting so badly he could barely breathe, Steve Sloan hit twenty of twenty-nine passes for almost three hundred yards. Ray Perkins alone snared nine of them for a hundred and fifty-nine yards. The newspaper headline from Miami said: "Absolutely, Mr. Perkins ... Positively, Mr. Sloan." And the running backs, Bowman and Kelley, found the Nebraska midsection far softer than they had imagined. They led a savage ground attack that chewed up more than two hundred yards.

Bryant sat in the locker room after the game and told the press, "I knew we could score on Nebraska. But if anybody had told me we would run up five hundred and sixteen yards, I would have laughed." Someone asked Sloan if the torn cartilage had affected his passing.

He started to answer. He paused.

He started to answer again. Once more, a pause. Finally, he whispered, "Naw. I just wasn't aware of it."

As was written in *The Miami News*: 'Last night, Alabama made the world safe for lightweights."

*When all of the Alabama tumult and shouting had ended, and before the Tennessee eyes had dried, the finish had to be labeled for posterity as one of the great comebacks in southern football lore.*

—<> Jim Minter, executive sports editor, *The Atlanta Journal*

The Year: 1966

## The Moment:
# A Win in the Rain

It all came down to sixteen seconds.

The final sixteen seconds.

The press, in a brutal war of bitter words, had built the clash between Alabama and Tennessee into the biggest game of the year in the Southeastern Conference.

It may have been bigger.

It was a day when hearts would be broken and the pieces left scattered in the rain that cloaked the summit of the Great Smoky Mountains, veiled by an acrimonious haze of disappointment and despair.

Alabama had won eight Southeastern Conference Championships.

Tennessee had seven titles.

It was the third Saturday in October.

It was D-Day.

Tom Siler had written in *The Knoxville News Sentinel:* "Alabama plays football as if the head coach was Stalin, as if defeat meant the firing squad. Bryant's running game is strong, not sensational, dependable, not electrifying. Kenny Stabler runs the show, a left-handed passer who runs like a snake."

Stabler could have played professional baseball.

He turned down a fifty-thousand-dollar contract from the New York Yankees.

As he said, "I had a chance to go to other schools and play football. But I wanted to win. I wanted to play at Alabama because my dad loved Alabama. It was our team. But most of all, I wanted to play for Coach Bryant and win a national championship."

Stabler could be wild off the field.

Or on it.

He had razzle dazzle attached to his legs.

He hardly ever ran straight ahead for ten yards when he could weave and snake his way for thirty

74

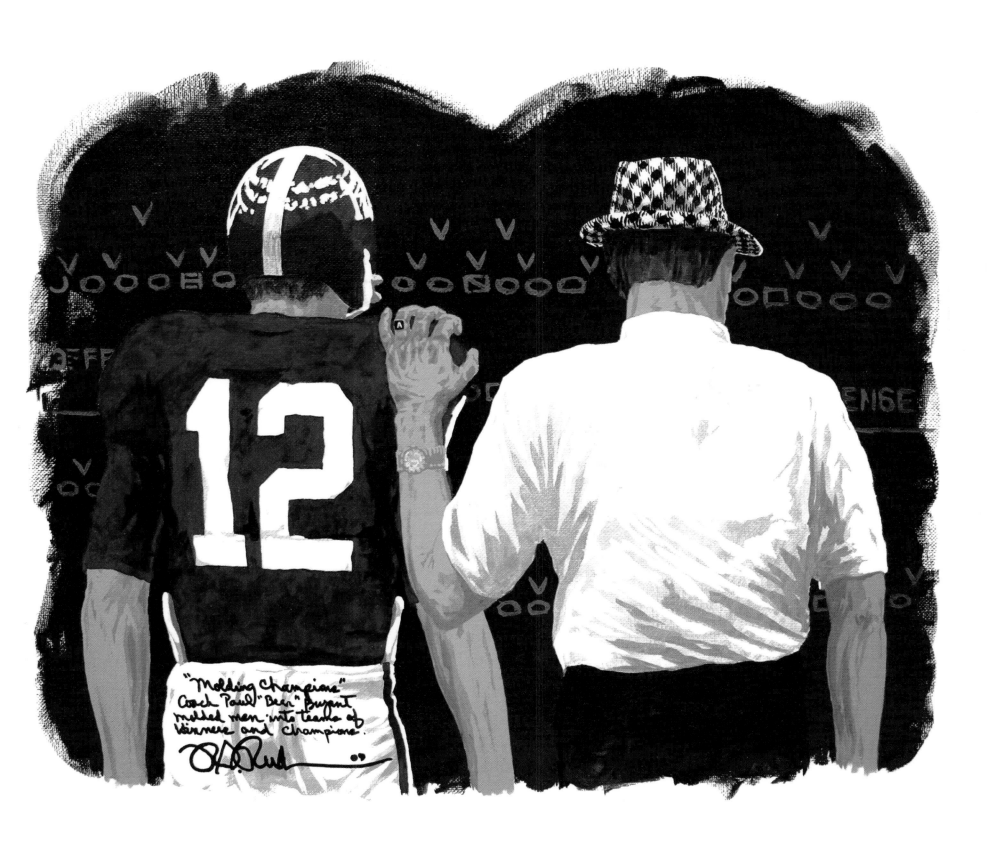

"Molding Champions"
Coach Paul "Bear" Bryant
molded men into teams of
winners and champions.

## ON THE SAME PAGE

Stabler And The Bear Plan The Attack

yards and wind up in the same place.

Stabler was a hot rodder at heart.

He was quick as a darter.

Darters generally didn't do that well in the rain.

In the first quarter, the Volunteers roared to a sudden 10-0 lead, scoring the first touchdown after recovering a Crimson Tide fumble and marching for twenty-three yards in only four plays.

A forty-yard field goal tore through the mist, split the uprights, and Tennessee fans felt as confident as they had in a long time.

Then tragedy turned Orange.

Triumph bore the color of Crimson.

As the game wore on into the closing minutes of the third period, Kenny Stabler uncorked a little homespun magic and went to work. He connected with Dennis Homan for fourteen yards, hit Wayne Cook for ten, and let Leslie Kelley battle his way to the three-yard line.

For the first time all day, Alabama was on the move.

Stabler, the mudder, not the darter, kept the ball.

Not much.

He kept it again.

Not much.

But enough for a touchdown.

A quick pass to Cook put another two points on the scoreboard, and the Tide had closed the gap to 10-8.

Fourteen minutes remained. It might as well have been a lifetime.

Short, quick runs.

Short, quick passes.

An Alabama fumble.

Damn!

A Ray Perkins recovery.

Thank God.

Rain in their faces.

A day turned gray.

But not yet black.

Alabama watched as placekicker Steve Davis drilled a seventeen-yard field goal. The Tide led, 11-

10. Was it enough?

Three minutes and twenty-five seconds were left on the clock.

And here came Tennessee. The Volunteers drove steadily to the thirteen-yard line. They faced fourth down with less than sixty seconds to play.

Gary Wright, the placekicker, lined up, facing a severe angle from the right.

No worry.

He had already kicked one field goal in the rain.

This one was closer.

All he had to do was thread the narrow eye of the needle with a wet football.

There were no time-outs.

When the ball was snapped, only sixteen seconds remained in a dying football game. The clock kept ticking. It was the sound of a beating pulse.

Even the rain had stopped falling.

The kick was up.

But was it good?

For a moment, no one knew.

The referee finally signaled.

Wide right.

Tennessee would never believe the kick was bad.

As Jim Minter wrote in *The Atlanta Journal:* "By exactly twelve seconds and perhaps less than thirteen inches, a tough and unyielding Tennessee football team failed to unseat unbeaten, defending champion Alabama in one of the most historic contests of the ancient and fabled series. A crowd of 56,368 – the most to ever see an athletic contest within the borders of Tennessee – folded their umbrellas and walked away in the dark, wet October afternoon."

The question still remained.

The controversy raged.

The debate was heating up.

Was the kick really bad? Really wide?

Or had the referee made a mistake?

In the locker room, Bear Bryant put the dispute to rest. "I don't think it was good," he said.

"Why not?"

"If the kick had been down the middle," Bryant drawled, "our kid would have blocked it."

*It was a case of a superstar rising to the occasion.*

<> Mal Moore, Alabama secondary coach

The Year: 1967

## The Moment:
# Mad Dash in the Mud

Paul "Bear" Bryant had said it once.

He would say it again.

And he believed it with all of his heart.

"You can never trust left-handed crapshooters," he said, "or left-handed quarterbacks."

So what was he doing placing the ball in the hands of Kenny Stabler?

A southpaw.

A renegade.

A daredevil.

The snake.

Said Alabama assistant coach Mal Moore, "Kenny had a real quarterback's mentality when it came to handling pressure. He always knew how to handle himself when things got tough. A quarterback's got to be able to forget about a mistake or an interception and put it behind him, and he could always do that and move on without getting bogged down in what happened."

In his first year as the Tide starting quarterback, Stabler led Alabama to an 11-0 record and a win over Nebraska in the Sugar Bowl. By all rights, the Tide should have had a shot at winning its third straight national championship. But the critical votes came from the East. The critical votes blessed the Fighting Irish of Notre Dame. The critical votes only looked South when they had no other choice. It was the one season of Bear Bryant's discontent.

Alabama had run the table. There was nothing else he could do. He stayed with Stabler. And the Snake stayed hot.

Alabama rolled into the Iron Bowl against Auburn with a 7-1-1 record and ranked seventh in the nation. But the Bear had new wrinkles of worry etched into his forehead. Alabama's fabled defense was dead last in the Southeastern Conference, giving up more than three hundred and fifty yards a game.

It was an unpardonable sin. It was beyond his comprehension.

He glanced up at the Birmingham sky. The rain fell as though it had been poured from a boot. The ground was soaked. He was soaked. The field was a swamp. He would later say, "It was the worst conditions I've ever seen a football game played in."

The swamp became a quagmire.

The Iron Bowl was a mud bowl.

Stabler remembered: "It was a driving rainstorm, ankle-deep in mud. The wind was turning umbrellas inside out. The winds must have been forty to fifty

miles an hour."

Legion Field was sod with natural grass. The grass was gone.

Said receiver Dennis Homan, "If you got tackled, you hoped your face didn't get buried in the mud, and then you hoped you'd be able to hold your breath."

Players feared they might drown in the mud, the quarterbacks didn't handle a dry ball all day, and Alabama punted thirteen times. Half of them came on third down.

The Bear was playing for a break.

He got a few. A bad snap that missed the punter. A fumbled punt. A wayward Auburn field goal attempt that drifted awry with the winds.

Alabama did not cash in on any of them.

Auburn defied the rain, knocked through a field goal, and those three points looked as valuable and as solid as if they had been locked up in a bank vault. On a day hounded and battered by the raging elements, neither team had been able to outthrow the winds or outrun the rains. They were bogged down.

The players lost their footing. If they weren't slipping, they were sliding. The line play was nothing more than a wrestling match in wet quicksand.

Nobody was going anywhere.

Alabama had the ball on the Auburn forty-seven-yard line. Slightly less than eleven and a half minutes remained in the game.

No mistakes. That's all the Bear was preaching. No mistakes.

The game wasn't life or death.

But it was just as important.

Stabler rolled wide on the option. He slithered cautiously down the line and read the pitch man, who never took his eyes off the trailing back.

Auburn's Gusty Yearout thought he had Stabler for a two-yard loss. He had recognized the formation. He knew the option was coming. He blitzed.

He lined Stabler up, dead in his sights.

He lost his sights. Tide tight end Dennis Dixon blasted him to never-never land.

Auburn Coach Shug Jordan was frantically looking and calling for a flag. The block, he thought, was illegal by the stretch of anybody's imagination. He would later say, "I wonder if Dixon thought he was on defense because he made one of the greatest tackles on Yearout I've ever seen."

Stabler cut inside. He did not want to pitch.

Not in the rain. Too many things could happen.

Not all of them were good.

Past the line of scrimmage, Stabler had one man to beat: Buddy McClinton. Dennis Homan took him out on a brutal crack-back block.

Stabler reached daylight.

It was gray. It was wet. It was daylight.

He veered to the sidelines and ran straight for the flag.

No.

He skated straight for the flag.

Auburn caught up, nailed him at the goal line, and Stabler slid ten yards, spinning through the swamp bog and past the back line of the end zone. He didn't stop until his body crashed into the chain link fence.

The mad dash in the mud had given Alabama a 7-3 victory.

*Tuscaloosa News* sports writer Charles Land wrote: "With Stabler's forty-seven-yard water excursion into the end zone, the Tide quarterback proved that if his head coach, as rumored, could not walk on water, he could."

As Stabler remembered, "Even with all of the rain and wind, not a soul left the game. It rained all day, and everybody stayed."

Bryant was waiting for Stabler after the game. He said, "Son, I am as proud of you as I am of anybody who's ever been here."

Stabler was a left-handed quarterback.

And probably a left-handed crapshooter.

As the Bear stood in the mud, rain dripping from the chiseled creases in his face, watching those seven points on the scoreboard flicker in the mist, seeing Auburn walk away from Legion Field with soggy jerseys and sagging shoulders, he no longer cared.

Kenny Stabler was his left-handed quarterback and crapshooter. If a game could be won, he knew, Kenny Stabler would find a way to win it.

## KEN STABLER

From Alabama To The Oakland Raiders

> *Records came tumbling down like autumn leaves in a windstorm.*
>
> <> Charles Land, *The Tuscaloosa News*

The Year: 1969

## The Moment:
# The Great Shootout

The newspaper headline said it all: *Clock has Heart Attack.*

It was past high noon.

It didn't matter.

The gunfight took place anyway.

Mississippi's Archie Manning won the battle of statistics.

Alabama's Scott Hunter had the last say.

The defense was left out in the cold.

The clock started having chest pains early.

Archie Manning, the Rebel with the slingshot arm, came away with five hundred and forty yards of total offense.

He completed thirty-three of fifty-two passes for four hundred and thirty-six yards and two touchdowns. He ran for a hundred and four yards, scoring three times on the ground.

He did everything he could.

He rocked the Alabama defense from the first time he dropped back to pass.

He kept the pressure on.

He had the rope around their necks and was pulling it tight.

He was in the spotlight, performing in the center ring of an aerial circus, and the high-wire act he put on was spectacular.

Only once did the Alabama defense rip the wire out from under him.

Once was enough.

The Tide had attempted an on-side kick, and Mississippi recovered.

Archie Manning brought his slingshot arm back on the field.

The Rebels had already scored three times, and they were on the move again.

But for two minutes, the Alabama defense dug in and refused to retreat.

For two minutes, Archie Manning was flustered.

For two minutes, he almost appeared human.

A mistake.

A take-away.

And Alabama had the ball at midfield.

Slowly the tide began to turn.

The Rebels led 32-25 at the time, and there were seven minutes remaining when Scott Hunter led his Alabama troops out to their own fifteen-yard line.

On a day like today, he thought, what were seven more points?

He was more concerned about the clock.

He had plenty of time, but he wanted to keep the Rebel gunner on the bench.

Manning could not score from the bench.

Hunter looked around at his backfield.

He stared into Johnny Musso's eyes.

Musso was wired and ready.

He had already scored twice.

And whatever Alabama needed, Musso was ready to deliver.

With the ball.

Or, without it.

It didn't matter.

Assistant coach Mal Moore called him a complete football player.

He could always reach deep and find something extra. He grinned to himself.

He wasn't called the Italian Stallion for nothing.

"Musso was a tremendous pass protector," Moore said. "He was an excellent blocker, very tough, and had exceptionally good technique.

"He could catch the all out of the backfield, and he was a real competitor running with the ball.

"He fought for every yard he could get.

"And he was a very smart football player. He really understood the game."

Hunter's other option was George Ranager.

In an afternoon of football, the Mississippi defense had not yet corralled or cornered George Ranager.

He, like Johnny Musso, was a threat to be reckoned with.

Mississippi could not ignore them.

But what the Rebels feared most was the arm of Scott Hunter.

All the Crimson Tide needed were a few more yards – eighty-five to be exact.

None of them came easy.

Alabama kept pounding away, marching past midfield and fighting its way into Mississippi territory.

The clock still wasn't a factor.

Manning may have had the swagger.

But Hunter possessed the final bullet.

He couldn't afford to waste it.

Alabama stalled on the Ole Miss fifteen-yard-line, and Hunter faced fourth and ten.

Jimmy Bryan wrote in *The Birmingham News*:

"Finally, the whole blooming shooting match, an entire afternoon of football brilliance, came down to one play. It was Alabama's to make."

There may have been nerves running askew in the Alabama huddle.

None of them were evident.

Ten yards.

A game depended on them.

A season was at stake.

Hunter gazed across the Mississippi defense.

The players were pawns on a chess board.

It was his move.

He had only one.

As Jimmy Bryan had written, it all came down to one play, and it was Alabama's to make.

Scott Hunter and George Ranager made it.

Hunter would say, "It was just throw and hope. That's all I did. Pitch and hope."

Mississippi rushed seven.

They were coming fast, all grit and gristle, pouring madly into the backfield.

Hunter had no time to think.

It was instinct now.

A lifetime rolled into a single pass.

Hunter threw.

Ranager said, "I knew the pass would come quickly. The Ole Miss defensive back hit me, and we started to fall. I caught myself, kept my feet, looked up, and there it was."

The ball cradled in his arms.

He scrambled the final four yards with Ole Miss draped across his shoulders like a Rebel flag.

Archie Manning may have owned the statistics.

Scott Hunter had a pretty fair day himself.

He completed twenty-two of twenty-nine passes for three hundred yards and one touchdown.

It was the final touchdown.

It was the one that counted most.

He glanced at the scoreboard.

Alabama 33.

Mississippi 32.

Never in his life had one point looked so big.

Never in his life had it meant so much.

## SCOTT HUNTER

From Alabama To The Green Bay Packers

*Alabama is looking for winning athletes and we don't care what color they are.*

The Year: 1971

⟨⟩ Paul "Bear" Bryant

## The Moment:
# Days of Destiny

The world around Bear Bryant was changing. He was not afraid to change with it.

A year earlier, his old friend John McKay had brought the University of California to Alabama and taught him a valuable lesson.

It had been a hard lesson.

It woke him up.

Southern football might still be in the race, but it was lagging far behind and, the Bear believed, lagging behind for the wrong reasons.

Back in the 1960s, the Bear had read the words of Jim Murray. They had cut deep. They cut even deeper because they were true. The Los Angeles columnist had written: "Alabama wanted to come to the Rose Bowl. The Bluebonnet Bowl gets to be a drag after a while. They thought all they had to do was beat Georgia Tech. What they had to beat was a hundred years of history. The word from Integration, U.S.A. was 'you can play us in Pasadena when we can play you in Tuscaloosa – or Birmingham.'"

The Bear had met McKay secretly and far removed from the press. Over a drink of hard whiskey,

he asked, "What if we offered you a hundred and fifty thousand dollars to come to Alabama and play us?"

McKay smiled. "Okay," he said, "but only if you take two hundred and fifty thousand dollars the next year to come out to California and play us."

The deal was struck. A passing era was fading before them.

By the first game in 1970, the Trojans were in town.

The Bear had defied history and tradition.

Southern Cal was playing in a southern stadium, and John McKay had a team loaded with an array of great black athletes.

The Trojans romped to a 42-21 victory.

USC rambled for four hundred and eighty-five yards. Alabama amassed thirty-two.

Southern Cal had six backs who each gained more than fifty yards, led by Sam Cunningham who butchered the Tide for a hundred and thirty-five yards.

Bear Bryant knew he had a young team.

It was, in fact, the youngest team he had ever coached.

But that hadn't been the difference.

The time, Bear knew, had come to change the color of Alabama's skin.

As Jim Minter wrote in *The Atlanta Journal*:

"Southern Cal may have added an exclamation point to the end of an era."

The devastating loss to USC would forever more be known as the game that changed Southern football.

In the late hours, Jim Murray wrote: "Well, Alabama can come to the Rose Bowl now. They're as welcome as Harvard and, if I know football coaches, you won't be able to tell Alabama by the color of its skin much longer. Grambling may be in for a helluva recruitment fight any year now."

The Bear had been soundly beaten, and he knew it. But he was a man of class and civility, a gift of the South.

He headed straight to the Southern Cal locker room. "When he walked in," said Trojan assistant coach Craig Fertig, "it caught everyone's attention. A legend was among us."

Bryant congratulated John McKay.

That was to be expected.

He sought out other players, both black and white, and shook their hands.

He had special praise for Sam Cunningham, who had trampled his defense.

He met with Clarence Davis, who had grown up in Birmingham, and said, "If only I had known about you two years ago. I was hoping you might not be very good, but I'm a believer now."

That was not expected.

Paul "Bear" Bryant realized what he had known all along.

Everyone's sweat was the same color.

He never forgot it.

A year had passed.

A new season was beginning.

And Alabama was flying west and on its way to California.

Bear Bryant read over the scouting report one more time. Southern Cal was bigger than last year.

And better.

The Bear didn't care.

The defeat at the hands of USC had been the game that gnawed at his psyche, kept him awake at night, and robbed him of his inner peace.

He never doubted himself or his team, but he knew there was a new road he must travel, and it would begin in California.

This was the game he wanted.

The Bear said privately, "I'd rather win this game than anything next to going to Heaven."

Bryant had broken the fading color line when he recruited Wilbur Jackson, a quiet young man, studious, polite, and soft-spoken.

He was fast as blue blazes.

Wilbur Jackson said he did not particularly come to Alabama to play for a legend.

He did not come because of the storied Crimson Tide tradition.

He did not come for the privilege of breaking a historic and ages-old color barrier.

He came to get a good education.

Bryant roomed him with Danny Taylor, a white athlete from Mississippi.

The times?

They were definitely changing. By the end of the first week of practice, Wilbur Jackson was running first team.

The Bear found a big defensive end named John Mitchell at Eastern Arizona Junior College.

Everyone thought he was headed to Southern California, which had a tradition for great defensive ends. John Mitchell could step right in.

Everyone knew he would.

Everyone was wrong.

Bryant brought him home to Alabama.

John Mitchell had played high school football down in Mobile.

He was strong.

He had quick feet for a big man weighing over two hundred and thirty pounds.

No one worked harder.

Bear always regretted that he had to go so far to find him.

Mobile was a lot closer than Eastern Arizona.

A year earlier, Alabama had been embarrassed by Southern Cal.

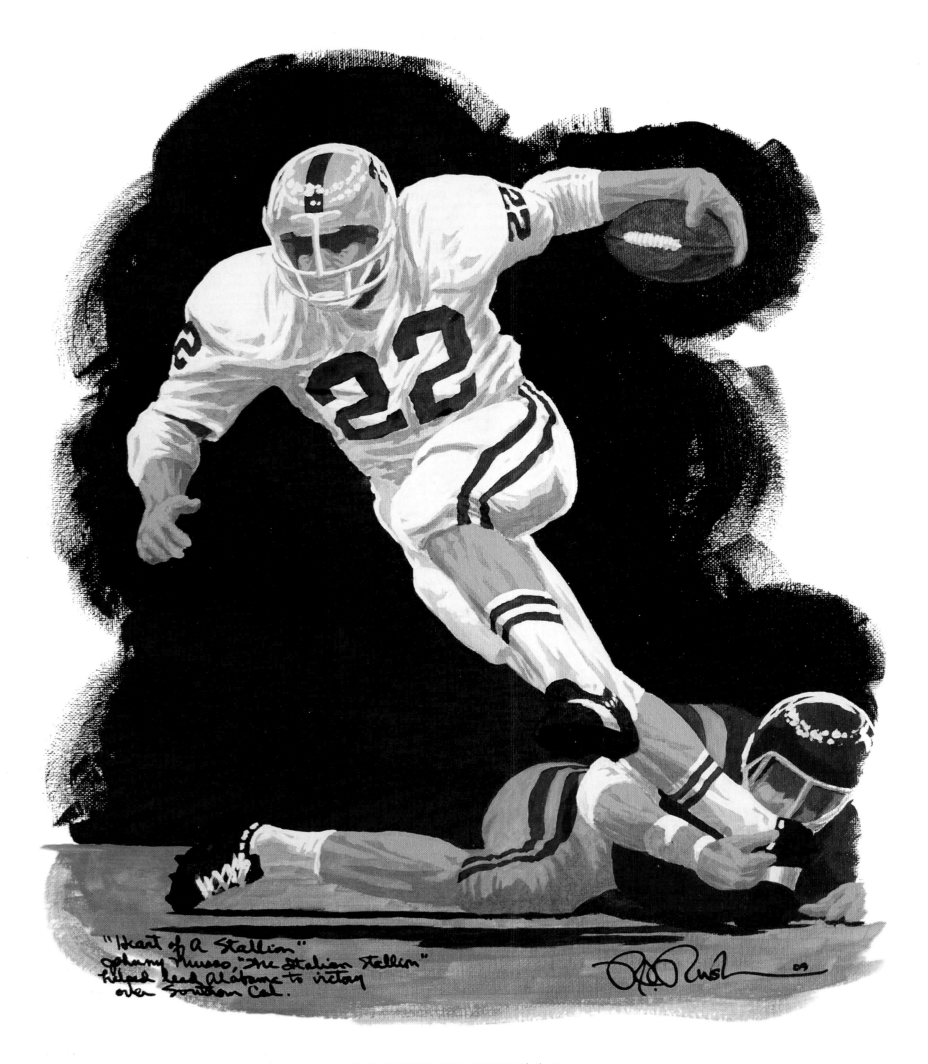

"Heart of a Stallion"
Johnny Musso, "The Italian Stallion"
helped lead Alabama to victory
over Southern Cal.

# JOHNNY MUSSO

A Rare Breed

Some doubted Bryant's sanity for taking his team back into the teeth of a USC meat grinder.

Jim Murray wrote: "Custer was coming back for more, and Custer should have stayed in the fort. Alabama should have stayed in the hominy belt. The wipeout last September would have been as total as Custer's except that USC, in effect, took pity and took prisoners."

Of the Crimson Tide, he wrote, "The cotillion was over. Alabama had to recruit black players – and God knows there were enough for a national championship within field goal range of Tuscaloosa."

Alabama stormed onto the Rose Bowl field, running the wishbone, a triple option offense under the guidance of quarterback Terry Davis and running backs Johnny Musso and Joe LaBue.

It was a new look.

It relied on power and speed.

Southern Cal needed a fast set of linebackers to stop it.

Southern Cal had fast linebackers.

They wouldn't be fast enough.

Bryant said, "We couldn't win last year with a pro-style passer, so I flew out to Austin, got with Darrell Royal, looked at his game films, and decided we were going to sink, swim, or die with the Texas stuff."

His mind was made up.

Forget the pass.

All he needed to do was find a magician to play quarterback, recruit a bruising fullback, and let the speedsters run wide and often wild.

He stuck one offensive philosophy in its grave and unearthed another.

Before the game, Johnny Musso said, "Last year, we played bad and didn't know what to expect. We won't be surprised this time."

Southern Cal settled back and waited for Custer.

Another massacre?

Perhaps.

A win?

Go ahead and chalk it up.

Custer did not have a chance.

Custer won.

Johnny Musso raced for ninety-four yards and two touchdowns.

He scored the first one when the game was barely three minutes old. Bryant would call him the "best back in America," and the Bear had seen Sam Cunningham.

Bryant said, "If you don't believe it, just watch him play. The worst thing Musso does is carry the football. He's a great blocking back, a great leader."

On a night when he had to lead, Johnny Musso took charge.

And the Alabama defense refused to crumble.

It didn't tame the Southern Cal tornado, but it did cut back the sheer force of the headwinds.

Sam Cunningham managed only seventy-six yards this time.

But the Trojans would not go away quietly, not at home, not when Custer had brought in a new regiment of reinforcements.

With Alabama leading 17-10, USC's Lynn Swan returned a punt fifty-seven yards and almost broke it for a touchdown.

The Tide's David Bailey stood in his way.

He was the only one to stand in Swann's way.

Bailey said, "I grabbed him by his jersey. Then my hands slipped down and knocked one of his legs into the other. I didn't get him by much."

Lynn Swann lay sprawled on the ground.

Nothing else mattered.

John McKay would say, "Alabama outhit us and outran us."

And Bear Bryant had Wilbur Jackson and John Mitchell waiting in the wings. A new era was on its way. And Alabama couldn't wait.

Wilbur Jackson and John Mitchell would do just fine.

Their blood was the color of Crimson.

In 1973, Bear Bryant would be asked by a reporter just before the Cotton Bowl, "How many black players do you have on your team, Coach?"

Bryant replied, "I don't have any. I don't have any white ones. I don't have any black ones. I just have football players. They come in all colors."

> *We like to win at the end. It always looks better on TV.*
>
> <> Paul "Bear" Bryant

The Year: 1972

## The Moment:
# Never Give Up

Forget the hits.

Forget the pain.

Forget the Tennessee assault that had relentlessly and recklessly bombarded the Crimson Tide and kept Alabama bottled up all afternoon.

It was all for naught.

The near and distant past meant nothing.

The pain had already passed. At least the pain had numbed.

It finally came down to this. The Volunteers led 10-3. The game was growing old and wearing out. Three minutes, and it would all be over.

On one sideline, Tennessee Coach Bill Battle had his lucky buckeye in his pocket.

On the other, according to the press, Coach Bear Bryant was wearing his magic hat.

Their minds were working hard and overtime.

They had ideas. They had plays. They had schemes. They had the wisdom of their years. Battle was the new breed. Bear came from the old school. Battle had played his college football at Alabama. The Bear was still there. His heart had never left.

The pupil had met the master, and the pupil had a seven-point lead. The master had three minutes and was running out of time. The game, however, lay in the hands of a bunch of kids barely older than teenagers on their way to a Dairy Queen. Neither coach felt particularly good about it.

As Clyde Bolton wrote in *The Birmingham News,* "The grave was dug, and the hearse cranked, but Alabama's funeral was cancelled at the last moment when the corpse suddenly sat up in the casket."

Tide Quarterback Terry Davis had been mauled and mangled all afternoon by the rampaging Volunteers. The potent Alabama wishbone may have not been broken. It was certainly cracked and hanging by a slender thread of gristle.

The clock said three minutes, more or less. The clock never lied.

Alabama needed two scores.

No.

Alabama needed a miracle.

Davis had just whipped a fourteen-yard pass to Wayne Wheeler, and the Tide had scrambled its way to the Tennessee thirty-four-yard line. In the huddle, big John Hannah, the offensive tackle who supplied the power up front, bowed his head, muscles bulging in his thick neck, and began to pray. As he later explained, "You can say all you want about the Fellowship of Christian Athletes, but I can tell you that all of us were praying in that huddle."

On the next play, fullback Steve Bisceglia slammed his way through, then past the Volunteers and rambled to the two-yard line. The thunder had come close. Lightning took over. Wilbur Jackson slashed savagely into the end zone, and, a kick later, Alabama had tied the game.

The Bear spurned the two-point try. He still had a minute and forty-eight seconds left to win. A lot could happen in a minute and forty-eight seconds.

John Mitchell made him look like a wizard. The defensive end wasted hardly any time. But then, he had such little time to waste. He jumped on a Tennessee fumble, and, thirty-six seconds later, Davis faked to his fullback, scrambled to the right, made an imaginary pitch to his trailing back, and found a hole no wider than a splinter. He was off to the races.

Twenty-two yards later, Alabama had the lead for good, 17-10. Said Davis, "I think it was just the greatest blocking I've ever seen. When I got outside, there was just one guy between me and the goal."

The Tennessee player may have had a shot. He may have taken it. But, in reality, he was nothing more than an innocent bystander waving at the traffic passing by.

Sportswriter Delbert Reed of *The Tuscaloosa News* penned, "It was a fairy tale victory for the Tide, which crammed two touchdowns into Tennessee's end zone in thirty-six seconds of the final three minutes of the game to escape certain defeat."

The Bear knew all about defeat. It did happen from time to time.

But at Alabama, defeat was never certain.

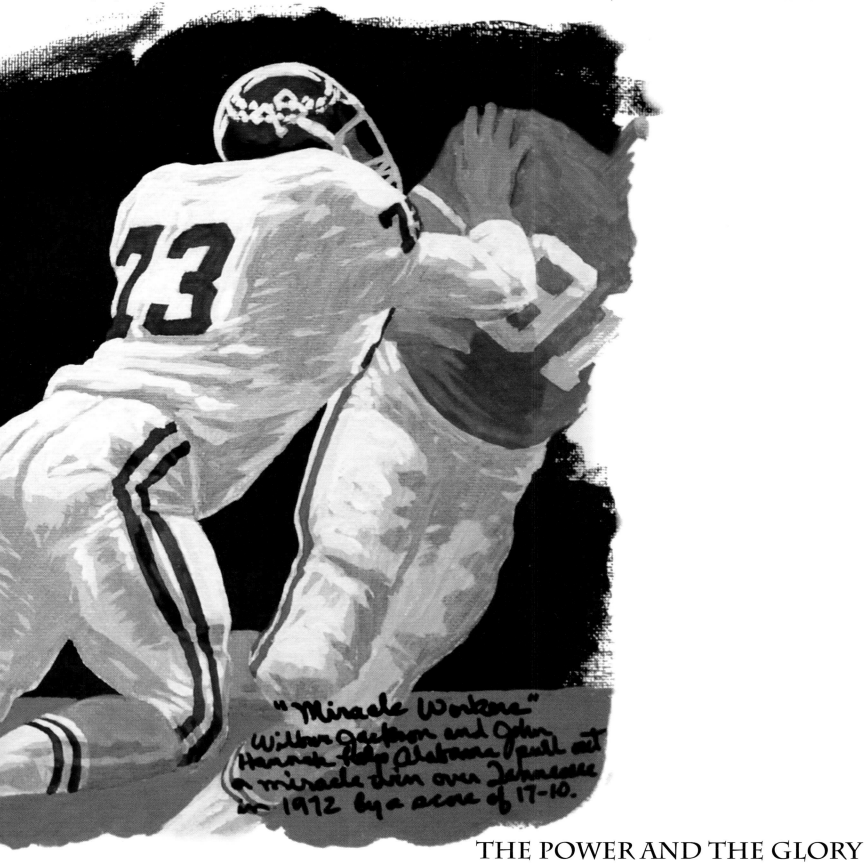

"Miracle Workers"
Wilbur Jackson and John Hannah help Alabama pull out a miracle win over Tennessee in 1972 by a score of 17-10.

## THE POWER AND THE GLORY

Wilbur Jackson Running Behind John Hannah

89

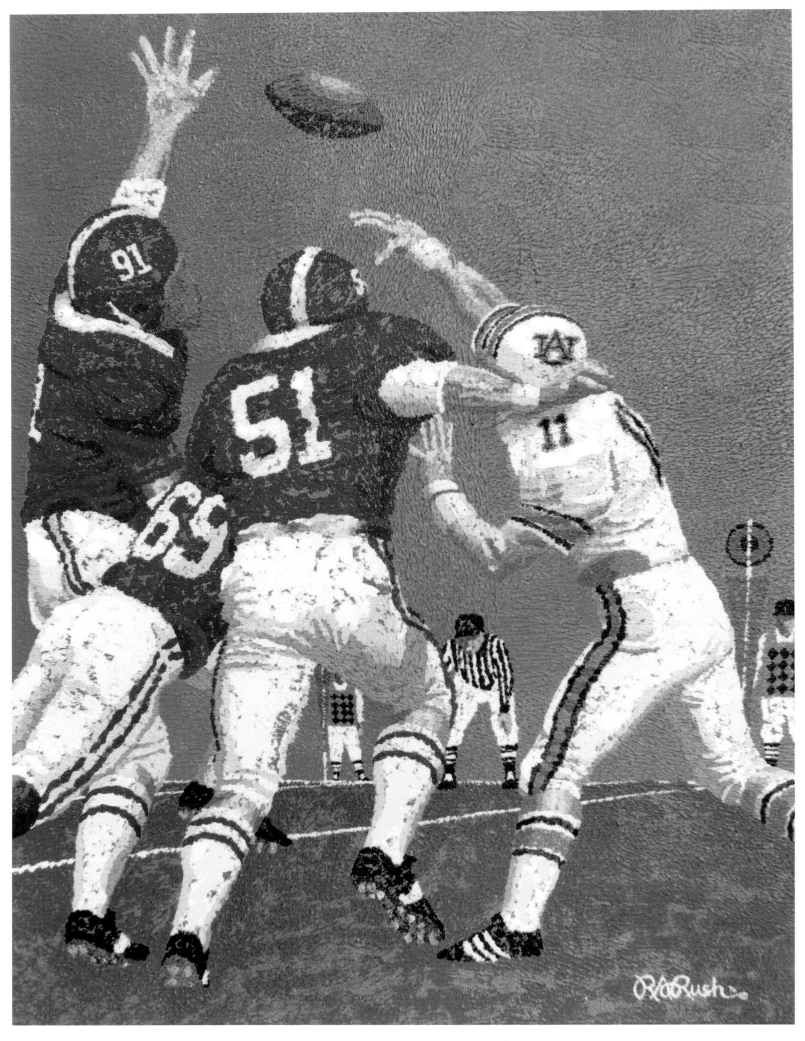

# BOB BAUMHOWER

The Play Stops Here

> *In a crisis, don't hide behind anybody.*
> *They're going to find you anyway.*

<div align="right">

⟨⟩ Paul "Bear" Bryant

</div>

The Year: 1974

## The Moment:
# The Sweetest Kick

**B**ob Baumhower had said it all along: "I want to be great at something." Until now, he had not been ready to invest his heart in it. God gave him the size, the strength, and the ability to play big-time football, and he had been quite willing to sit back and let God do all the work.

Baumhower had emerged from spring practice, especially after a dominating A Game, with a place solidified on the starting defensive unit of the Crimson Tide, which, he thought, wasn't bad for a sophomore. He was feeling good about himself, maybe even cocky. He was glad he had turned down those opportunities to play college football for Florence State, Vanderbilt, or, God forbid, Auburn.

When he told the defensive line coach at Auburn that he had a meeting scheduled with Alabama and Paul "Bear" Bryant, Charlie Bradshaw simply shook his head and told him, "Well, I probably won't be seeing you again." He didn't.

Bob Baumhower didn't work out much that summer. He didn't need to. He was big enough and strong enough and tough enough to play for the Bear. Starters didn't have to work hard. They had already proved themselves. As he recalled, "I didn't do a whole lot be-tween spring and fall ball because, in my mind, I had already arrived."

He swaggered out onto the practice field in the fall, and Bryant had an orange jersey waiting for him. He had been demoted to the scout team. He was no longer on the first string. He had been shoved down to the last string. Baumhower had shown up at two-days just a little too big, too slow, too out-of-shape, and in no condition, the Bear said, to play for Alabama. He wanted beasts, not bellies.

Three days, later, Baumhower was still wearing the orange jersey. He angrily tossed it back in the basket and stormed off the field. He didn't come back.

Now he had a change of heart, sitting in the head coach's lobby with his father, waiting to meet with the Bear, hoping and maybe even praying for a chance to mend and correct the errors of his way. The punishment, he knew, would be hard. It wouldn't be swift. He looked up and saw the Bear standing in the doorway. The coach had a genuine handshake for the elder Mister Baumhower. He turned to the towering hulk of a boy and growled, "What the hell are you doing here? I don't talk to quitters."

His words were a sledgehammer between the eyes. They jolted him. For Bob Baumhower, it was the defining moment in his life. As the Bear told him, "Let's take a look at the boys playing ahead of you. During the summer, one guy lost weight, another got

stronger, and a third got faster. What did you do?"

Bryant, after Baumhower had been forced to sit there and sweat off a few pounds, relented, and said, "Son, I don't think you're a quitter. I think you're frustrated. The game doesn't mean enough to you. To have someone on the starting line, I have to know this is their number one priority." Quit now. Quit in a big game. It would be so easy, and Bryant wouldn't tolerate it.

Bob Baumhower understood his place. The bottom was as good a place as any to begin again. Defensive Coordinator Ken Donahue led him out of the office. The Bear's parting words were: "Donahue is probably going to kill you." He tried. Bryant did not want Baumhower's heart. The Bear wanted his soul.

By the time Alabama took the field against Florida State in the fifth game of the season, Baumhower had slugged his way back into the starting defensive unit along with Randy Hall, Charles Hannah, Woodrow Lowe, and Mike Dubose. It was just in time. No one expected much from the Seminoles. Alabama's winning streak had reached fifteen games, and Florida State had fallen on hard times.

The Seminoles were playing the game of their lives. Alabama's offense had thrown a rod. It wasn't going anywhere. The number one quarterback, Gary Rutledge, was injured. The number-two signal caller had seen better days. With the Tide trailing and time sputtering like a lit fuse off the clock, the Bear reached down on the bench and called on an untried, untested, unknown quarterback named Jack O'Rear, who tossed a critical pass that had more wobble than spiral to freshman Ozzie Newsome with the Tide trailing and time sputtering like a lit fuse off the clock.

The big receiver stretched his six-foot, three-inch frame, tipped the ball, juggled it for a moment, then cradled it gently into his arms. He said, "I thought I could have stayed in bounds and gone for the touchdown, but Coach Bryant told me before the play that my job was to catch the ball and get out-of-bounds, so that's what I did. I did what the man told me to do."

Alabama had the ball on the Florida State sixteen-yard line. The clock showed thirty-three seconds. A fifteen-game winning streak hung in the balance. The Seminoles led, 7-5, and were within sixteen yards of knocking down Alabama and recording the biggest upset in the nation. They had gambled. It might cost them. Facing fourth down on is own five-yard line, Florida State chose to run the ball out of the end zone, give up two points, and have room – and time – to punt the ball deep. For Head Coach Darrell "Dr. Victory" Mudra, the strategy had sounded a lot better then than it was feeling by now.

He watched placekicker Bucky Berrey race onto the field and immediately called time-out to freeze him. Give him time to think. Give him time to worry. On the sidelines, Berrey's coach, Sam Bailey, told him, "Take it easy. Just like in practice."

"Yes, sir."

"I was afraid I would blow the whole thing," said center Rand Lambert, whose trembling knees looked like road maps from so many surgical scars.

"I was scared," said Robert Fraley, whose job was to catch the snap and place the ball on the field. He shouldn't even be in the game. This was a chore always handled by one of the Tide's top two quarterbacks, but they were injured. "I knew if I didn't catch the thing, I would never be able to go in the dressing room again," Fraley said.

Berrey had already kicked one field goal of forty-four yards. This one was closer. Of course, they all looked far away when the game was on the line. Only he faced the football without fear. Take it easy, he thought. Just like in practice. It was so hard.

He kicked. He said, "I hit up under it real bad. I thought it was short. I kept my head down and didn't look up until after the ball had cleared the crossbar."

"It was," a teammate said, "the sweetest kick I've ever seen."

The Alabama defense had made it possible, slamming the door, time and again, on Florida State. The defense had stayed on the field for most of the game. It was tired. It was beaten. It was bloodied. It never quit. Bob Baumhower was part of it. Now he had a better understanding of the Bear who had taken his heart and soul. He would never quit again.

> *We would rather beat Auburn five times than Ohio State.*
>
> — Paul "Bear" Bryant

The Year: 1978

## The Moment:
# A Meeting of Giants

It was a Sugar Bowl's dream, a confrontation between two old warhorses, two old mavericks who, by their own admission, were stubborn, bullheaded, arrogant, dead set in their ways, compassionate, short-tempered, demanding, unwilling to accept anything but the best from the young men they coached,. Both knew, above all else, the sacrifice and the dedication it took for a team to win it all.

Yet, there were differences between the two.

Paul "Bear' Bryant of Alabama took the blame when he lost.

He was reluctant to accept the credit when he won.

Woody Hayes of Ohio State liked the credit.

He thought he deserved the credit.

After all, only one coach in college football had ever won more games than the illustrious Woody Hayes.

Bear Bryant.

Hayes might never catch him.

Age stood in his way.

But the Sugar Bowl, he figured, would be a good place to show just which legend would be able to cast the broadest shadow.

Two great men were on the field, and no one, at least no one in the inquiring press, cared about anything else, least of all the fact that Alabama and Ohio State happened to be playing a football game.

It was all about Woody and the Bear.

Newspapers had to look for more ink.

Together, Bryant and Hayes had devoted sixty-five years to coaching, and they had collected five hundred and sixty-three wins, six national titles, twenty-eight league championships, and thirty-five bowl appearances.

At a hundred and eighty pounds, Woody Hayes had played center, tackle, and guard for a small Ohio college, and he said, "Hell, I couldn't even make the Ohio State traveling squad today."

He may not have made it then.

And the Bear?

He was, he said, "the other end" for an Alabama team that rode the aerial wizardry of Dixie Howell and the pass-catching artistry of Don Hutson to an upset Rose Bowl win.

The Tide of 1935 impressed him, but, as was his style, he downgraded his own exploits, explaining simply, "When I went to school, the coaches' offices were upstairs. Downstairs is where they put all the roughnecks. That's where they put me."

# A MEETING OF GIANTS

Alabama And Ohio State

The Bear had stature on a national stage.

Woody Hayes had lost a measure of his.

During one of his notorious histrionic fits on the sidelines, when he fought a personal battle with his own anger and lost, Hayes had punched a television cameraman.

Of course, over the years, he had pushed his way through more than a few newspaper photographers and rudely shoved his share of sportswriters out of the way.

From time to time, he tried to make amends.

But had Woody Hayes mellowed?

"No," Hayes told the reporter, "I'm still a mean old coach."

He, like the Bear, could be a tyrant. Both were dictators when it came to running their programs.

The cameras never left their faces.

As far as Bryant was concerned, the press was following the wrong story.

He told sportswriters, "The game will be decided down on the field where the players will be. I can assure you that I'm not going to play the game."

He paused a moment. He shrugged.

But I sure hope Woody does," he said.

It had been said of the Bear, "He doesn't coach football. He coaches people."

He pulled his famous Hounds-tooth hat down tightly on his head and turned his people loose.

To the press, he was diplomatic.

He said, "Ohio State is the best team I've ever seen that lost two games."

Privately, he was not worried at all.

He did not think the Buckeyes were particularly strong or quick.

They had been effective in the Big Ten.

Alabama was not in the Big Ten.

Welcome to the South, Mister Hayes.

Bryant's own Crimson Tide was ranked number three in the nation, and, in the Sugar Bowl that afternoon, Alabama played a flawless game.

The Tide wanted to beat Ohio State all right. Tide players wanted to make sure that no one would ever again mention the name of Woody Hayes in the same sentence with Paul "Bear" Bryant.

Senior offensive tackle Louis Green even stuffed his socks with pictures of the Ohio State defensive linemen before he took the field.

"I wanted to put them on my helmet," he said, "but somebody said that would look trashy."

On Alabama's first touchdown drive, the Tide had pretty much gone where its offense wanted to go, running at will, battering and bolting its way down inside the ten yard line.

Power inside.

Lightning bolts on the outside.

Zip.

Zap.

Ohio State suddenly dug in its heels, tired of being gutted by a ramrod stained the color of Crimson, and quarterback Jeff Rutledge found himself facing third and goal.

He made the call.

He caught split end Bruce Bolton by surprise.

Bolton would say, "Jeff didn't know I was in the game when he called the reverse. We hadn't run that play in a game before."

Bolton, all hundred and seventy pounds of him, took the pitch and scampered to the one. "I should have scored," he said.

Tony Nathan knifed his way for the final yard.

On the next drive, Rutledge fired thirty-seven yards to Bolton, and it became a day when Alabama was a runaway that could not be stopped.

The Tide ran away with a 35-6 victory, and senior offensive guard David Sadler told the press, "Our kicking game won it. We just set up and kicked them in the butt."

For Bear, it was just another win.

For Woody Hayes, it was an ignominious defeat.

However, it was Bryant who put the game in its proper perspective. He said, "I don't think this game had anything to do with how good a coach I am or how good a coach Woody is."

The Bear paused and thought it over a moment.

"Woody's a great coach," he said with a sly grin, "and I ain't bad."

> *In my opinion, there is only one team in the country that could have made those plays on the goal line, and that team is Alabama.*

<div align="right">

⤙⤚ Paul "Bear" Bryant

</div>

The Year: 1979

## The Moment:
# The Goal Line Stand

**B**arry Krauss had come face to face with a hard and terrible truth.

There were times when a man would not be measured by his life, good or bad, his deeds, daring or dastardly, his decisions, wise or otherwise, or the choices he made.

For an instant, they didn't count.

For a brief moment, lasting no longer than a wisp of smoke fading in the wind, his name would always be attached to something far less.

For linebacker Barry Krauss, he would be measured by a yard.

A single yard.

No more.

No less.

The Sugar Bowl of 1979 became an engagement for only the stoutest of hearts. Joe Paterno's Penn State flew into New Orleans ranked as the nation's number one team. Bear Bryant's Crimson Tide was wedged solidly into the number two slot.

A national championship hung in the balance. Only the brave hearts dared place a wager.

The Nittany Lions possessed the country's toughest defense against both the pass and the run. Their All-American signal caller, Chuck Fusina, had finished runner-up in the race for the Heisman Trophy. He was pass happy. He threw bullets. He was accurate, and few had been able to slow him down. No team had stopped him. Fusina's arm might be a difference maker, but the core of Penn State's offense was the firepower of its two running backs, Matt Suhey and Mike Guman. They were battering rams that could hurt and punish a defense with neither conscience nor mercy. As the game wore down, their constant pounding would soften the underbelly of anyone who dared stand in their way.

They had not met Alabama's defense, not up close and personal anyway.

Their helmets bore no tarnish of Crimson. They would before the day ended.

Alabama had seen all of the glowing reports and advertisements about Chuck Fusina. He was almost as good as the national press thought he was, throwing the ball thirty times in the Sugar Bowl, connecting on fifteen of his passes for a hundred and sixty-three

yards. He drilled Scott Fitzkee for a touchdown, and members of the fourth estate immediately cranked up their typewriters, searched for another adjective or two, and nodded their wizened heads.

Look out, they wrote. *Here comes Fusina.*

But something went awry.

Alabama caught four of his passes, and the Tide wasn't his intended target. He was throwing the ball up for grabs. He had no other choice. He could eat the ball, but it left a bad and bitter taste in his mouth. He was sacked, tackled, and thrown down for losses totaling sixty-four yards. The press held him in high esteem. He didn't quite measure up that high in Alabama.

Said linebacker Barry Krauss, "We didn't go into the game thinking we would blitz nearly as much as we did. It just kind of developed that way during the game. We knew if we let Fusina sit back there, he would pick us apart."

With time running low in the first half, Tide quarterback Jeff Rutledge tossed thirty yards to Bruce Bolton, who made a diving, rolling catch in the end zone, and the battle suddenly bogged down and retreated from the backfield to the trenches.

The war would be won or lost with the foot soldiers. A hero came from the unlikeliest of places, the far end of the Alabama bench.

Lou Ikner was listed as number three on the depth chart. He had only returned one punt in eleven games. He had a broken arm. So, everyone wondered, why had he come into the game, what was he doing downfield, and why was Penn State punting to him?

Major Ogilvie was Alabama's top returner. But, during the last Tide possession, his lead block had been so fierce at impact that it ripped his facemask off his helmet. At the moment, he couldn't go back into the game. His helmet was feverishly being patched back together.

The Penn State punt traveled fifty yards.

Ikner returned it sixty-two yards.

There was no problem running with a broken arm. His only concern had been the catch.

Ikner caught the ball cleanly and threaded his way deep back down into Penn State territory. He was the speedster, fast and furious, always one step away from being gone. It was just as well that Ikner had fielded the punt, Ogilvie said. "The best I can do in comparison to him is a trot." In big games, teams didn't get many chances. They could never afford to waste the few they got. Alabama didn't.

The third quarter was winding down when Rutledge rolled left, patiently waited until the defensive end committed, and worked the pitch to perfection, flipping the ball to Major Ogilvie, who dashed the final eight yards for a touchdown and a 14-7 Alabama lead. But would it last? And for how long?

Alabama had the national championship in a tenuous grasp.

Bear Bryant feared the Tide was on the verge of giving it away.

A few ticks less than eight minutes remained in the game. A rugged Penn State defense angrily rose up to disrupt the option and recover a misdirected pitchout at the Alabama nineteen-yard line. So close. And yet so far.

Joe Paterno had been waiting for a break.

He had one.

It would be his last.

It would decide the game.

The Nittany Lions slugged out a yard at a time, chewing up the clock, moving ever closer to Alabama's sacred ground.

Chuck Fusina faced third down.

The goal line lay a yard away.

Two chances to get there.

Fusina sent fullback Matt Suhey driving hard up the middle. Linebacker Rich Wingo did not move, flinch, or falter. He drove his helmet into Suhey's chest, and the movable object shuddered on impact and fell beneath the weight of the irresistible force. He vanished beneath a churning sea of Crimson jerseys.

The fullback had gained inches, perhaps.

That was all.

Fourth down.

Chuck Fusina walked toward the ball.

Alabama's Marty Lyons stood in his way.

Lyons smiled.

"How much is it?" Fusina asked.

Lyons spread his hands apart. "About that much," he said.

"Ten inches?"

Lyons smiled again. "You better pass," he said.

Bryant had watched a lot of game film. He knew Paterno's tendencies. He said, "I thought they would go over the top or off tackle like they had done against Pittsburgh."

Defensive coordinator Ken Donahue called the play. He knew what was coming. He tossed all caution aside. He ignored any and all possibilities that Penn State might put the ball in the air. Paterno was old school.

Paterno was sending his troops up the gut.

Said Marty Lyons, "We weren't really guessing. It was a case of preparation. Before the last play, I was so scared there were cold shivers going through my legs. I remember looking down at the ball at the goal line and thinking, damn that's close."

Suhey had his shot.

Now Fusina turned to Mike Guman.

Guman could get ten inches on guts alone.

Defensive back Murray Legg recalled, "We got in the defensive huddle and took hands. Wingo called the defensive signals for the front and said, 'This is it, we have to stop them.' I called defensive signals for the secondary and said, 'We have worked too hard to let them score. The game, the national championship, is riding on this play.' We all looked at each other, then at Penn State. They looked real calm, sure of themselves."

Marty Lyons started yelling, "This is a gut check and we have to pass it."

As he would say, "We just bowed our necks."

A train wreck was on its way.

Alabama pinched inside and moved its tackles into the gaps. As Penn State center Chuck Correal recalled, "They collapsed the middle. We were outnumbered. Alabama had guessed right. They stacked up, and we couldn't move them."

Barry Krauss said, "My job was to read the fullback. I had watched them a lot on film, and they liked to go over the top on close yardage situations near the goal, When Fusina took the snap and turned, I dropped back a step to protect in case he sprinted out. But when I saw the fullback come up the middle on a lead block, I dove into the middle."

He met Guman helmet-to-helmet.

The impact was shattering.

One line could not move forward.

One line refused to go backward.

Said Krauss, "He gave me a stunning lick, and I went to the ground in pain. It was probably one of the hardest hits I ever made." The collision knocked the rivets on his helmet loose.

Defensive tackle Byron Braggs remembered, "Everybody started piling on top of me, and I couldn't tell what was happening. I heard Penn State fans yelling like crazy on my left and Alabama fans going wild on my right."

The whistle blew.

Braggs looked up at the scoreboard.

It still read 14-7.

It flashed *first and ten*.

He knew Alabama had held.

Krauss said, "I never knew we stopped them until I saw our offense run out on the field. Then our trainer told me to hurry up and get off the field." He staggered toward the bench in pain. Krauss had aggravated a pinched nerve in his neck.

Legg remembered, "Marty was screaming at the bottom of the pile. Krauss was crying like a baby. I had tears rolling down my cheeks. I looked at the Penn State players, and they were crying, too."

There it lay before them.

One yard.

Penn State had frantically tried to take it.

Alabama refused to give it up.

Said Lyons, "We stopped them, so I guess the Old Man was smiling on us. Either that, or we just peeled our ears back and went after them."

It was the last stand.

It had held strong.

# YOU BETTER PASS

## No Room To Run

*This is a lose-your-gut week.*

<> Paul "Bear" Bryant

The Year: 1979

## The Moment:
# The Plow Incident

The stars and planets hung crookedly in the sky.

They had definitely not been properly aligned.

A year ago, Alabama had won the Sugar Bowl and solidified another claim to the national championship. This year, they were undefeated with only one game left to play. Yet, in an ironic twist of fate, rumors began to make the rounds that the Crimson Tide must win its annual clash with Auburn, or perhaps be locked out of a bowl game for the first time in twenty-one years.

Alabama was in a state of disbelief. Surely, the rumors were wrong.

But here it was the last week in November. Thanksgiving had come and gone. And Paul "Bear" Bryant merely shrugged and said, "I haven't seen a bowl man yet."

He might not unless the Tide took down Auburn.

One slot was left.

The Sugar Bowl.

It was waiting for a winner.

The Bear sat back, propped up his feet, and drawled, "If we can't beat Auburn, I'd just as soon stay home and plow."

It was a bold statement, maybe even a rash one.

Auburn did not let him forget it.

The Tiger attack featured a pair of fast and powerful running backs – James Brooks and Joe Cribbs. Each had gained more than a thousand yards, and assistant coach Bill Oliver said, "That is all the ammunition a team needs. They look like the Russian army coming at you."

The game had always been a fierce rivalry. The game had always divided the state in half. The game had always been a Civil War. Alabama fullback Steve Whitman said, "If we don't beat Auburn, I don't want to be seen in public. Beating them is everything."

So it was.

Auburn head coach Doug Barfield made the game personal. He said, "Alabama has always looked down its nose at us. It is an atmosphere they have created. They feel they are a little better than we are. If we win, we will claim the conference championship whether it is official or not."

Alabama was a seventeen-point favorite.

But the fire was raging hot in the belly of Auburn.

The Tide figured it was just indigestion.

Former Tiger head coach Shug Jordan poured gasoline on the fire during the fateful week, telling the press: "I sure hate to see that my friend Paul Bryant will have to get up Monday morning and start plowing. As strong as he is, I would hate to see him dressed in overalls again, slaving in those wet flatlands of Arkansas."

That became Auburn's battle cry.

Send Bear home to Arkansas.

Send him back to the farm.

Give him a plow and forty acres, hook him up with a pair of good mules, and turn him loose.

Even before the game began, Auburn students were wedged together and on their feet, screaming, *Plow, Bear, Plow.*

He took it in stride.

He had walked into the dressing room on Thurs-day before the game and quietly told his team, "Don't worry, boys. Just be brave."

There was no need to rally his troops. No one needed motivation.

He had read their eyes.

"For Auburn, this a bowl game against the number one team in the country," said tackle Buddy Ayde-lette. "For us, it is a chance to keep on going toward bigger things."

Quarterback Steadman Shealy explained it this

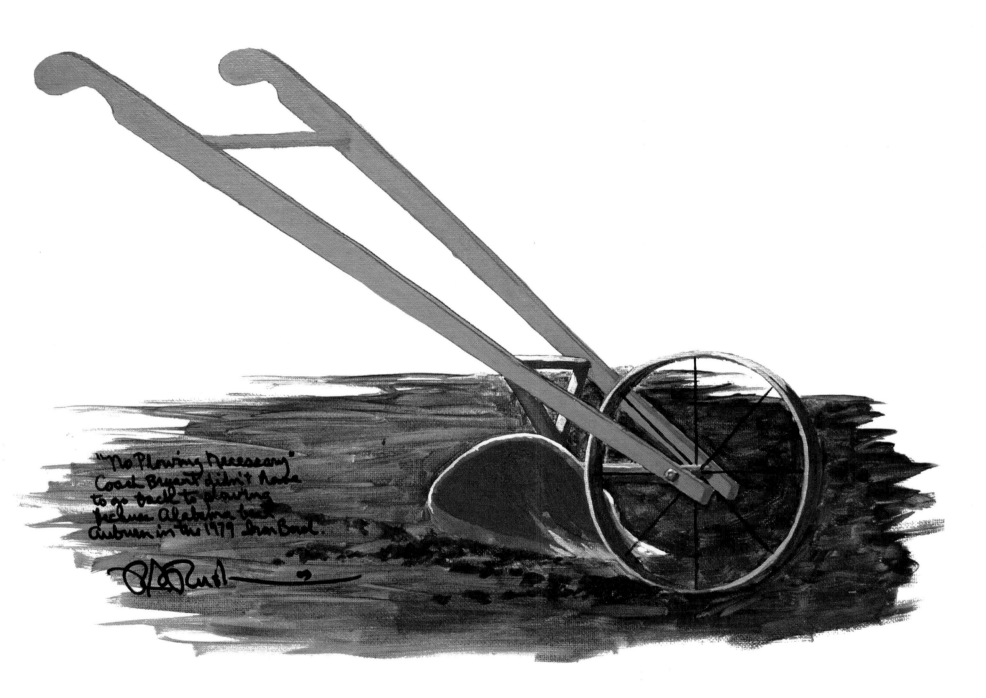

## PLOWING THE FIELDS

The Bear Had Other Ideas

way: "if we lose this game, nothing much matters anymore. It is that simple. It is the game of our lives."

During the week, a reporter had asked one of Alabama's Christian players, "What are you praying for?"

"That both teams play up to their potential," the young man said.

"Why?"

"Why do you think?" the player said with a mischievous grin.

The game was a dogfight. However, some sportswriters began to refer to the nerve-wracked affair as "the fumble bowl."

The ball hit the ground ten times.

In the third quarter alone, Alabama fumbled five times.

The Tide lost four, which kept its back against the wall. The firing squad was locked and loaded. Auburn had the guns. One quick shot, and it might be all over.

Alabama had not been able to ignite a sputtering offense. It was cranked up all right. But it kept misfiring and just wouldn't go. The Tide had been plowing all right. It had plowed itself into a fourth quarter hole with eleven and a half minutes remaining.

Said Shealy, "When we went back into the game, trailing 18-17, I thought to myself, well, here it is, do or die. That was one of the toughest situations I have ever faced as a quarterback."

On the first play, it happened again.

Alabama fumbled.

Running back Major Ogilvie scrambled to recover the ball, and that, said Shealy, might well have been the biggest play of the game.

The Tide quietly settled itself down. It forgot the clock. It forgot the rivalry. It forgot the ill will festering deep within the two teams. Alabama rolled up its Crimson sleeves and calmly went to work.

Steadman Shealy was poised, daring, and electric. He slashed his way for gains of nine, fifteen, and two yards, then drilled the ball to Keith Pugh on a pass play that carried Alabama to the twenty-eight-yard line. Steve Whitman found a crease, or maybe he made crease himself, and rambled for twenty yards. Shealy cut into the end zone, and, since he was on a roll, why stop? He kept again for the two-point conversion.

Bryant said it was the most dramatic drive he had ever seen, and the Bear had witnessed a lot of drama.

Alabama surged into the lead, 25-18. It almost wasn't enough. Seconds later, James Brooks, a lightning bolt with shoelaces, took the Tide kickoff and broke free, sprinting for sixty-four yards.

Jeremiah Castille was Alabama's last hope. He had not played much. He was a freshman. He was on special teams. He was raw and untested. He was, he said, scared to death, and he had only made one tackle all day.

The second was the one that counted.

Castille watched Brooks as he headed on a one-man stampede for glory, and said, "I knew I could catch him. I just didn't know if I'd get a good enough hold on him to make the tackle."

Brooks was quick.

Castille was quicksilver.

Castille bulldogged him, grabbed him by the shoulder pads, and hung on. He was desperately searching for the kill switch and couldn't find it. The Tiger running back's throttle was busting wide open, but he couldn't bust loose. Castille dug in his heels and slowed Brooks long enough for Don McNeal to race across the field and knock him off his feet. The goal lay thirty-one yards away.

Auburn had four new downs. The Tigers used them all. They needed ten yards and only managed seven. A last chance died within the shadows of the goal post.

Clyde Bolton wrote in *The Birmingham News*: The fourth quarter comeback "saved Paul Bryant from spending his remaining years in over-hauls and a sweat-stained straw hat, a sharecropper cussing the stones of the earth."

The Bear finally saw a bowl man.

The Sugar Bowl bid came late.

It was worth the wait.

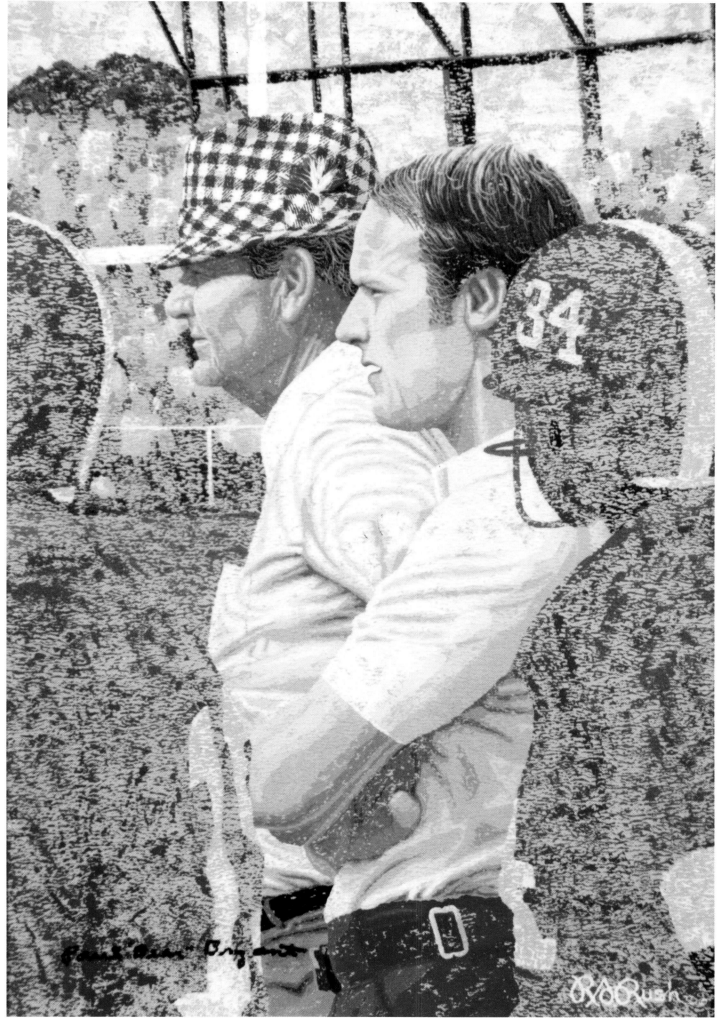

# HEIR TO A THRONE

Standing In The Bear's Footprints

*Little did I realize that the best football team in the country would play an almost perfect game.*

<> Lou Holtz, Arkansas head coach

The Year: 1980

## The Moment:
# Quick Kicking Arkansas

It was the lull just before Christmas.

It was the lull before the storm.

Bear Bryant walked slowly onto the Alabama practice field and yelled with a voice that could have passed for a foghorn, "Give me a center out here."

Bear Bryant was planning to shock Arkansas in the Sugar Bowl. He did not want Alabama to be so predictable. He had decided he would use a little sleight-of-hand, show the Razorbacks one thing, then take it away and give them something else to worry about. Before the day ended, the Crimson Tide would learn the art and the artistry of the quick kick. The Bear was known to dust it off from time to time.

Bryant was always looking for an edge. The Bear was always trying to unearth some unpredictable way to crawl inside an opposing coach's head and rewire the circuitry in the man's game plan. When Bryant began playing Russian roulette with his own schemes, he made it a point to know which chamber held the missing bullet.

For a time, the center worked at snapping the ball through the quarterback's legs, firing it on a direct line to a halfback. It hardly ever worked. Players were bigger now. They had thicker legs.

The quick kick was looking more like disaster waiting to happen. The Bear changed tactics.

He suggested that his quarterback take the snap as he always did, then spin around and pitch the ball to the halfback. Up to now, the charging Arkansas line would not have any suspicions that the Bear was about to knock them on their heels.

The halfback would handle the punt. On the wrong down, perhaps. But never at the wrong time.

As Bryant said, "My first two years here, every game we won was with the quick kick. That was all we had then."

He had a lot more firepower now. But the quick kick, he believed, might still be the most decisive weapon he had. He was an aging maverick. He never forgot the wars he had fought, how he lost them, or what it had taken to win them. If a play worked once, it just might work again. He would find out on a crisp

New Year's Day.

Bryant's mind was in overdrive.

Alabama ran the wishbone. So did Arkansas.

The Razorback defense practiced against the wishbone all day, every day, all week, every week of the season. The defense probably knew the nuances and tactics of the formation as well as the offense. The defense certainly knew how to exploit any weaknesses the Tide wishbone might have.

In the Sugar Bowl, Arkansas lined up to stop the wishbone.

The Bear struck back with the good old double-wing. He had feared that the forward wall of Arkansas was too quick for his large, powerful offensive line. He wanted to turn the strength of the Razorbacks into a weakness. He no longer cared how fast the line of defense might be. The players could be quick as minnows in a bucket for all he was concerned. The Tide was not trying to outrun them. The Tide ran straight at them, over them, and sometimes past them when Arkansas wound up turned around, turned upside down, and headed in the wrong direction. The Bear particularly liked it when an opponent was off-balance, off-stride, and headed in the wrong direction.

He said, "We've had the double-wing for a long time. This is just the first time we've run it."

The team Arkansas watched in the film room had not taken the field. Head coach Lou Holtz was on the sideline and in the locker room at halftime, frantically picking up the pieces and making adjustments on the run. He sketched out a scheme to stop the double-wing dead in its tracks.

The Bear knew he would. Holtz, he said, was a damn good coach.

The Razorbacks bunched up in the middle. They dug in. They tightened up. They stood shoulder-to-shoulder. No holes. No gaps. No creases. Nowhere for Alabama to run.

Alabama switched to the I-formation and an unbalanced line.

Arkansas was caught off-guard and confused.

The Crimson Tide was suddenly running sweeps, beating a faster and a quicker team to the corner, skirting the pile and leaving it stacked in the middle of the field. The Bear unleashed nine different running backs, including two freshmen, but, as usual, it was Major Ogilvie who scored two touchdowns and set up a field goal with a fifty-yard punt return.

None of it, of course, would have been possible without the quick kick.

The Bear didn't forget. He used it twice.

In the second quarter, with Alabama perilously backed up on its own six-yard line and needing five yards on third down, Shealy took the snap, pitched quickly to Ogilvie, and he drilled a line drive, tumbling end over end, for forty-three yards.

With ten minutes left in the third period and the Tide stalled on its own eleven-yard line, facing third down and still nineteen yards away from a first down, Joe Jones took the toss from Shealy and hammered a punt for forty-nine yards.

Those quick kicks, Bryant said after the game, "were the most effective things we did all day. We were buried in a hole both times, we kicked our way out, and nobody was back there to return either one of them."

The offense confounded Arkansas.

The quick kicks cut their hearts out.

The defense never let the Razorbacks off the Superdome carpet. Kevin Scanlon, the Arkansas quarterback, was sacked five times as Alabama ran off with a 24-9 win. He said, "They just kept coming at me. I'm as beat up as I've ever been. Even when I did hit a pass, I got decked. I was always looking up at Alabama from the ground." He should not have been surprised. The Tide defense had recorded five shutouts for the season and led the nation by allowing only a scant 5.3 points per game.

Before the dawn of the 1980 Sugar Bowl, only five teams had ever won two straight national titles: Oklahoma, Notre Dame, Nebraska, Army, and Minnesota. By the time the jazz was flowing down Bourbon Street, the Hurricanes were spilling from the doorways of Pat O'Brien's, and New Orleans had once again become the city that care forgot, Alabama had made it six. They made it easy in the Big Easy.

*No coach has ever won a game by what he knows. It's what his players know that counts.*

<div style="text-align: right">↞ Paul "Bear" Bryant</div>

The Year: 1981

## The Moment:
# Move Over Mr. Stagg

It had been the chase of a lifetime.

It was almost over.

For so long, it had been generally believed that no one would ever endure or survive long enough to catch Amos Alonzo Stagg, who was revered as the winningest college football coach of all time. Mr. Stagg had three hundred and fourteen victories.

He had been an innovator, introducing the man-in-motion and lateral pass to the game. He had been born ten years before the Battle of Gettysburg, played football while a divinity student at Yale, and coached at Springfield College, the University of Chicago for forty-one years, and College of the Pacific after Chicago had the audacity to force him into retirement at the age of seventy.

Bryant once said of him, "Coach Stagg was the Babe Ruth of college football. To me, he is on a pedestal. You can't compare what he did years ago with football of today. In those days, he didn't have a large staff. I've heard his wife scouted games for him, and both of them mended team uniforms. It was a completely different game back then."

Amos Alonzo Stagg had posted a lot of wins.

Paul "Bear" Bryant needed only one more to move into a tie with the venerable old legend, a gentleman of the game, whose name was synonymous with football long before football was synonymous with college sports.

The Bear would be facing an old friend and an old enemy – Joe Paterno. At the moment, only Penn State stood in his way, and the Nittany Lions were preparing to derail and delay that next win up in Happy Valley, in Beaver Stadium, on its own field of battle.

Bryant's team and his assistants were tight and fraught with frayed nerves.

The number three hundred and fourteen never strayed from their minds.

They were perched on the threshold of a historic day, a monumental moment, and they had a front-row seat.

The Bear, years ago, had drawled, "Well, if there has to be a winningest coach of all time, it might as well be me."

Now, he was ignoring the number. But he felt the pressure all the same.

In those rare times of quiet and peaceful solitude, away from the crush of the maddening crowd, the Bear simply wanted to relive the journey. When

sportswriters inquired about his thoughts as he neared the record, Bryant preferred talking about the old family farm in Moro Bottom and walking to Fordyce, Arkansas, which was seven miles if he took the road but only a mile and a half across the fields. He said, "I drove the wagon to Kingsland for a year. I had to get up at four in the morning. The other kids would be playing basketball, but I had to feed the damn mules."

He laughed.

The sportswriters waited to hear about those three hundred and fourteen wins, provided, of course, he could outwit Joe Paterno in the foreign territory of Beaver Stadium, which was not the easiest of places to play, much less win a game.

If the Bear had thoughts, and surely he must, he kept them locked up and tucked away in the deep recesses of his own mind.

Offensive coordinator Mal Moore sat alone in the darkness and watched game film flicker on the screen, frame after frame, hour after hour, night after night. Start. Stop. Start again. The projector was protesting. The film kept running.

He noticed that, only two weeks earlier, Miami's passing attack had been able to hurt the Penn State secondary. He tossed aside the old Alabama game plan and began crafting a new one.

The Tide had been running the triple option wishbone for a dozen years.

The pass was in Alabama's arsenal, but it was hardly ever the weapon of choice.

The Tide threw from time to time just to keep the opposition awake and its secondary away from the line of scrimmage.

Alabama just wanted room to run. Alabama was notorious for chewing up large chunks of ground like an earth mover on the prowl.

All week, in practice, Alabama worked on and polished up its passing game. The team considered it a curiosity and little else. Wide receiver Joey Jones said, "Even then, I didn't get too excited because almost every week the coaches would come out saying we were going to pass more, and we never did."

Paterno no doubt anticipated a few forward passes being thrown his way.

He did not expect a barrage.

Bryant installed sophomore signal caller Walter Lewis, and the aerial assault was underway. Passes filled the air and descended on Happy Valley like a sudden and violent hailstorm. Deep. Short. A post. A curl. The slant. The flare. A screen. It didn't matter. Penn State's secondary had holes, and Walter Lewis found them all.

He might as well have been in a shooting gallery. Joey Jones was downfield running loose and free;. Split end Jesse Bendross had more escapes with fewer defensive manacles than Houdini. And fullback Paul Carruth generated the power. Alabama piled up three hundred and thirty-four yards through the air, and the Bear had his win, 31-16.

Joe Paterno would always say, "When I stood toe to toe with Bear Bryant, he outcoached me." It gnawed at his gut. It forever rubbed a raw nerve.

He may have gotten over it. He never forgot it.

Bear Bryant was carried to the far end of the field on the shoulders of his players. He heard the crowd screaming his name. He heard the applause, the shouted words of congratulations.

He saw tears in their eyes, tears running down their cheeks, and he thought to himself, Alabama has the greatest fans in the world. Then he looked again.

More closely, this time.

The cheers – the tumult and the shouting – belonged to those wearing the colors of Penn State. For the first time all night, he felt humbled.

Defensive lineman Warren Lyles presented Bryant with the historic game ball in the locker room. He said, "I felt like a man who had been poor all of his life and suddenly found a million dollars. Only double it."

The Bear was proud because his team was proud.

Now the chant began again.

One more.

In the life of a football coach, it was always one more.

And one more was never enough.

> *All I know is, I don't want to stop coaching, and I don't want to stop winning, so we're gonna break the record unless I die.*
>
> — Paul "Bear" Bryant

The Year: 1981

## The Moment:
# Goodbye, Mr. Stagg

The focus of college football was on Paul "Bear" Bryant.

His focus was on Auburn.

All of Alabama was waiting for him to break Amos Alonzo Stagg's record of three hundred and fourteen wins.

All he wanted to do was beat Auburn.

And he was worried.

The Bear always was.

On Monday before the game, he said after practice, "We had a wasted day. The defense did okay, but the offense has sure gone backward. They acted like they were playing with a bowling ball."

He thought for a moment.

He shrugged.

He growled, "I can't think of anything good I saw."

It was a game that could only have been scripted by the gods.

He would have a rare chance to establish the record as the winningest college football coach of all time against Auburn, Alabama's greatest rival and its most fierce competitor, in the Iron Bowl, in Birmingham, on the last glorious Saturday of the season.

The Bear could have asked for nothing better. He could have asked for nothing more. He would be trying to climb atop a record that had stood for fifty-seven years.

On the week of the game, the country wanted to know more about the Bear.

In Alabama, he was flesh and bone.

On a national level, he had become a myth, the stuff of legend, partly fact and partly fiction, caught somewhere between the veil of truth and a thread of contradiction.

Bill Lyon, a syndicated writer for *Knight-Ridder*, penned: "In the old black and white pictures, he was rakishly handsome. He had the look of a rogue, a go-to-hell daredevil who should have been climbing into the open cockpit of a bi-wing fighter with a white silk scarf flowing majestically in the breeze, flipping away a last cigar with a contemptuous sneer, and shouting, 'Contact.'

"He is sixty-eight now and, from a distance, he looks like a shambling old man, shuffling along, his

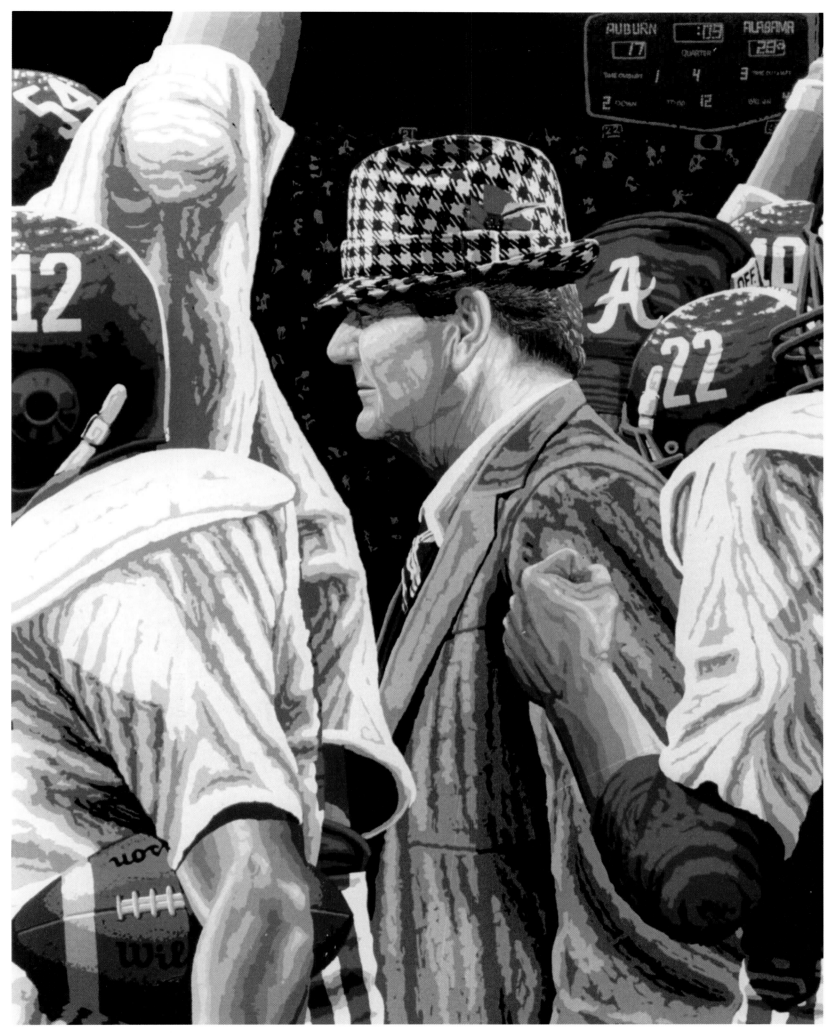

AT LONG LAST

The Dream Is Realized

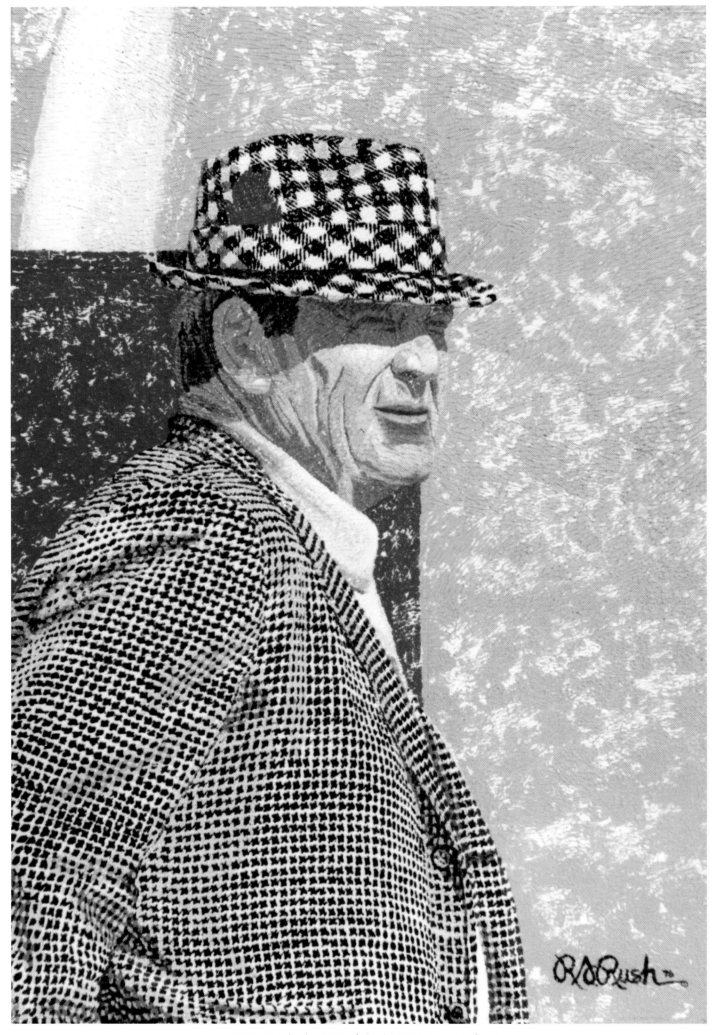

## AWAITING THE KICK

Saturday Afternoon With The Bear

face craggy and seamed and creased, the eyes scrunched up from too many years of squinting into the sun. But up close, he is still a galvanizing presence, still a massive man at six feet, three and a half inches, and two hundred and five pounds, still erect, his eyes glinting with hidden mirth, with passion ... He has been nicked and sliced, and they have tried to chew off his ear, but the Bear still owns the briar patch.

"He has adjusted to some truly traumatic transitions in society. He has won with players who wore crew cuts, with players who use hair dryers. He has won with players who gave blind obedience and with those who rebelled. He has won with generations from the post war '40s, the unquestioning '50s, the protesting '60s, the racially stirred '70s, and now the unsettled '80s. He has won with white kids, black kids, sharecroppers' sons and millionaires' scions."

The players had come in all shapes and sizes, from cities, from small towns, from farms, rich and poor, big as the bear who, once upon a time, wrestled the Bear, quick like flashes of daytime lightning, ornery as horses with a burr under their saddles, the praying kind and the drinking kind, tough as leather, smooth as silk. They were devoted to the man who worked them, drove them, and pushed them far beyond their limits, and loved them like his own children.

He stood behind them, and they fought for him.

The faces and the numbers kept changing. The devotion remained steady.

They had indeed won for him. For three hundred and fourteen times, they had won for him.

His legacy had been placed in their hands one more time.

Auburn had no interest in being part of history.

Sooner or later, the Tigers knew, the Bear would own the record. They preferred that it be later.

The Bear would not be denied.

He lit the fuse and turned loose three quarterbacks, none of whom were playing with a bowling ball any longer. Alan Gray sparked a drive early with a sixty-three-yard dash and capped it with a touchdown run from the one. In the second quarter, Ken Coley hooked up with Jesse Bendross on a twenty-six-yard scoring pass. With the Tide battling back during the final period – after Auburn had regained the lead, 17-14 – Bendross broke loose again with a thirty-eight-yard touchdown pass from Walter Lewis.

Three minutes later, Alabama struck again, taking only three plays to travel forty-nine yards. Halfback Linnie Patrick ripped off thirty-two of them, then sprinted for fifteen more on a wild final gallop to the end zone.

Under pressure and pounded recklessly by a determined Auburn offense, the Crimson Tide, down but never out, trying to grab, earn, or steal the most important game of its life, overcame one obstacle after another in a backyard family brawl of monumental and historic proportions to present

Paul Bryant his record-setting, three hundred and fifteenth win, 28-17.

Auburn Coach Pat Dye, a former Bear assistant, met his old mentor on the field. Congratulations were in order. He gave them.

Then Dye said, "Coach, we whipped you in the statistics. I sure wish they counted."

Bryant laughed. He glanced at the scoreboard. It was habit. He knew where the points counted. For three hundred and fifteen times, that's where they had counted the most.

The Bear buried the pride he must have been feeling and was as disgruntled as ever when he strolled in to meet the press. "Offensively, we did nothing in the first half," he said. "The offense treated Auburn like their brothers or their children. It looked like we were afraid we were going to hurt them.

"To turn it around and come back the way we did was one of the greatest wins I've ever been associated with. I thought we played real well, but it looked like the Good Lord wasn't going to let us win there for awhile."

The Good Lord had not chosen sides.

He was quite content to let Alabama win, even if Bear and the Tide had to do it the hard way.

The Bear, He figured, could take care of himself.

He always did.

> *Sure I'd like to beat Notre Dame, don't get me wrong. But nothing matters more than beating that cow college on the other side of the state.*
>
> — Paul "Bear" Bryant

The Year: 1984

## The Moment:
# Gut Check Time

It would become known with two words: *The Play.*

For Alabama, it was a justified ending in the final seconds of a difficult day.

For Auburn, it would live in infamy.

Paul "Bear" Bryant had walked away two years earlier, saying sadly, "I love the players, but, in my opinion, they deserve better coaching than they have been getting from me this year. My stepping down is an effort to see that they get better coaching from somebody else."

It was the end of an era. Less than thirty days later, Paul "Bear" Bryant was laid to rest in the Alabama clay that held his footprints, his gravel voice silenced, his legend even larger in death than it had been in life.

He was gone far too soon.

As a solemn Woody Hayes said at his funeral, "He literally coached himself to death. He was our great-est coach."

The reins of Alabama's storied program were handed to one of Bryant's former receivers who had made quite a name for himself in the National Football League, Ray Perkins.

The Bear had always told his players, "You never know how a horse will pull until you hook him to a heavy load."

Alabama wasn't hooked up to a heavy load.

But the Tide would have to stop one.

The choices had been pared down to one.

Alabama was desperately hanging on with broken fingernails, leading Auburn, 17-15.

The Tigers were just outside the goal line.

They needed a yard.

The Tigers had harnessed, perhaps, the most feared tandem of running backs in the nation: Brent Fullwood and All-American Bo Jackson, who stood an inch taller than six feet, weighed two hundred and twenty-two pounds, and ran mean, some said, like a wild boar.

He would win the Heisman Trophy, and Auburn

head coach Pat Dye said, "Bo is superior to anybody I've seen before or since. He can do things that defy human logic."

Perkins himself thought that Jackson was the finest running back he had ever seen, pro or college.

The year before, the Tigers had defeated Alabama with Bo Jackson carrying the ball only twenty times and ripping up the ground for two hundred and fifty-six yards.

Among men and boys, Bo Jackson was a beast.

And Alabama had to stop him.

Cold.

Dead in his tracks.

The minutes were fading to zero, and Auburn had decided to ignore the field goal.

Dye had more faith in the famed combo sweep.

He put his trust in Jackson and Fullwood.

They were money.

If the game was on the line, he wanted one of them to have the ball in his hands.

He wanted Bo at the goal line.

Bo knew what to do.

Scale the wall.

Or, run through it.

He was, Dye knew, good at both.

Auburn, behind quarterback Pat Washington, swaggered to the line of scrimmage.

Alabama was ready for the field goal.

There was no kicker in sight.

He remained somewhere on the far end of the Auburn bench.

Ray Perkins would say, "Two thoughts immediately came to mind. First, I couldn't believe it. Second, let's stop it."

The play – simple, direct and deadly – the feared staple of the Tiger attack, was called in the huddle, but Auburn backs would not know the direction of the sweep until Washington reached the line and looked over the Alabama defense, searching for one weak link that might be a step too slow or crack under pressure.

He didn't like what he saw.

The noise was loud, and growing louder.

It was deafening, becoming difficult and almost impossible for anyone to hear.

Washington's words, his cadence, and his critical audible were drowned out by a heavy rumble, not unlike the heat of August thunder, rising up in a crescendo that erupted and enveloped Legion Field with a wall of white sound.

He looked at the twenty-five second clock.

Time was running down.

Washington should have called time out.

He had one left.

He didn't.

For the last three times in short-yardage situations, Bo Jackson had gone left.

That's where Alabama would be expecting him to go once more.

Washington decided to catch the Tide off guard.

He would sweep right.

He called the play.

Bo Jackson strained to hear.

The words were lost in the throbbing noise of the crowd.

Washington and Fullwood swept right.

Bo Jackson went left.

He had taken himself out of the play.

Alabama free safety Rory Turner crept closer to the line, and he remembered, "I knew Bo Jackson would get the ball in a critical situation like that. I was surprised when Fullwood took it."

Washington was ready to pitch to Jackson.

Jackson wasn't there.

He tossed instead to the only back trailing behind him, and Turner hit him chest high, rocking Fullwood for a three-yard loss.

His own description of the play was quick and to the point. "I waxed the dude," he said.

Auburn had its eyes set on a major bowl.

All hopes faded when Bo Jackson headed in the wrong direction.

All the next week, the conversation in Tuscaloosa remained the same.

"How do you get to the Liberty Bowl?"

"You go to the one-yard line and turn left."

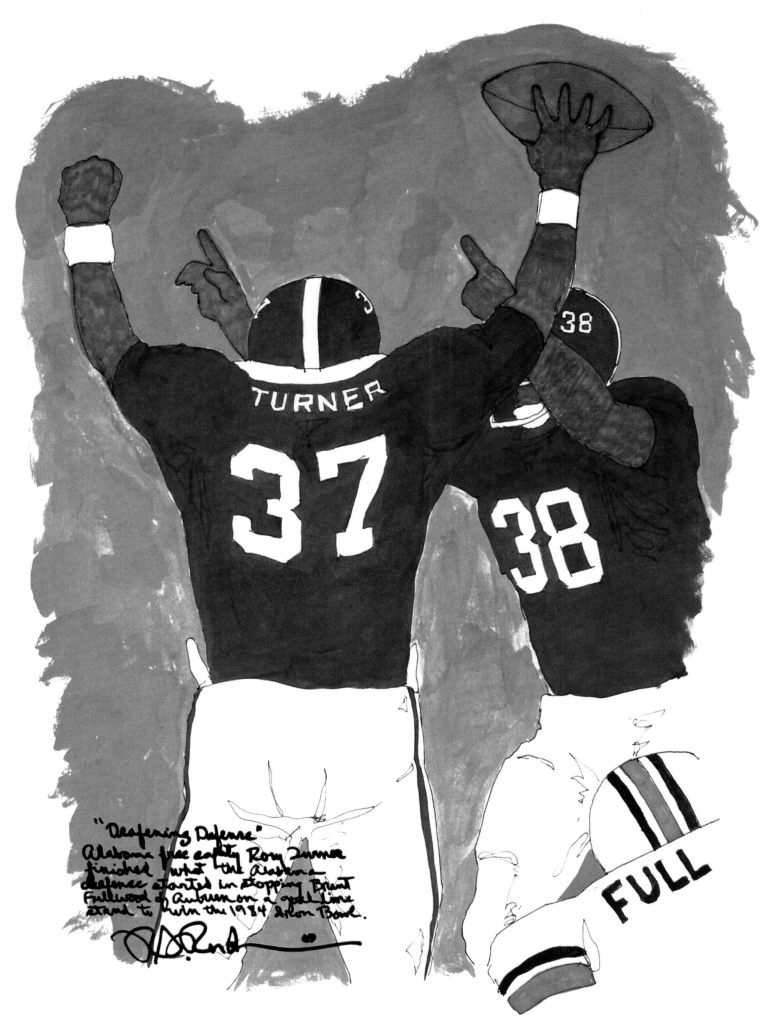

## GOING HAYWIRE

Alabama Stops Auburn and Fullwood Short

*Mike Shula did exactly what he had to do to win. He's a winner.*

⤳ Vince Dooley, Georgia head coach

The Year: 1985

## The Moment:
## The Final Fifty

Ray Perkins had no reason to try and confuse the Bulldogs. His basic strategy and game plan were far more straightforward and far less complicated.

Play tough, he told his team.

Play aggressive.

Outhit Georgia.

And outhustle them.

Alabama players dug the trenches a little deeper. They tightened their shoelaces, ignored the pain, which would heal, forgot the bruises, which would fade, wiped away the blood, which wasn't their own, peeled their eyes, laid back their ears, worked their cleats into the ground, and hit Georgia with the force of a locomotive that was burning on new coal and headed for a downhill grade.

The Tide was clinging to a 13-9 lead as though life depended on it.

It did.

And all Alabama had to do was hang on. The final seconds were spilling off the clock. Just a minute or so longer.

That was all.

Hold on.

Take your time.

Let the clock keep bleeding.

No hurry.

Punt the ball deep.

Give Georgia a long field, an impossible field.

Bunch up.

Hold tight.

Hold on.

It was almost over.

Suddenly, from out of the blue, came the most dreaded sounds in football.

Thump.

Thump.

The toe of the punter hammered the ball.

The ball hammered against the chest of a rushing Bulldog defender.

Thump.

Thump.

Terrie Webster blocked the punt, and Calvin Ruff finally corralled the ball, falling on it in the end zone for a Georgia touchdown.

For Alabama, it was like a swift and sudden kick in the gut.

The bile hung sour in its throat.

The clock dropped under a minute, and now it was Alabama facing a long field, an impossible field.

117

Fifty seconds.

That was all the Tide had left.

Victory and defeat were separated by a scant fifty seconds.

The final fifty seconds.

The Crimson Tide came to the line of scrimmage seventy-one long and arduous yards away from a touchdown.

There were no time outs left, and Ray Perkins placed the game in the hands of his quarterback.

Mike Shula had never been able to throw the ball seventy yards.

But he was deadly accurate.

Shula wasn't fleet of foot.

Defensive linemen could outrun him.

His time in the forty-yard dash was closer to 5.4 than 4.5.

The game was as good as lost.

But Mike Shula didn't know it.

He was calm.

He was confident.

He looked into the eyes of his team in the huddle and saw neither fear nor panic.

Good.

Alabama had a chance.

He said, "Coach Perkins told us to line up in our two-minute offense. We always talked about taking what the defense gave us and working the clock down."

If worse came to worse, and in football it often did, Perkins had decided that, if the Tide was anywhere within striking distance, he would send in his placekicker and go for the tie.

He didn't like ties.

But they were far better than losses.

After all, Van Tiffin had already booted field goals of forty-one and forty-eight yards and could kick farther than Shula could throw.

If Van Tiffin was his last prayer in a game where most of the prayers had already been wrung from his throat, Perkins felt good about his chances.

For the moment, Van Tiffin would have to wait.

On the field, Mike Shula still had his hands and his heart wrapped around fifty seconds. He believed he would have to outwit Georgia.

He could not trick the clock.

It kept running, and every tick was a dagger point in his heart.

The march began.

Shula remembered, "We got in the huddle, and we had good plays called. We couldn't have asked for better defenses than the ones Georgia used. Coach Perkins called the first play, and I called the next one. With each new play, something opened up for us."

Shula kept finding his receivers.

And they kept finding the sidelines.

Alabama was playing as though the out-of-bounds line was a twelfth man and suited up in Crimson.

Grab the ball, twist around, stretch for the chalk, and listen for the clock to stop.

It stopped just often and just long enough.

On the fifth grueling play after the kickoff, Perkins felt that Georgia would blitz.

It might be a gamble.

The Bulldogs had no choice.

They had to interrupt Shula's rhythm.

They had to rush him.

Maybe he would make a mistake.

Georgia needed a mistake.

Defenders split the creases and poured through the cracks.

Eyes wide.

Arms up.

It was the charge of the heavy brigade.

But Mike Shula was in a zone that time could not penetrate and the clock did not dare interrupt.

He caught a glimpse of Al Bell breaking free.

An instant.

All he had was an instant.

Shula fired, and the flanker came down with his second touchdown catch of the day.

Fifty seconds hadn't been much.

They were enough.

Mike Shula had used them all.

Far less happened in some lifetimes. An impossible ending fell hard on an improbable day.

*When he got past the line of scrimmage, I knew he was gone. Nobody was going to catch him.*

<>  Head coach Ray Perkins on Gene Jelks

The Year: 1985

## The Moment:
# The Kick

The season ended as it began, with Alabama staring hard into the unsightly face of defeat, searching for a glimmer of hope, and somehow managing to find it in a cruel game where wins were never promised and losses never certain, and the scoreboard did not always reflect the size of man's heart, only the odd, crazy little ways that a football happened to bounce.

Against Georgia, it was the calm leadership of Mike Shula, shedding the pressure that wrapped itself around his shoulders, marching seventy-one yards in five plays on the final drive, and completing the last pass he needed to throw, hooking up with Al Bell for a touchdown.

For a fleeting moment, Mike Shula felt as though he were caught in a time warp.

Nothing had changed on the defensive side of the ball but the uniforms.

Auburn had just scored to capture the lead, 23-22, and the hands on the clock were locked at fifty-seven seconds.

It all seemed so similar.

It had such a strange and eerie feeling.

*Déjà vu* always did.

Could lightning strike twice?

Would it even dare to strike twice?

On the sidelines, Ray Perkins gathered his team around him and softly prayed : "Father, we thank you for giving us the strength and the power, the will and the pride, for giving us the opportunity for this victory. Amen."

No other words were spoken.

Not a sound came from the sideline huddle.

Silence.

Perkins did not have to give his team any strategy, any scheme, any plays to run. He team already knew what it had to do.

Alabama had been there before.

It didn't start well at all.

The Tide lost time.

The first pass was knocked down.

A sack lost a few yards.

A quick pass gained some of them back.

But Alabama had lost valuable downs, three of them. Shula faced fourth and still needed four yards

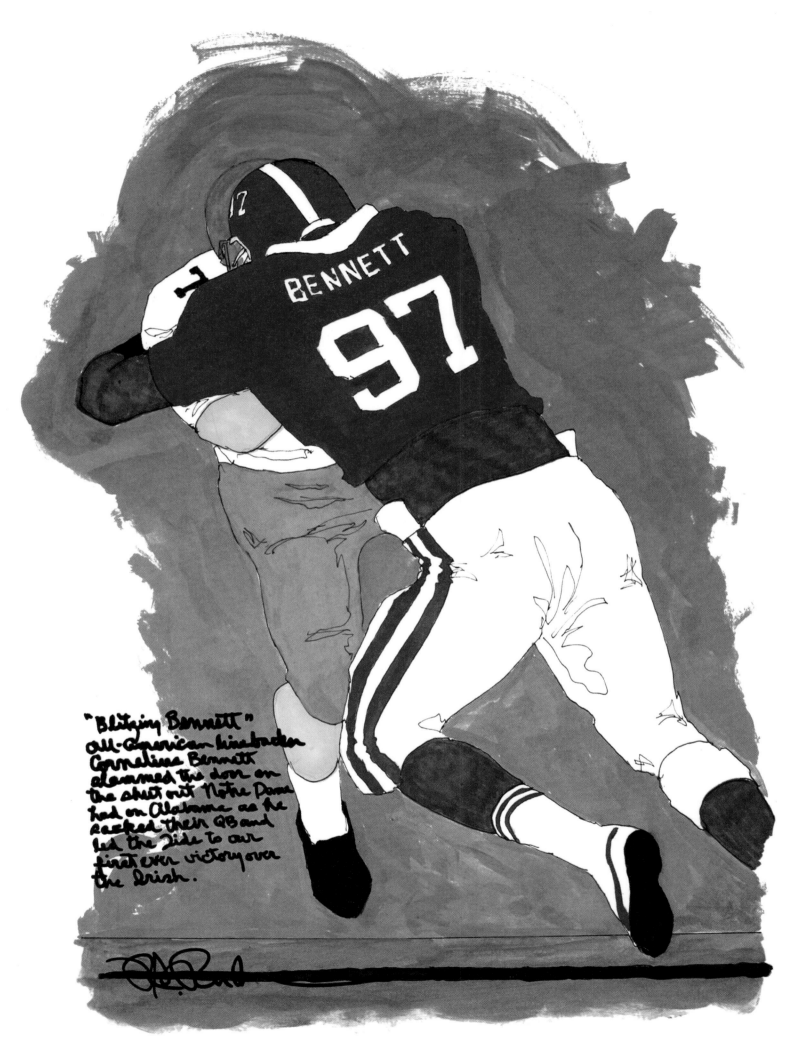

"Blitzing Bennett" All-American linebacker Cornelius Bennett slammed the door on the shut out Notre Dame had on Alabama as he sacked their QB and led the Tide to our first ever victory over the Irish.

# CORNELIUS BENNETT

Turning Up The Pressure

with the ball placed squarely on his own twenty-six-yard line.

Perkins had a decision to make.

Go for the first.

Or, go for it all.

He decided to try and get the four yards.

A first down wasn't the promised land, but it was headed in the right direction.

Without it, Alabama could pack up and go home.

Auburn was waiting for Gene Jelks.

In the eyes of the Tigers, he was the likely choice.

After all, the running back had already gained a hundred and ninety-two yards and broken for a seventy-four-yard touchdown.

He was Shula's bread-and-butter back.

No doubt about it.

The fleet-footed and hard-running Gene Jelks was headed their way.

Auburn buckled down, tensed its muscles, bowed its back, and waited.

Mike Shula did not disappoint the Tigers.

He pitched the ball to Jelks, who darted right and handed off to Al Bell, scampering left at warp speed on the reverse.

Bell had hit against the grain.

No one saw him coming until he had cut down the left sidelines for twenty-six yards, bouncing out of bounds to kill the clock.

A pass down the middle to Greg Richardson thrust Alabama closer. The clock was spitting away seconds like used watermelon seeds.

But it stopped when Richardson edged his way out-of-bounds.

It wouldn't stop long.

Auburn had been the enemy.

The clock was the villain.

Van Tiffin, the walk-on from Red Bay, Alabama, raced on the field.

He recalled, "We had the rush field goal team ready. Nobody even waited to be told to go in the game, and we didn't even look at Coach Perkins."

They didn't need any direction.

Alabama had no time-outs.

There was no time to collect his thoughts.

It didn't matter.

Kickers of field goals didn't necessarily have thoughts to collect.

Thoughts could be dangerous, maybe even deadly. He hurriedly placed the tee on the ground and stepped back.

Time was moving fast and picking up speed.

For Van Tiffin, time stood still.

He was in a mental vacuum where only kickers ever dared enter.

Van Tiffin had already kicked three field goals, missing one from fifty-two yards.

He was facing another fifty-two yarder.

It was an omen.

Good.

Or bad.

He said, "I wasn't nervous. Everything had been rushed, so there really wasn't time to think about it.

"The snapper dictated when the ball would be snapped. As soon as Larry Abney [the holder] put his hand up, out came the ball. I was kind of shocked, and I was late leaving."

By the time the ball was snapped, the final six seconds were already draining from the clock.

"When the ball got up," Tiffin said, "I knew it had a chance. Then when I saw where it was, I didn't even bother to finish watching it."

It split the uprights. The distance wasn't even a question. He had a big leg.

Adrenaline had provided a high octane fuel.

Alabama had a 25-23 victory, and Billy Mitchell wrote in the *News*, "Tiffin's kick meant the difference between a eulogy and euphoria for Alabama."

Wayne Hester of the *News* penned: "It was a game in which its combatants left not only all their energy and effort, but even their hearts, on the field."

The kick had been like a heartbeat.

A second.

Maybe less.

And it was over.

> *Playing at Alabama taught me mental toughness, being a team player, being a winner.*
>
> ⎯◇⎯ Cornelius Bennett, Alabama Linebacker

The Year: 1986

## The Moment:
# So Long to the Jinx

The ghosts were everywhere.

They were waiting. They had waited for so long.

They weren't going anywhere.

Their faces were no longer seen, their voices no longer heard.

Their memories were out of sight but not out of mind.

They shuffled quietly amidst the dust and cobwebs that blanketed the inner sanctum of Legion Field, but it could have been any field where Alabama had lined up to face the Fighting Irish of Notre Dame.

Time and space meant nothing, not to ghosts.

Only tradition. Alabama and Notre Dame had long been swathed in tradition.

Frank Thomas, the great Alabama coach, had played for Notre Dame, roomed with the famed George Gipp, been coached by the legendary Knute Rockne, and, as head man with the Crimson Tide, ran an innovative offensive formation, far removed from the single wing, known as the Notre Dame Box.

But too many times, Alabama had gone to war against Notre Dame.

Too many times, the Irish had emerged as the winner.

Not even Bear Bryant had been able to beat Notre Dame.

Season games.

Bowl games.

It did not matter.

Notre Dame had the mystique.

Notre Dame had the horses.

Notre Dame had the history.

Notre Dame always won.

And the ghosts of games played and games lost were restless.

Time had never been able to erase the memories. Time no longer tried.

The wizened heads of the national sporting press said that Alabama was fighting a losing cause, that Alabama would never be able to overcome the Notre Dame jinx.

Tide assistant coach Sylvester Croom grumbled, "There is not a jinx unless you want to believe in one."

He didn't.

The wizened heads of the national press said that

Alabama could not rise above the famed and notorious Notre Dame mystique.

Head Coach Ray Perkins said quietly, "I don't think I've ever seen mystique beat a football team. But I've seen eleven guys on offense and eleven guys on defense go out and beat a football team."

Perkins may not have been superstitious, but he was not taking any chances.

Notre Dame was a Catholic university.

Perkins was Catholic.

He flew his own personal Catholic nun, Sister Carol Ann, up to South Bend for the game.

And he wore the same light blue shirt with white collar he had worn so many times.

The so-called jinx did not bother him, but Perkins was concerned about Irish quarterback Steve Beuerlein and flanker Tim Brown.

One could dissect and dismantle a defense with his passing arm.

The other had raw speed equipped with afterburners.

Alabama could not take its eyes off Tim Brown.

Speed could kill.

Speed hit the Alabama defense.

Tim Brown hardly ever touched the football, and, when he did, he found himself in a cage with Crimson jerseys.

Speed had been slowed to a crawl.

Mike Shula threw a couple of touchdown passes to flanker Al Bell and another to tight end Howard Cross.

Greg Richardson busted past the Irish for a sixty-six-yard punt return.

The Tide nailed twenty-eight points to the scoreboard.

And an angry Crimson swarm descended on Steve Beuerlein.

He faced pressure.

He faced the blitz.

He knew what was coming: an avalanche of Crimson. He flinched.

Notre Dame could not plug the dam, and Steve Beurlein could not escape the mad, determined rush of linebacker Cornelius Bennett.

Bennett said, "If people ever watched me work, they'll know I was working with a purpose and not just out there showing off. I was working to get the job done."

His job was stopping Steve Beurlein.

He was working overtime.

Beurlein was paying a heavy price.

During the fourth quarter, the Notre Dame quarterback dropped back, looking for a receiver.

He should have been looking for Cornelius Bennett. He knew the train was coming.

He should have gotten off the tracks.

He was looking left, and Bennett came from the right. Beurlein went one way.

The ball went another.

His head rocked back.

His eyes rolled back.

The field went dark.

It would be known for all time as "The Sack."

As Beurlein said, "It was to a point where I would be trying to figure out where he was going before the snap and understand where he was coming from. Those are the things you really don't want to be thinking about before the play even gets started. He knocked me woozy. I have never been hit like that before and, hopefully, I'll never be hit like that again."

Bennett said, "I had always been taught to get the man with the football as fast as I could and as many times as I could."

That's where Beurlein made his mistake.

He kept the football.

The final score was 19-10.

The damage was far worse.

As Billy Mitchell of the *News* wrote: "Alabama slammed the door on the haunts of the past and slammed Notre Dame."

The lights dimmed.

Silence fell amidst the dust and cobwebs of Legion Field and upon all the fields where Alabama had lined up to play Notre Dame.

Darkness cloaked the night.

The ghosts were gone.

> *I don't remember a player ever running the ball on us like Bobby Humphrey did tonight. He is a remarkable football player.*
>
> ⟨⟩ Joe Paterno, Penn State head coach

The Year: 1987

## The Moment:
# The Dream Game

It was judgment day, a time for retribution.

Twice during the past four years, Alabama had lined up undefeated teams against the Nittany Lions of Penn State.

Twice during the past four years, the Crimson Tide had been chasing the outside but very realistic odds of winning a national championship.

Twice during the past four years, Alabama walked away with the bitter taste of defeat hanging in its throat.

Bitter turned sour.

And sour turned to gall.

Only a year ago, Penn State had triumphed again. Alabama didn't lose, the press said. Alabama was abused and manhandled. Alabama had taken a "woodshed whipping."

The loss hurt still.

Joe Paterno had never been able to beat the Bear. The bitterness and disappointment hung haunted him.

Time and again, he had been soundly out-coached, out-thought, and out-gambled by the Bear.

It was a new day and a new time. Suddenly, the Crimson Tide could not beat Joe Paterno.

Alabama was cursed.

It was up to new Alabama head coach Billy Curry to break it.

He loaded up, packed his players in the plane, and headed for Pennsylvania to face the defending National Champions and the dastardly confines of Beaver Stadium.

Alabama was treading into perilous territory and walking on dangerous ground.

The weather forecast predicted that the field would be wet and soggy, blanketed deep with the miseries of mud and mire.

The Crimson Tide had a formidable ground game.

Penn State was not worried. Penn State would not have to stop the ground game.

The mud would.

Running back Bobby Humphrey knew what to expect: a great venue, a national television audience, and the rain.

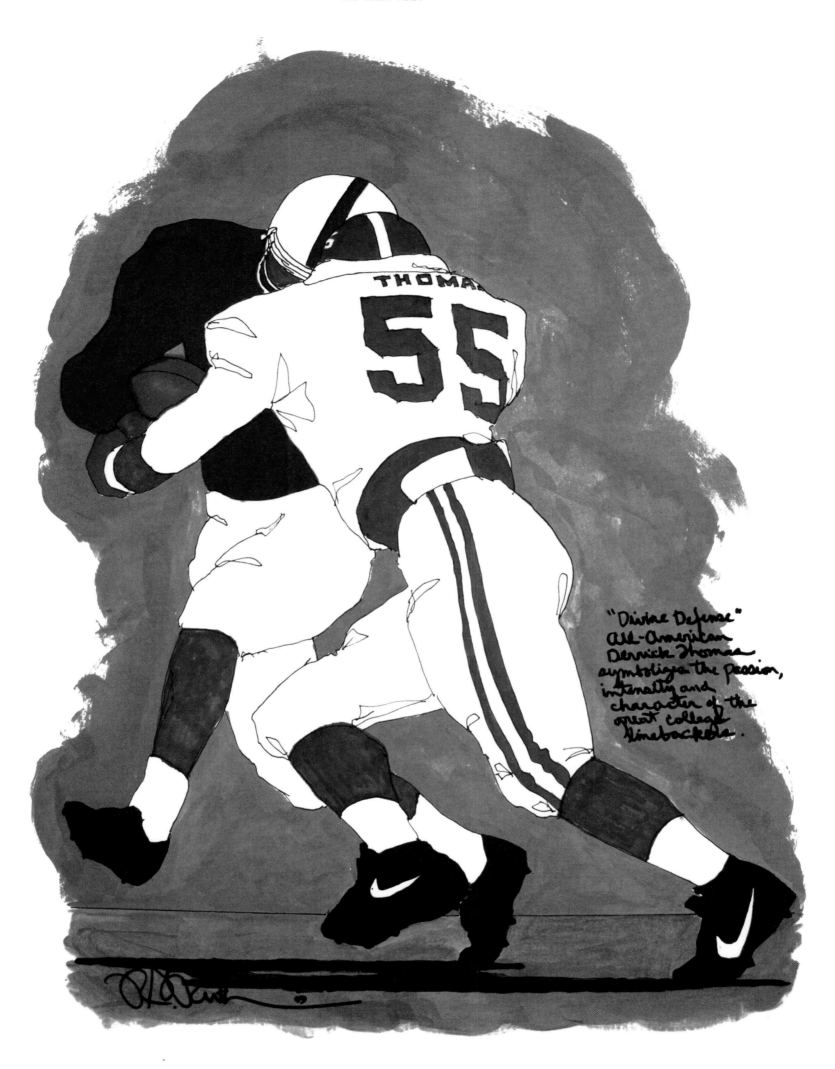

"Divine Defense" All-American Derrick Thomas symbolizes the passion, intensity and character of the great college linebackers.

# DERRICK THOMAS

The Motor Never Stops

The sky was dark and turning green, the clouds boiling and purple like a bad bruise.

For Humphrey, it was a simple equation.

The mud might slow him down. It could do that.

It would also slow down the Penn State defense.

He would still be faster.

He said, "We felt that it was going to be a slippery field and probably a wet night, but I would play Penn State under any conditions, even rain or snow. It wouldn't bother me one bit."

It didn't.

On Alabama's second possession, Humphrey cut back against the grain, found traction and a higher gear, tore past the line, and raced through the sludge for a seventy-three-yard touchdown.

"I was supposed to go outside the right tackle," he said. "I didn't see any daylight, nothing but Penn State jerseys, so that's when I made the cut and hit back up the middle. When I broke, I knew I was going to have a good night."

When Bobby Humphrey broke, he had already had a good night.

Philip Doyle connected on a forty-six-yard field goal, and quarterback David Smith began orchestrating a laborious eighty-nine-yard drive in the second quarter with time falling like raindrops from the clock.

On the sidelines, the Alabama fullback sidled up to Humphrey. "Dry your hands," he said.

"For what?"

"You're gonna throw the ball."

Humphrey was shocked.

Curry nodded.

Humphrey grinned.

"Let's do it," he said.

Penn State never saw it coming.

Penn State would not have believed Humphrey would dare throw the ball in such soggy conditions even if he had handed them the playbook.

He took the pitch and drifted wide.

The Nittany Lions bit. They never saw the pass coming. It hit before they heard the shot.

The defense was still rushing up hard to stop the run when he hooked up with flanker Clay Whitehurst for a fifty-seven-yard gain.

Moments later, David Smith slipped into the end zone.

Whitehurst had caught the ball.

Now he surprised the Nittany Lions by throwing it, hitting tight end Lamonde Russell for the two-point conversion.

The Tide was rolling hot and often, and Penn State had not yet scored.

Penn State had not yet threatened.

The Nittany Lions were being battered and bruised by a defensive hammer known as Derrick Thomas.

He was fast.

He had a knack for making the turn as a speed rusher coming off the edges, flying around the corner, leaving his own mark on whomever happened to have the ball at the time. It looked a lot like a bruise..

Derrick Thomas played bigger and stronger than he really was.

Bobby Humphrey still had unfinished business. In the final period, he carried seven times in a nine-play drive, gaining forty-seven yards and possessing the endurance of a warhorse.

He would say, "I took a lot of shots tonight."

So did Penn State. Most of them had been fired by Bobby Humphrey and Derrick Thomas.

The Tide running back gained two hundred and twenty yards, and Curry told the inquiring press, after the 24-13 victory, "I don't even know what to say about Bobby Humphrey. I ran out of superlatives two weeks into spring training."

The week before, Joe Paterno had won his two hundredth game. He met the Crimson Tide in search of two hundred and one.

After the smoke had cleared, the sky dried, silence descended on Beaver Stadium, and Alabama had flown out of Happy Valley, he was still looking for two hundred and one.

The Tide had come north looking for revenge.

The Tide left with respect.

Happy Valley wasn't so happy anymore.

Bill Curry said Alabama had played The Dream Game.

> *The expectation level is high at the University of Alabama, and it should be. What's wrong with people expecting excellence?*

—< Gene Stalling, Alabama head football coach

The Year: 1990

## The Moment:
## The Coming of Gene Stallings

He had been molded in the image of the Bear. Gene Stallings had the same rugged, weathered face, chiseled from granite. He spoke in a low voice with a throat full of gravel. His voice had the tenor of approaching and impending doom.

He talked slowly, his rough-hewn drawl torn from the harsh badlands of the Southwest rather than the gentle grace of the Deep South. He chose his words carefully. There was never a misunderstanding about what he said or meant.

He was the man in charge. No one doubted it.

Lee Roy Jordan said, when the announcement came down that Alabama had hired a new head football coach, "Gene Stallings was Coach Bryant's selection to replace him when he retired. It didn't happen at that time, and that may have happened for a reason. We may not have been ready for it. I think the

University of Alabama, the fans, and the people are ready for Gene Stallings now."

Stallings had played for the Bear. He had been one of Bryant's storied "Junction Boys" at Texas A&M, the bunch that had been hauled out to a remote, Hill Country patch of hardscrabble ground known as hell's little acre. A sportswriter would describe two-a-days at Junction as "the toughest and most brutal fall camp ever."

Only the best would survive.

Three busses with football players had gone to Junction. Two busses came back empty. Only twenty-seven had endured the heat and harsh conditions beneath a searing, unforgiving August sun. One of them was Gene Stallings.

On looking back, he said, "I never did understand the meaning of quit. There was a time in Junction when I wanted to die. That would have been the honorable way out. But quitting never crossed my mind."

Gene Stallings was part of a rare breed.

He said, "Out of the many things I learned playing for Coach Bryant at Texas A&M was you'd better look out if he ever started singing Jesus Loves Me.

Things were about to get tough, if not unbearable." Stallings served as an assistant under Bryant at Alabama, returned as head coach at Texas A&M, won a conference championship, and even defeated his old mentor in the Cotton Bowl. He worked for eighteen years in the National Football League – as an assistant with the Super Bowl-winning Dallas Cowboys and as head coach of the Arizona Cardinals.

Gene Stallings was a strict, no-nonsense disciple of Bear Bryant and he had the same go-for-the-throat mentality.

As Stallings said, "I know that I picked up a great deal of things during my association with Coach Bryant. I know he influenced me as a coach by teaching me to never give up on your talent. And he told me there was no substitution for work. He convinced his people. And when players and coaches are convinced they can win, they're going to win."

He had been motivated, inspired, and shaped by Paul Bryant. Now he stood in the Bear's shadow. Anyone coaching Alabama stood in the Bear's shadow.

Alabama had promised that the university and its fan base would be patient, give him a chance to recruit and build a team for his system with his kinds of players. Gene Stallings knew better.  He said, "There will be a lot of expectations. You don't have thirty-one years of rich tradition and say you're going to give a guy two or three years to prove himself. You can say that in the summer, but you can't say it in the fall.

"I loved the years I was with Coach Bryant, but I'm not Coach Bryant. I wish he were around so I could consult him, but he's not. I don't have his style. I don't coach like him."

Nobody expected him to. No one could.

There was idle talk, however, of a national championship. It wasn't so idle.

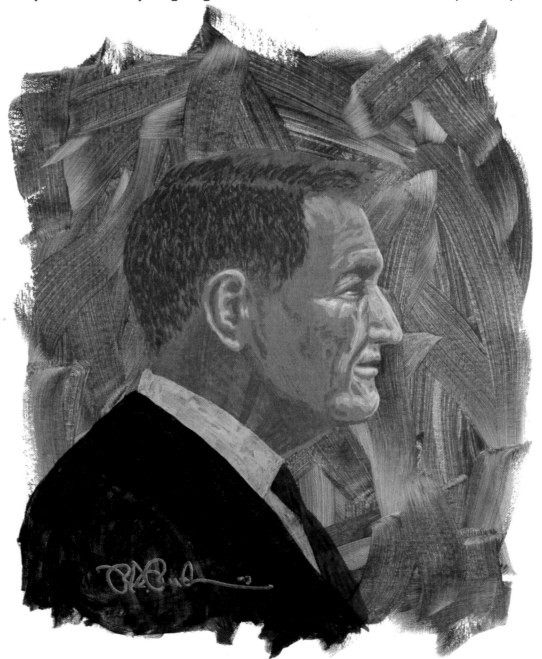

## GENE STALLINGS

Bringing Home A Championship

> *I looked around, and everybody was going crazy.*
>
> —◇— Linebacker Antonio London on his blocked field goal

The Year: 1991

## The Moment:
# Fourth Down Gambles

On a Saturday in Baton Rouge, the faint hint of an autumn chill was in the air. Tailgates were loaded down with crawfish boils, blood sausage, pork ribs, and a never-ending pipeline of whiskey. The sounds of drunken laughter echoed toward the far bayous and beneath the Spanish moss. Angry young men, beer-joint bandits, and little old ladies cursed every outsider who dared venture toward Tiger Stadium. LSU football was meant to be played after dark and beneath the moonlight.

The ball had been kicked off at two-thirty in the afternoon while the winds lay still, the tides remained at sea, and a brooding heat tumbled ashore from the distant and wayward gulf.

Even the football had begun to sweat.

Alabama had struck for long distance, with flanker David Palmer returning a punt ninety yards for a touchdown and Matt Wethington nailing a forty-two-yard field goal.

The Tide, under the direction of quarterback Jay Barker and powered by the running of Siran Stacy and Kevin Turner, had become a well-oiled machine hitting on all cylinders – and some of them twice.

But as the day grew long and the shadows of darkness began to gather around Baton Rouge, LSU changed its persona from Jekyll to Hyde and became rogues on the loose.

It was darker now.

There was a moon hanging from above.

It was Tiger time, and LSU was storming back.

Every Saturday night during the autumn in Baton Rouge was Halloween. Some teams played football. LSU dealt in nightmares.

The Tigers intercepted an Alabama pass, ratcheted up its offense, and marched to the eleven-yard line.

So close.

No closer.

LSU, still trailing 20-17, with two minutes and forty-nine seconds remaining, was staring into the dead, hollow eyes of fourth down.

There were still two yards to go.

LSU head coach Curly Hallman would say, "I considered going for it on fourth down. But with the way our defense was playing and with our kicker, I felt we could get the ball back and have a chance to win it."

At the moment, he decided to settle for a tie.

He wouldn't lose, and he still had an outside chance for victory.

Three quick defensive stops, and LSU would have Alabama by the throat.

Hallman sent his placekicker out on the field.

The distance was only twenty-eight yards.

For Pedro Suarez, it was a chip shot.

In the defensive huddle, Alabama players were telling linebacker Antonio London, "If you've ever blocked one, you need to block it now."

He was the one.

Nobody else.

On two successive weeks, Antonio London had blocked a punt or a field goal.

Make it three.

He said, "I tried to time it just right from the moment they snapped the ball until the time they placed it down. We don't practice the block at full speed. We just practice the timing of the jump."

He had the timing down.

He leaped.

The ball came off the tee.

London felt the impact of the block before he heard it.

In that frozen moment of time, when the world abruptly stopped spinning, and a patchwork of muted colors drifted past his eyes in slow motion, and all sound was lost in the abyss of a faraway blur, he heard only the voices, the shouts, of his teammates.

"They were going crazy," he said.

Still, there were almost two and a half minutes left in the game.

Alabama had no time to rest, relax, or celebrate.

Curly Hallman thought his defense could get the ball back.

He still had a chance.

It was growing dim.

He liked the dark.

He liked the night.

LSU always stalked the night.

His Tiger defense stiffened.

Alabama reached the forty-three-yard line and faced a fourth down of its own.

No problem.

Everyone knew the tough, conservative mind of Gene Stallings.

He would play it safe.

That's what the Bear would have done.

Stallings lived inside the mind of the Bear.

He was his own man.

But he had learned from the master.

Stallings would punt the ball away, preferably into the end zone, and leave LSU with a long field and a short time clock.

If nothing else, in crucial situations, Stallings was predictable.

Everyone waited for the punter.

He was sitting on the bench.

He had not moved.

Gene Stallings did not even look his way.

Stallings had gone mad.

No question about it.

Jay Barker took the snap and handed off to Kevin Turner, running straight into a massive LSU wall.

The bricks crumbled down on top of him.

He needed one yard.

He made one yard.

In a game measured by inches, Turner had managed to scratch for the last one.

LSU would never touch the ball again.

Turner bolted for forty-nine yards to the seven, and the excruciating hands of time peeled off the last seconds on the clock.

Stallings tried to explained in the locker room.

Yes, he had gambled.

No, he had not gone mad.

Probably, he should not have done it.

He said, "The fourth-down play wasn't really a very smart call on my part. If I were smart, I'd be doing something else. The players wanted to do it, and I let my heart override my good judgment. The game was on the line. I went ahead and let them do it."

The crawfish had all been shucked.

The curses had become harsh and bitter whispers, mostly lost in the sea winds.

The pipeline of whiskey had turned dry.

The day had turned to darkness and moonlight.

For LSU, the night came too late.

*I told the players we have something to say about setting the tone for the next hundred years.*

<> Gene Stallings, Alabama head football coach

The Year: 1992

# The Moment:
# The Interception

Alabama had an old score to settle, and the Tide was facing a hired gun.

Twenty-one games ago, Florida had lured Alabama down into the mystical confines of the dreaded Swamp in Gainesville and buried the Tide, 35-0. No one had beaten Alabama since. Once again, Florida would get its chance. But this time, the Gators weren't in the Swamp. They were on foreign soil. It was supposed to be on a neutral field. It wasn't.

Head Coach Steve Spurrier had brought his high-powered, long-distance, levered-action, heavily-oiled, fun-and-gun offense to Birmingham to shoot it out with Alabama in the Southeastern Conference Championship game. The winner would be headed to the Sugar Bowl for a confrontation with Miami.

The Swamp.

Birmingham.

Steve Spurrier did not care where he was. He had an offense that could not be stopped, and he knew it. His quarterback, Shane Matthews, held a dozen records in the Southeastern Conference, and he was within a mere hundred and sixteen yards of becoming the leading passer in college football history. Spurrier, if the press could be believed, was an offensive genius, the maestro who was orchestrating the most potent and flamboyant passing scheme in college football. He had style. He had flair.

Rush seven. Rush one. He didn't care. Play one-on-one. Drop back into a zone, shallow or deep. Spurrier had a package of plays for any occasion, any situation, any down, and from any place on the field. He punted only if it were a last resort. Even then, he would rather throw the ball. A punt was nothing more than a necessary evil.

He still remembered the 35-0 debacle. In the face of a blistering air assault, the Alabama defense had been lost, always out of place, and helpless. He liked it that way. Steve Spurrier, however, would learn that a man, especially a football coach, should not condemn himself to live in the glories of the past. He might have the same weapons, but seldom could he repeat it.

Florida was off and running in a hurry, taking the opening kickoff and driving for seventy-seven yards to score the first touchdown that Alabama had al-

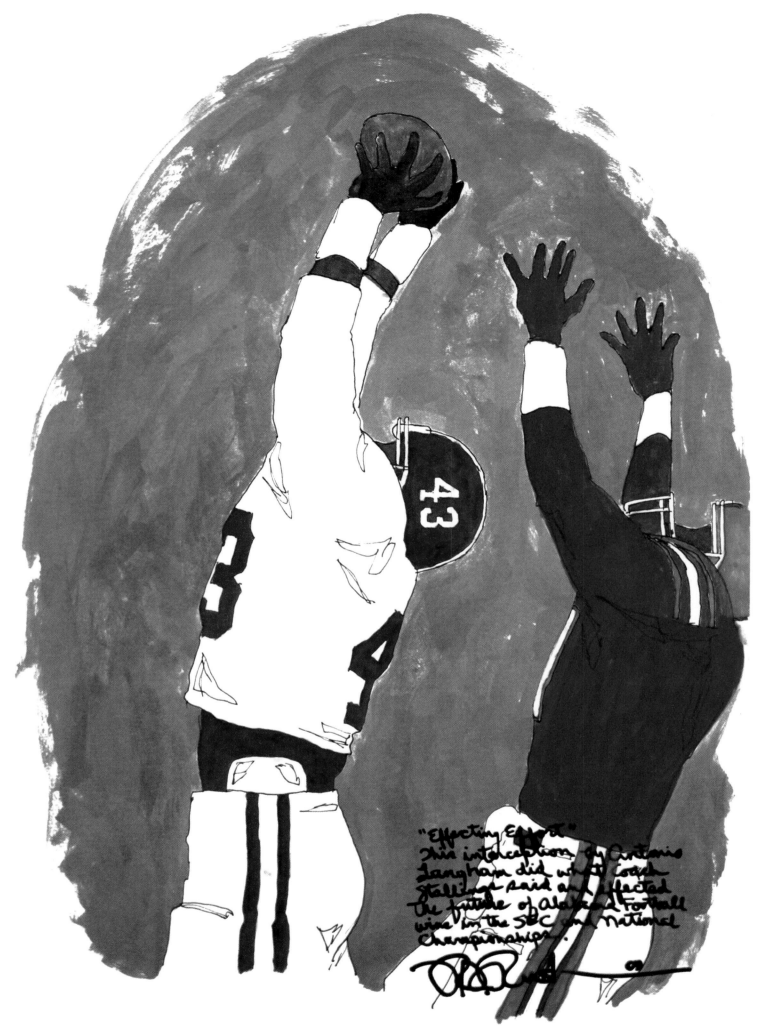

## ANTONIO LANGHAM

A Dagger in Florida's Heart

lowed in the first quarter all year. Shane Matthews said, "We nickled and dimed them to death." He led an attack that came armed with a hair trigger. He could throw long or short and often.

A touchdown was bad enough. But the Gators started to snarl and strut, taunting the Alabama bench, rolling imaginary dice on the turf, laughing loudly, and pointing at the stands. Alabama could not tell how many fingers were raised or which one it was. In the minds of the Gators, the day was already over. And it had barely begun.

The Tide didn't get mad. The Tide got even.

Florida had not encountered a team that could withstand the raw, blistering firepower locked away in the Gator air arsenal.

Florida had not met Alabama.

The Tide immediately fought back with an air raid of its own. Barker called a play that the Tide had worked on in practice all week.

Split end Curtis Brown flanked right and raced to the post. He was a decoy. Go deep and stretch the field. He was the last-hope receiver, the safety valve if the play broke down. Curtis Brown was loping along without a care in the world, and Jay Barker stood in the midst of pressure, frantically looking right for his wing man. He was covered.

Jay Barker did not hesitate. He spun and whipped a thirty-yard strike to Curtis Brown, the decoy, the safety valve, who made only his second touchdown catch of the season.

It came at the right place at the right time.

Derrick Lassic fueled the ground game, and the Gators had no luck at all trying to cover David Palmer one-one-one. Florida's pride had always been its great speed. Florida could not keep up with Palmer. Florida was a step slow.

For fifty-six minutes, the game was dead even. Steve Spurrier had said that twenty-one points would win the game. He was wrong.

Florida had twenty-one. So did Alabama.

Nothing had been decided, but, with three minutes and sixteen seconds left, the Gators had possession of the ball. The game was in the hands of the Florida sniper, the most prolific passing quarterback in the nation.

Alabama had played a hundred years of football, and Gene Stallings told his team that the moment had arrived for them to set the tone for the next hundred years. The glory of the past and the hope for the future were separated by three minutes, no more. The Crimson Tide could either play for a national championship or leave behind a season of heartbreak and despair. There was nothing else that Stallings could do. It was all up to the players. These were the times that would define Alabama football.

Cornerback Antonio Langham said, "We all got together and told ourselves that somebody had to do something. I decided I would do something."

On third down, Shane Matthews fired to Monty Duncan as he had done so many times before. The ball was in the air. A perfect spiral. A perfect strike. Duncan had slid past the first-down marker and was reaching for the football.

Antonio Langham wanted it more. He stepped in front of Duncan, stole the ball with the deft moves of a cat burglar on a hot tin roof, and weaved his way for twenty-seven yards and the go-ahead touchdown. Imaginary dice were scattered all over the field. Florida did not roll them. Florida could no longer find them.

For Shane Matthews, it was the end of the line. Twenty-two seconds later, Tide linebacker Michael Rogers intercepted another pass, and Steve Spurrier watched a season of triumph break apart and heard the pieces hit the ground. Matthews was shell-shocked. No one could thread the needle better than he. The needle had come back to stab him.

He and the Gators, however, were given one last-ditch, last-gasp chance with a mocking clock running down and almost out. Shane Matthews threw four times, and four times the ball hit the ground where the imaginary dice and Spurrier's season of triumph lay in splinters.

Gene Stallings had a national championship staring him cold in the face.

He tried not to think about it.

> *Everyone says we can't beat Miami, but we are not just anybody. We are Alabama.*
>
> —<< Flanker David Palmer

The Year: 1993

## The Moment:
# Shutting Up Miami

It was a clash between two teams that did not like to lose. Alabama had won twenty-two straight games. Miami had captured twenty-nine in a row, and, as one newspaper columnist reported, "The Miami Hurricanes has been ranked as the nation's number one team by *The Associated Press*, CNN Television, *United Press International*, and the Federal Bureau of Investigation."

Miami had swagger. Miami had the headlines, not all of them good, not the ones outside the lines anyway. Miami was the loudmouth bully of college football, beating up on the little guys, playing with all of the guile, finesse, and sportsmanship of a street gang carrying night sticks, and doing its damndest to intimidate anyone who had the audacity and misfortune to stand in the way of the Hurricane.

Miami also had the Heisman Trophy winner, and the nagging question loomed as large, as dark, and almost as ominous as a gulf thunderhead rising above the Sugar Bowl in New Orleans. Could Alabama tarnish the golden arm of All-American Geno Torretta?

The Tide's defensive line coach, Mike Dubose, pointed out, "The defense usually knows where the ball is going when Torretta drops back to throw it, but the hard part is stopping it." As far as Tide All-American defensive end Eric Curry was concerned, "It's like a cannon going off the way he gets rid of the ball. Torretta takes the snap, steps back, and fires."

He and Miami had the magic to turn a five-yard reception into a fifty-yard gain.

Alabama had built its defensive game plan around the ball-hawking ability of George Teague, who, during the year, had pulled down fourteen interceptions. He could swagger with the best of them, never saw a pass he didn't like, and if the Tide had only one shot at stopping the heralded Geno Torretta, it would definitely be Teague.

But George Teague looked awful. He was tired. He was pale. His nights had been restless and sleepless. He was coughing. Sneezing. Wheezing. He was wracked with the pain of a nagging and debilitating chest cold. He was weak and lifeless. The energy had all leaked away.

Miami acted as though George Teague was just some name in a phone book, a character in some two-bit comic strip. They weren't worried about no stinking George Teague. As Hurricane receiver Lamar Thomas said, "Alabama's cornerbacks don't impress me one bit. They're overrated. Real men don't play zone defense."

The trash talking began as soon as the Hurri-

canes reached Bourbon Street. They had won two national championships within the last three years and were feeling no pain and no pressure. Adrenaline was pumping hard, and their nerves were as tight and taut as the banjo strings in a Dixieland jazz band. They laughed at Alabama. They derided Alabama.

They insulted and provoked Alabama.

And why not? they asked. They were Miami. The Hurricanes. And Alabama was entangled in the eye of a deadly storm.

Paul Finebaum wrote: "The word class is never used to describe Miami. Perhaps a more appropriate word is trash. Just hang around these guys for ten minutes, and you feel violated. Yesterday, following a Miami press conference, I wanted to immediately run upstairs and shower. I wanted to wash away the sleaze and the slime."

The national press, however, had bought into the Miami masquerade.

Michael Ventre of *The Los Angeles Daily News* wrote on the day of the game: "Miami is No. 1. It will stay that way. Alabama doesn't have a hope or a prayer or a shot in the dark of upsetting the Hurricanes ... and it won't even be close. Alabama will be trounced, clobbered, mauled, devastated, humiliated, and left for dead.

"Tonight, they will experience low tide ... probably even ebb tide. Having respect is nice, and maybe one time it worked in college football, but having a chip on your shoulder seems to be far more effective these

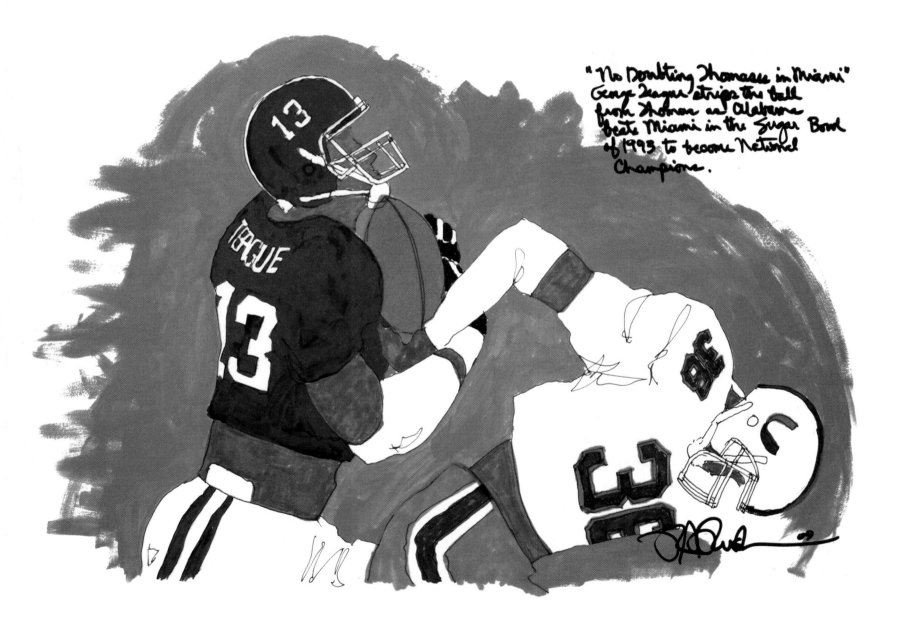

# RUNNING WILD

Making Believers In Miami

days.

"Alabama will not be able to move the ball. It won't be able to BUDGE the ball."

Alabama was the lamb looking for the slaughter.

It didn't quite work out that way.

Gene Stallings had developed the perfect offensive game plan. He took the pass, dusted it off, and tucked it away in his hip pocket. Didn't want it. Wasn't needed. His quarterback only threw for eighteen yards. His running backs, however, could slice a defense like new razor blades. Derrick Lassic and Sherman Williams ran roughshod over the Hurricanes, exploding through, and past the feared and self-righteous Miami Hurricanes for almost three hundred yards.

So much for not being able to BUDGE the ball.

Said Derrick Lassic, "Miami said we were a one-dimensional offense that couldn't beat them. Our offensive line accepted the challenge."

Defensive coordinator Bill Oliver's scheme totally confused, bewitched, and befuddled the great Geno Torretta. As Teague explained, "We threw a lot of things at Torretta. We never came back with the same thing twice in a row."

Said cornerback Tommy Johnson, "We dared Torretta to throw long. We put eleven on the line of scrimmage. We stuffed it. He never knew who or how many would be blitzing, where they were coming from, and how many would be dropping back."

For the first time in his life, Torretta was starring hard at a defensive secondary plugged with seven jerseys, all the wrong color, all daring him to find an empty hole on the field. He had little time to throw and less time to look. The Miami bullies, the street gang, the intimidators could not block Alabama and had no luck at all trying to outrun them. Torretta felt only pain, bewilderment, and frustration.

He knew there should be a seam, but Alabama had zipped it tight.

"I think we got in his head," Tommy Johnson said.

Torretta was rattled. His raw nerves, the ones as taut as Dixieland banjo strings, snapped. He didn't fall apart, but the screws were missing. Defensive end John Copeland saw Geno Torretta look over at him

and freeze for an instant. Their eyes locked. "I saw fear," Copeland said.

Torretta's cool, poised exterior began to crack. His swagger was more of a limp. He threw thirty-two incomplete passes. Tommy Johnson caught one of them. He might as well. He was open on the play. And poor old George Teague – tired, pale, weak, needing sleep, coughing, sneezing, and wheezing – picked off another and raced unscathed for a touchdown. Torretta couldn't have thrown the pass any better. It hit Teague on the move and headed the other way.

After awhile, the Heisman Trophy winner with a tarnished golden arm was simply dropping back and throwing from memory. He told Bill Campbell of *The New Orleans Times Picayune*: After the Teague interception, "I don't remember much of the second half. It was a blur." Campbell wrote that the rampaging Alabama defense had, without mercy or ceremony, "sent Torretta into the twilight zone."

Derrick Lassic said, "Coach says the game's never over until it's over. But in the back of our minds, we knew it was over. There was no way they would score twenty-one points on our defense."

The victory was never in doubt. The sheer power of the domination was stunning. Alabama broke the night sticks, kicked the swagger out from under Miami, throttled the Hurricanes, shut their mouths, and nailed them shut. The outcome, in reality, may have even been worse than 34-13.

Michael Ventre, who doubted if Alabama could even BUDGE the ball, much less stay on the same field with Miami, threw up his arms in surrender. He wrote: "The results were shocking. Miami, supposedly the proud dynasty of the '80s and '90s, the new wave of college football, the swaggermeisters of South Florida, played like pipsqueaks. They shrank to trash."

Lassic was more succinct. He said, "We shook up the world, baby. We shook up the world."

Back when Alabama was courting Gene Stallings, someone casually mentioned something about a national championship.

Stallings had brought one home.

*I thought Nebraska was the most football-crazed state until I came to Alabama.*

The Year: 1999

→ Author James Michener when writing his book on *Sports in America*

## The Moment:
# A Second Chance

For Alabama, it had been a game of second chances. Now it all came down to one chance. The last one.

Alabama was back in the dastardly, despicable Swamp of Ben Hill Griffin Stadium in Gainesville, where Florida had not lost a game during the past five years. Thirty-one games. Thirty-one victories. The Swamp was definitely not a place for the faint of heart. Nobody survived the Swamp.

Somebody forgot to tell Alabama.

The Gators took the lead, as the ever-scowling Head Coach Steve Spurrier knew they would, and they continued to hold tight as the game wore down. Spurrier had become the only coach to ever beat Alabama seven times. He was minutes away from number eight.

Alabama trailed, 33-26, and was forced to punt. Head Coach Mike Dubose understood the problem facing his Tide. Give the ball to Florida and the wizardry of quarterback Doug Johnson, and you might never get it back. Still, he had no choice.

Dubose was playing the odds. They were slim.

They exploded in Florida's face.

A fumbled punt set up Alabama deep in the Gator end of the Swamp. Running back Shaun Alexander dashed for thirteen yards, Chris Kemp drove home the extra point, and the Tide had fought its way to a 33-33 tie.

But Doug Johnson had the ball. He was dangerous any time he touched it. As long as a tick or two remained on the clock, Florida believed it was in a position to score. The yardage be damned.

Johnson took one too many steps. He held on to the ball a second too long. A blitzing Chris Horne blasted him. Johnson crumpled. Horne said, "It was the perfect play call. Darius Gilbert told me he had a feeling I was going to come clean, and I did."

For the Gators, the end of regulation had come swift and sudden. Spurrier didn't mind. Overtime only gave his Gators another four downs, maybe more, and a chance to shove another touchdown down Alabama's throat. Lord, how he did love touchdowns. Florida wasted little time driving into the end zone. Spurrier turned his back to the field. He wasn't worried. The extra point was automatic. Jeff Chandler sailed the ball wide right.

Alabama had the Gators guessing and dared them to guess wrong. Quarterback Andrew Zow had virtually matched Johnson pass for pass, connecting

137

on twenty-eight of them and piling up three hundred and thirty yards. He had thrown for two touchdowns, and Florida waited for him to put the ball in the air one more time.

Shaun Alexander had other ideas. On the sidelines, he turned to his coaches and said, "You know, we've still got the counter."

"You think it will work?'

"I'll make it work."

Alexander said, "If you get your play, it doesn't matter if there are twenty folks out there. You've got to run through all twenty of them."

He took the handoff from Zow, cut back to the left, broke free past the line of scrimmage, and hit the Florida secondary running free and clear. He said, "I thought, just don't go down, and we've got the game won. I think there was one guy in front of me, and I simply had to pick my feet up and use what God gave me – a little toughness. I knew when I got in the end zone the game was over."

It wasn't over.

Florida had missed the extra point. Chris Kemp had a chance to nail one for a 40-39 victory. It wasn't automatic. The ball sailed wide right. His heart went silent. The beat lost its rhythm. The dreaded and contemptible Swamp had worked its voodoo magic one more time.

Maybe not. Yellow flags were bouncing on the floor of the Swamp. The Gators were offside.

The game had indeed been one of second chances. Now it was down to one. The last one.

Chris Kemp should not have been in such a crucial, pressure-packed situation. He was the second-stringer, but the regular placekicker had a pulled quadriceps muscle. He had trouble walking. Kicking was out of the question.

Kemp was facing Florida. He was standing in the Swamp. For too long, it had been a place where Alabama victories went to die. Kemp had been born in Gainesville. He had played high school football in Jacksonville. He was a native son of Florida.

His blood ran Crimson. He said, "I just got back

there and took a deep breath. I looked up at the goal post, looked down, and hit it. I always listen to the crowd, and that usually tells me if it's good or not."

The Alabama crowd stood on his left. Florida flooded his right. He heard the cheering. He heard it with his left ear and grinned. He knew that all was right with the world.

Steve Spurrier simply told the press, "He just missed it like our kid missed it, and we jumped offside, and they didn't. So they're still out there hollering and laughing, and we're crying. That's the way sports is."

The Swamp had lost its bite. It had been the home for thirty-one straight Florida wins.

There would be no thirty-two.

# TRADITION OF CHAMPIONS

### Shaun Alexander Rolls Through Florida

*He's one of the toughest quarterbacks I've ever coached.*

<∕> Offensive coordinator Dave Ruder on Brodie Croyle

The Year: 2006

## The Moment:
# Ugly Is Good

**B**rodie Croyle had been a fighter. As the Alabama quarterback, he faced adversity. He faced disappointments. He was criticized. He was praised. He won more than he lost. Croyle never won enough. Not for Alabama. Not for himself.

Brodie Croyle tore an anterior cruciate ligament in his knee.

He hobbled along on crutches, and he persevered. He stared at hardships and misfortune squarely in the face and never blinked.

He played under three different coaches who brought in three different systems and asked him to learn three different playbooks.

He endured.

He may have been at the throttle, but Croyle had nothing to do with starting and stopping the train.

He just never got off.

Brodie Croyle had been jolted a time or two.

He went down.

He never stayed down.

Brodie Croyle kept on fighting.

Wars were won that way.

On a January morning, he sat in the dim, beleaguered bowels of the Cotton Bowl in Dallas and pulled on his Alabama jersey for the last time.

He had one last game to play, one last play to call, one last pass to throw.

The ragged hopes of a lifetime would be packed into sixty minutes of football.

His one and only bowl would be for Cotton.

His father had played for Alabama on the same field in 1973.

John Croyle knew his name was in the program, but he could not remember much about the game.

He had awakened in the dark recesses of a hospital room, and wasn't sure why.

All he knew was that his helmet was dented and crushed, and he read that Alabama had been beaten by Texas in a 17-13 thriller.

The thriller was a haze trapped somewhere between his eyes and his brain.

His son had a chance for redemption.

Brodie Croyle could win a Cotton Bowl game for them both.

He wouldn't be playing Texas.

He would be battling Texas Tech.

That was close enough.

Croyle's offensive coordinator, Dave Ruder, told him, "Son, you're going to finish strong, and people will be talking about Brodie Croyle for a long time."

Alabama coaches were worried about a high-fly-

ing Texas Tech offense that, some believed, didn't even bother to use a playbook.

The Red Raiders were averaging as many as forty-one points a game, and it sometimes seemed as though Head Coach Mike Leath simply stalked the sidelines and made up the plays as he went along.

Draw them up in the dirt.

Pull them out of his back pocket.

Flood the field with receivers.

Let the quarterback find one.

He had a tendency to find one thirty or forty times a game. It was a lot more complicated than that, but just as outrageous and generally a lot more disconcerting. As the scouting report said, "They're as liable to go for it on fourth down as they are to punt it. You have to play all four downs and do your best each snap."

Texas Tech had the number two offense in the nation. Alabama, however, had the number two defense. It would be raw power against raw speed, hammer on quicksilver.

As the press said, thunder made the most noise, but lightning did the damage.

Lightning had pretty much stayed tucked back behind the clouds. Brodie Croyle kept it there. He was running a steady and methodical offense, one that kept chewing up the clock. Alabama would keep the ball in its possession for almost thirty-nine minutes.

The high-powered Tech offense – wild and unpredictable, and full of tricks – had trouble leaving the bench, and, when it did, the Tide came in waves with a punishing defense that possessed more damage than noise. The Red Raiders threw a few and caught a few, but not nearly enough.

With four seconds less than three minutes remaining to play, however, lightning struck quickly and suddenly. A field goal tied the game, 10-10. A lesser team might have folded, but Alabama and adversity knew each other quite well.

Brodie Croyle led his team onto the field for the final time. He would say, "Coming into Alabama, that was what you dreamed of: your last game, you're in the Cotton Bowl, and you have two minutes to score."

He was no stranger to hard times. Or pressure.

Beginning at his own fourteen-yard line, Croyle whipped Alabama down field for fifty-eight yards in ten plays, hitting Matt Miller with a critical third-down pass, then finding Keith Brown for twenty-three yards. The Tide would get no closer.

Head Coach Mike Shula might have time for another play. He did not want to risk it. He took a last time-out and sent his placekicker out on the field.

Jamie Christensen had already made one field goal for thirty-one yards. He was facing a forty-six yarder. Jamie Christensen had never kicked a field goal that far before.

The stadium went silent.

Alabama was afraid he would miss it.

Texas Tech was afraid he wouldn't.

The pressure tightened. Jamie Christensen kicked the ground, then the ball. The ball was low. It had a wobble. It was spinning sideways and in the wrong direction. It was hooking badly toward the left corner of the goal post.

Jamie Christensen had no idea whether or not the kick was good. Alabama was hoping for the best. Alabama was prepared for the worst. All eyes were on the referee. He threw his arms skyward.

Good.

Texas Tech quarterback Cody Hodges thought the kick looked more like a three-iron punched into the wind. He said, shaking his head, "No offense taken, but that's the ugliest kick I've ever seen."

Ugly, of course, was strictly in the eyes of the beholder.

Mike Shula sat slumped in the locker room. His Alabama team had ripped off nine wins, then suffered two crushing defeats to end the season, and now the Tide owned a Cotton Bowl trophy. He said, "The last few years have been tough. We've been through some tough times, but we've stuck together. There were a lot of different ways we could have gone, but this team pulled together."

He was talking about his football team. Shula could just as easily have been talking about Brodie Croyle.

141

NICK SABAN

The Mark of a Champion

> *What I would like for every football team to do that we play is to sit there and say, I hate playing those guys.*

<div align="right">⋖⋗ Nick Saban, head football coach</div>

The Year: 2007

## The Moment:
## The Coming of Nick Saban

Nick Saban had trekked through the precarious and treacherous terrain of the Southeastern Conference before. He knew all about the dangers, the perils, and the pitfalls. He knew it was a shooting gallery, and Alabama stood directly in the line of fire. Always had and always would. Week after week, Saban would be eyeball-to-eyeball with the best teams, the best players, the best coaches that America had to offer. It was survival of the fittest.

Nick Saban was back. And he touched down in Tuscaloosa.

He had been the man chosen to resurrect Alabama football.

There had been good men and good coaches in the recent years before him, but the Capstone was not quite like any other place on earth.

The years were broken down into two distinct seasons: football and waiting for football. It was a religion, deeply felt, emotional, and often spiritual on Saturday afternoons – or nights – in the calm, graceful beauty of a southern autumn. Kick off, however, and peace along the Black Warrior River turned to bedlam.

Alabama had never been satisfied with mere wins, even big wins.

String a few victories together, and they led to something far more powerful.

The Crimson Tide wanted championships.

It was time for championships.

As the headline in a special edition of *The Tuscaloosa News*, proclaimed, it was, at long last, Saban Time.

He had taken a moribund Michigan State team, and, in five years, upset number one Ohio State, routed highly ranked Notre Dame, and led the Spartans to a 9-2 record and a bowl game. It had been so long between bowls.

Saban left for the bayous of South Louisiana, reshaped a struggling LSU program that had suffered through seven gruelling and losing seasons during the 1990s, and whipped the Bengal Tigers to a na-

tional championship.

Saban was the miracle worker. In the recent past, Alabama had run out of miracles.

The Tide wondered if he had a pocketful left.

When Athletic Director Mal Moore made the decision to find a new head football coach, he was looking for someone who already had national stature, success, and a winning legacy.

No longer would the Tide be content to sit around and wait for a young coach to grow into the role.

Moore, as the newspapers reported, wanted a proven winner.

The press bandied about the list of usual suspects, obvious names that might or might not be given a shot at the job: Houston Nutt of Arkansas, Bobby Petrino of Louisville, Steve Spurrier at South Carolina, Jim Grobe in Wake Forest, Rich Rodriguez of West Virginia, and a man who had suddenly departed LSU and college football for a head coaching job with the Miami Dolphins – Nick Saban.

It was an impressive list of candidates.

Good men.

Good coaches.

All with winning resumes and credentials.

Mal Moore knew whom he wanted, no doubt about it, but the opinions around the nation all assumed he was spitting in the wind.

Alabama had no shot at Nick Saban. Even Saban had said he had no intention of leaving the Dolphins.

Moore did not listen. He piled up a stack of guaranteed money worth thirty-two million dollars, offered a deal that would last eight years, and signed Nick Saban's name to the dotted line.

Moore said, "When I set out on this search, I was seeking a coach who had a proven record of accomplishment and leadership for our program. The hiring of Coach Saban signifies a new era of Crimson Tide football and affirms our commitment to provide our student-athletes and fans with a leader who will continue our commitment to excellence across the board."

A wave of raw, unbridled emotion fell across the Alabama nation.

Happy Days were here again.

Saban arrived amid a fervor bordering on hysteria, walking on campus with wild, almost deafening, chants of *Roll Tide* falling around him.

He had the status of a rock star, and Cecil Hunt wrote in *The Tuscaloosa News:* Saban "gave a virtuoso performance at his introductory press conference. He was confident and commanding, emanating the precise qualities that Alabama fans want in a head football coach. He spoke of championships and working three hundred and sixty-five days a year 'to dominate his rival in the state.' He spoke of fielding a big, physical football team and of hard work."

Saban talked of winning titles, perhaps.

He talked more about building teams.

He certainly knew the territory – he had traversed through dangerous and unfriendly terrain before – and it did not faze him.

The Swamp in Florida.

Between the Hedges in Georgia.

The haunts of the Iron Bowl.

Saturday night in Baton Rouge, where the four horsemen were death, famine, pestilence, and LSU, and the most dreaded of these was LSU.

This time, the Bayou Bengals would not have his back. This time, they would be gunning for him. A few had grieved when Saban left Baton Rouge. The rest were irate.

Revenge was too nice a word.

LSU was searching for something far worse.

Nick Saban was consumed by football. He demanded a lot from his team. He was even harder on himself, a defensive-minded coach with a flair for offense. As Gil Brandt of the Dallas Cowboys said, "While everyone is talking about how good his defense is, you might notice that his offense tends to score a lot of points." His LSU championship team had set a school record, averaging over thirty-three points a game.

Alabama had high expectations. His were higher. "I want to win every game we play," he said.

And, somehow, Nick Saban always believed he would. For him, and for all time, he said, Alabama would be the last stop.

> *We know it meant a lot to Coach Saban after a win like that. He won't say anything, but we know how he feels.*
>
> — Guard Mike Johnson

The Year: 2008

## The Moment:
# A Hell of a Storm

Nick Saban was a year, maybe two, ahead of schedule. His Crimson Tide was undefeated, only Penn State had a higher ranking in the national polls, Alabama was inching ever so slowly toward a possible national championship, and he was walking without a detour into the valley of the shadow of death with his head up, his chin out, and doing his best to dodge the passion and rage surrounding his return to Baton Rouge. Nick Saban had walked out on LSU, and the Bengal Tigers were daring him to come back. It would be a night, they said, he would always regret.

All week long, down among the bayous, where crawfish were nothing more than an excuse to drink beer, Saban had been derided, insulted, criticized, condemned, and burned in effigy.

He said, "You name it. I heard it. And none of it was really that creative."

The year before, LSU had traveled to Alabama and whip-lashed the Tide 41-34 in the cozy, comfort-able confines of Bryant-Denny Stadium.

It was bad then.

It would be worse now.

Nick Saban – the traitor, the betrayer, the deserter – was headed to Death Valley where, according to tradition, LSU would score a touchdown every time Mike the Tiger roared.

No matter how hard he tried, Saban would not be able to muzzle Mike.

The big cat already had a bad temper, and the sight of Alabama brought out the mean in him.

Security was tight.

Undercover police officers roamed the parking lot and the inner sanctum of the stadium.

Some wore LSU colors. Others were clad in Crimson. They weren't taking any chances.

Some Tiger fans were dressed in tee-shirts that said, *Nick Satan*, and others set fire to a scarecrow bearing the coach's likeness while the crowd chanted, *"Fire him up,"* and *"Burn, Saban, burn."*

Alabama may have worried about his safety.

Nick Saban didn't.

He had seen it all before.

It was just a typical, old-time, down-home, lay-your-

head back and howl at the moon Saturday night in Baton Rouge.

As Adam Wren wrote in his *Bleacher Report:* "Alert the masses. Stock up on water, bread, batteries, and flashlights. Nail those windows shut with plywood and send the loved ones inland. Death Valley is preparing for the storm of the century! Forecasters predict a storm tide eighty-five strong, and it doesn't look as if it's going to let up anytime soon. Nick Saban is coming back to Tiger Stadium for the first time since 2004, and LSU fans have been foaming at the mouth, waiting impatiently and rabidly for his bittersweet return … This is going to be one hell of a storm."

Matt Zenick wrote in *Scout.Com:* "It's well known, in the SEC or anywhere else college football is taken seriously, that when you win, you're targeted and hated to an even greater degree … Seeing Saban strut into town with an unblemished record and big-time bona fides only has to rankle the home folks even more, ratcheting the rancor and resentment to an exponentially higher level … Hating a man's actions is one thing. When that man breaks your heart and succeeds more quickly than even he probably expected, the vinegar and vitriol will only shoot through the roof."

As far as Nick Saban was concerned, the games were over.

Let the game begin.

Alabama was one victory away from clinching the Western Division title of the Southeastern Conference. It might as well come against LSU, Saban thought. He wasn't worried about fate. He would take the win over anybody.

The game meant a lot to Alabama.

His relationship with LSU, good or bad, meant absolutely nothing.

Alabama was sky high. The Tide fell flat, and none of the players knew why. The offense was sluggish. It had lost three fumbles during the first thirty minutes of play. The turnovers hurt. The penalties hurt. A proud run defense that had only allowed an average of sixty-five yards a game sprung a serious leak. No one could slow LSU down.

Nick Saban was livid. His anger spilled over into the locker room during halftime. He ranted, and he preached. His rage boiled over. He said he thought he pulled a stomach muscle imploring the Tide to play harder. The word implore may have been an understatement. "It was," he said, "as lethargic a half of football as Alabama had played all year." It was, he swore, the last lethargic half of football Alabama would play all year.

Paul Gattis, of *The Huntsville Times*, wrote: For Alabama, "it was time to wake up, with a record Tiger Stadium of 93,039 watching and the ones wearing purple and gold smothering the place with eardrum-splitting noise. Apparently, Saban's lone voice was louder than those of ninety-three thousand."

The Tigers had an upset on their minds.

Alabama had stood around most of the night, looking as though it were waiting to be mugged and victimized.

An aroused band of Bengal Tigers had grabbed a 14-7 lead and forced Tide quarterback John Parker Wilson into unfamiliar territory.

He said, "For the first time all season, we had to come from behind. We were beating ourselves. We were doing things that were plain stupid. But we kept our heart."

Safety Rashad Johnson popped out of nowhere and picked off a Jarrett Lee pass in the second quarter, racing for fifty-four yards and a touchdown, knotting the score at 14-14.

He had spent a lot of time in the film room, and he wasn't guessing on defense.

He had already crawled inside Lee's head.

He didn't read his thoughts.

He knew the eyes.

After feeling the unsettling wrath of Nick Saban at halftime, Alabama awoke with a vengeance.

The Tide came storming out of the locker room and thundered to a fairly quick and easy 21-14 lead.

The game became trench warfare again, hand-to-hand combat, and LSU battled its way down field late for a 21-21 tie.

The Tigers knew they had Alabama on the ropes.

Now all they had to do was wrap that rope around Nick Saban's throat and pull it tight.

He had other ideas.

With five minutes remaining, John Parker Wilson put the game on ice.

He dashed for thirty-two yards and the go-ahead touchdown.

It was a long run. It was all for nothing.

Flags lay in his footsteps.

Flags tarnished the color of yellow.

Holding.

The touchdown came back.

No problem.

With seconds left, the reliable Leigh Tiffin lined up for a twenty-nine-yard field goal, not much more than a chip shot.

He could kick them in his sleep.

A crack suddenly fractured the offensive line.

It widened.

A legion of purple and gold roared through.

Bam.

A block.

Alabama was stunned. Alabama had taken two dead-on shots at LSU and missed them both.

The Tide was facing the worst nightmare it could imagine – overtime on a Saturday night in Baton Rouge, overtime in a den of noise that rivaled the howls of the damned.

LSU had the ball first.

On the sidelines. Alabama defensive coordinator Kirby Smart told his players, "We're gonna make a play to stop them from making any points, and we're gonna win this game."

Motivation?

Maybe.

A prophecy?

Perhaps.

Tiger quarterback Jarrett Lee rolled right, felt the pressure of the blitz, and threw to Brandon LaFell.

It was a hope and prayer.

The prayer fell on deaf ears.

The Tide's Javier Arenas was all over LaFell.

The throw sailed, and here came Rashad John-son one more time, one last time.

As Arenas said, "He came over the top like Superman. That's why he's here. He just changed the game a lot today – three times.

Johnson hit the ground with the ball tucked against his chest.

It was just like Coach Smart had said.

No points.

A shot to win.

Legitimate chances in big games came few and far between.

Alabama would not miss its third one.

A twenty-four-yard pass to Julio Jones carried to the one-yard line, and Wilson kept the ball himself, driving for the final yard.

"After four hours of raw emotion and carnage," wrote Gentry Estes of the *Mobile Press-Register*, Wilson lay "under a pile with both arms stretched into yellow-painted grass, hands viciously clutching a football until someone in stripes told him he didn't need to anymore."

It had been the toughest, hardest-fought, and most brutal test in a charmed season for Alabama. Ian Rapoport of *The Birmingham News* wrote, "The day began with Nick Saban rushing into Tiger Stadium, flanked by security, paparazzi bulbs popping, and LSU fans taunting. It ended with the spiteful crowd emptying onto the street, as a small, Crimson-clad band of fans partied as if it were 1999. For Alabama, it was."

The Crimson Tide had won the West.

Saban was looking for more.

He said, "We're about nineteen thousand feet, and the mountain is probably twenty-six thousand feet. The air is changing. It's a little bit rare. You've got to change how you breath sometimes, but you still have to focus on the task at hand. Because if you slip up and don't, the consequences can be devastating, even more so than when you were down at seven thousand feet."

A long climb faced him. He had met the mountain. LSU had simply been a crevice in the great stone wall, a place to step and hang on along the way.

> *It's a great accomplishment to get where they are now, and they did it with a lot of hard work and perseverance.*

<div align="right">

⟨⟩ Alabama head coach Nick Saban

</div>

The Year: 2008

## The Moment:
# Day of a Champion

Alabama had become the capstone of great expectations.

Alabama wanted a championship.

Alabama wanted a win over Auburn.

Thus far, Nick Saban had delivered neither.

Any coach needed time to build a program, recruit a team, and find the right players who could best run his system.

It always took time. For Nick Saban, time was a waste. He would win. He would win with the players he already had. He would win now. He already had.

Alabama owned one of the nation's longest winning streaks at twelve games and had risen to the top of the national polls. Saban had taken the Tide to a bowl game the year before, and a stunning victory over Colorado – with John Parker Wilson throwing three touchdown passes – began to solidify a team that was desperately trying to learn the nuances of a new coach and a new system.

Only Auburn remained. Auburn, in good times or bad, was always formidable.

The Tigers had a six-game winning streak of their own. Their offense had spit and sputtered for a time but was suddenly running wild and wide open. It was wired with players who had never lost or even been threatened by Alabama. The Tigers from down on the plains, in fact, had beaten the Tide for six consecutive years. For those who wore Crimson, it was a drought of unspeakable proportions. A loss every now and then could be tolerated. Never accepted. But tolerated. But six in a row? It was the unforgivable sin.

Maybe, Alabama thought, this would be the year to take the losing streak and break it over Auburn's bowed neck. Nick Saban knew it was the year. He had never seen a team he didn't think he could beat.

Sometimes, the turning point in a game came early. Sometimes it waited to the end. The secret was to recognize the moment, seize it, and take advantage of it. Alabama did.

The Tide was holding on to a tenuous 3-0 lead in the first half of a game that could easily go in either direction. Momentum was fickle. It had no loyalty. It could turn on you in an instant. Auburn had the ball.

Alabama's defense stiffened. An incomplete pass brought up fourth down, and the Tiger punt rolled out of bounds at the Tide's thirty-four- yard line.

It didn't seem like much at the time. But three plays rolled up twenty-five yards, and Glen Coffee suddenly crashed off right tackle and broke clear. He was in the Auburn secondary as quick as a pistol shot. Auburn saw him fly past. Auburn never touched him. He said, "I was able to go around the outside, and Drew Davis had it shielded off. I just saw the daylight when I turned the corner. The line had cut off everybody, so it was just a race to the end zone."

It was an unfair race. Glen Coffee had the lead like a thoroughbred breezing into the homestretch, and he had no intention of giving it up.

Auburn came fast. Not fast enough.

Of his offensive line, Coffee said, "Running behind them doesn't really give us that much to do except hit those holes full speed and take care of the rest."

His run ignited Alabama to a 10-0 lead.

No one realized it at the time, but, in reality, the game was good as over. All that remained was the simple matter of tallying up the points.

There would be thirty-six of them.

A punt recovery by linebacker Rolando McClain at the Auburn thirty-nine-yard line set up a quick touchdown strike from John Parker Wilson to Nikita Stover. The Tigers could only handle the ball three times before fumbling again, and, after a Terrence Cody recovery, Wilson dumped off a screen pass to Mark Ingram for twenty-seven yards, then hit Julio Junes for fifteen more. Ingram slashed inside for the final yard. After Greg McElroy went ahead and connected with Marquis Maze for a thirty-four-yard touchdown, Alabama could race off the field with its largest margin of victory – 36-0 – in forty-six years.

Auburn's offense never gained any traction. It ran up against an Alabama defense that could not be moved. There were no holes, no place to go.

And Alabama controlled the airwaves. The Tigers threw the ball at their own risk.

The Tigers chiseled out a yard at a time, and after a while, the chisel was worn down and dulled by pressure so constant, so suffocating, so intense that Auburn was much more concerned with surviving the game than winning it. The Tigers were never able to move inside the Crimson Tide red zone and only scraped out fifty-seven yards on the ground. Auburn did manage a hundred and seventy yards of total offense, but most of it was carved out far from the narrow shadows of the goal line.

Terrence Cody, Alabama's monster of a nose guard, said that before the game, all the defensive linemen said they were going to play this game for our lone senior on the line, Bobby Greenwood. We played the game for him and came out there and played hard."

Greenwood threw his own bitter grade of gasoline on the fire. He blocked a field goal and recorded half a sack. Auburn may have run his way but not often. He was a man possessed. Greenwood had one last chance to atone for three years of misery. He did not ruin it.

Safety Rashad Johnson was his own one-man wrecking ball on Senior Day. He had five tackles, a fumble recovery, and broke up a pass, saying, "My emotions are through the roof. I cannot really explain how it feels. It is just a great feeling. We did it in a first-class manner, with a shutout, and were able to dominate the game."

Said Auburn Coach Tommy Tuberville, "All streaks must come to an end, and our streak came to a halt tonight. We needed them to make mistakes, and they didn't. And we needed not to make mistakes, and we did. They're very aggressive. They forced our hand."

Saban had beaten Auburn. Chalk one off the list.

And he had guided Alabama to the SEC West Championship. Chalk off another.

Alabama was once again emerging from the shadows to become a national force. The climb back had not taken nearly as long as some had predicted it would. Saban was not surprised. He knew his team. He knew the character of his team.

It was Alabama.

He was Alabama.

He wanted more.

# Epilogue

The power and glory of Southern football has long been reflected
by the rich heritage and tradition built by Alabama.
Great coaches.
Great players.
Twelve National Championships, occurring during the years of
1925, 1926, 1930, 1934, 1941, 1961, 1964, 1965, 1973, 1978, 1979, 1992.
Coach Wallace Wade won three of them.
Frank Thomas led the Crimson Tide to two titles.
Paul "Bear" Bryant collected a half dozen.
Gene Stallings captured the last one.
And Nick Saban has his eyes set firmly on the next one.
The Tide rolls on forever.
And the moments  never end.

## A WARRIORS HELMET

The Legacy Of The Crimson Tide

"Helmet of a Warrior"
University of Alabama

150